Lost Restaurants

OF

TULSA

Lost Restaurants
OF
TULSA

————— RHYS A. MARTIN

Published by American Palate
A Division of The History Press
Charleston, SC
www.historypress.net

Copyright © 2018 by Rhys A. Martin
All rights reserved

Front cover (clockwise from top left): Mandarin Café, courtesy of Jean Eng;
postcard, author's collection; Louisiane, courtesy of the Tulsa Historical Society and
Museum; Pennington's, courtesy of Mark Messler.
Back cover (clockwise from top left): Metro Diner, author's collection; Connors' Corner, courtesy
of the University of Tulsa; Bishop's Restaurant, courtesy of the University of Tulsa; Ray's
Coffee Shop, courtesy of Charles and Norma Miller.

First published 2018

Manufactured in the United States

ISBN 9781625859105

Library of Congress Control Number: 2018952866

For my mother, whose creative encouragement has finally borne fruit

Contents

Introduction

Food connects us like nothing else does. Everybody has to eat, and we have so many options to choose from. Whether you want to spend an evening with family eating comfort food or if you'd rather immerse yourself in a book and nibble on a morning bun, Tulsa has always offered a wide range of dining options. You can eat somewhere different every night of the week or become a regular at a diner counter where your meal is started as soon as you walk in the door. This book will tell you the story about many such establishments throughout the city's history.

I realized something about halfway through the writing process: the more I dig, the more I find. There are so many restaurants that I did not get to feature in this book: Borden's Cafeteria, Sleepy Hollow, Martin's BBQ, Cardo's Cadillac—so many more. I also made an early decision to stay away from franchises unless the Tulsa store was a *really* big deal like Casa Bonita.

I hope you enjoy reading this as much as I enjoyed writing it, whether these places exist in your own memory or you've just heard stories about them. If you have additional stories or photos from the restaurants in this book or others in Tulsa, please share them with me at www.cloudlesslens. com. This is an ongoing journey, and we're all a part of it.

Today, when you go out for a meal in Tulsa, the menu typically comes with a drink section. It's not a big deal. That wasn't always the case; in fact, Oklahoma's liquor laws had quite an impact on restaurant operations for most of the state's history.

INTRODUCTION

When Oklahoma was founded in 1907, it was established as a dry state. Even though national prohibition was repealed in 1933, Oklahoma's constitution kept the Sooner State dry beyond low-point beer. On April 7, 1959, Oklahoma finally voted to repeal prohibition—but there was a condition. Liquor could only be purchased on a per-drink basis from bars; restaurants and clubs were forbidden to sell alcohol.

People who wanted a strong drink while out on the town had to bring their own bottle to a private club. Each club was licensed by the city and required individual membership. Customers could order a setup—just a glass of ice and some water—for a nominal fee. The alcohol had to come from *your own bottle*, which you were expected to have brought with you.

In reality, though, the experience was much different; people referred to it as "Liquor by the Wink." As long as you had a club membership card for the restaurant (which cost next to nothing) you could order a drink. The alcohol would be poured from a bottle in the back that was already labeled with a name—hence, it could be argued that it was *your* bottle. The murky connection was not lost on the authorities; clubs were regularly raided by the Alcohol Beverage Control (ABC) Board. It was just part of the experience of running a restaurant.

Multiple attempts were made to legalize liquor by the drink sales, but time and again they failed at the ballot box. Passions were high on both sides of the issue. Churches organized voter registration drives and awareness initiatives in favor of keeping the state dry, and affiliated organizations ran fiery television spots preaching the horrors of passage. Dry state supporters even installed shells of wrecked automobiles around town covered with "Support Liquor by the Drink" bumper stickers to illustrate the dangers of drunk driving.

Legalization finally passed on September 18, 1984, 52 to 48 percent. Oklahoma was the last state to allow liquor by the drink. The first license to sell was awarded in June 1985 to Mike Samara, owner of the Celebrity Club in Tulsa and the legislation's staunchest supporter. He personally poured the first drink to celebrate Oklahoma's progress.

Most of the restaurants you'll be reading about went through this experience firsthand. I imagine many readers of this book also experienced it themselves. It's a part of the overall picture that is Tulsa's culinary history. Our stories begin with the discovery of oil and how that influenced the rise of the city's prominence.

PART I

OIL CAPITAL
OF THE WORLD

1
An Emerging Market

When oil was discovered in Red Fork, Oklahoma, in 1901, it began Tulsa's meteoric rise as the "Oil Capital of the World." Four years later, the Glenn Pool oil field was discovered—a bounty so rich that it caused dozens of oil and gas companies to move to the city. Tulsa's claim to fame was bolstered by multiple new discoveries around the area through the 1920s.

The booming community was not immune to the Great Depression; however, the area wasn't as hard-hit as the rest of the Midwest. The riches generated by the oil industry helped propel Tulsa as a leader in the aviation industry; Douglas Aircraft built a mile-long plant dedicated to building bombers during World War II.

Tulsa's earliest restaurant success stories were made possible due to the massive influx of wealth and workers from the oil industry. Most restaurants were simple affairs like lunch counters or small diners. As the oil money rolled in, people came to Tulsa to serve the rapidly growing population. It became possible to ship in more exotic foods and the wealthy citizens demanded something more sophisticated. By the time the United States entered World War II, Tulsa had something for everyone.

BISHOP'S

William W. "Bill" Bishop was born in Charleston, Illinois, in 1883. His father, Charles William Bishop, worked on the railroads at the turn of the twentieth century. When dining cars were introduced, Bill and his father worked them together. On a trip through central Oklahoma, Bill marveled at all the oil wells on the horizon. He also saw an opportunity, as eating places were scarce. Bill Bishop moved to Drumright to fill that gap in 1913. He was joined by his good friend Joseph H. "Harry" Powers, and together they took over a fledgling café at 136 East Broadway Street. Inspired by their experience working together in Missouri, they named their restaurant the Kansas City Waffle House.

Bishop was known for being high tempered and "nobody's fool." Harry Powers was always calm and called Bill "the straightest man I ever met"; they balanced each other well. Their prior experience ensured their success; the men of the oil fields loved the waffle foundry. After a few years, Bill and Harry moved to Tulsa to take advantage of the city's growth.

Their first Tulsa restaurant, Kansas City Waffle House No. 2, opened at 121 South Boston in 1916. It was a counter-only place that served downtown workers during the early boom era. Within a few years, two more locations opened downtown (one at 122 East Third Street and another near Fifth and Main). The restaurants were doing so well in the 1920s that they offered employees bonuses twice a year and had installed on-site bathing facilities for employees who didn't have them at home. Charles Bishop bought a farm at 21st and Lewis to help supply their growing chain of restaurants.

In 1930, Bishop and Powers expanded again. Together, the two men converted their waffle foundry at 510 South Main Street into a much larger full-scale operation inspired by the Harvey Houses in the southwestern United States. They renamed it Bishop's Restaurant.

Bishop's was open twenty-four hours a day and offered a greater variety of food with a focus on quality. The new restaurant was two stories tall: the bottom level had a large U-shaped counter and a dining room. The second floor was home to an extensive buffeteria. Red upholstery provided a pop of color against the black-and-white checkered floor in the counter area; a selection of expensive paintings lined the walls.

Bishop's was a social hub for many people for all occasions: anniversaries, first dates, a quick bite before a movie. "In the '40s and '50s, you could stand down in front of Bishop's, and if you stood there for, oh, two hours, you could meet most of the people you knew," said Don Powers, Harry's son.

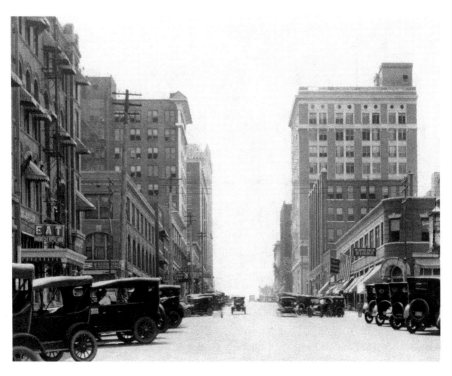

Looking south on Boston Avenue. The EAT sign on the left marks the first Kansas City Waffle House in Tulsa. *Courtesy of the Tulsa Historical Society and Museum.*

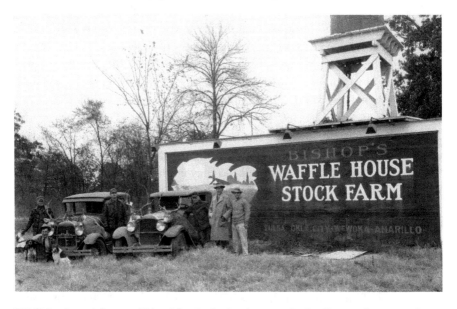

Bill Bishop's stock farm at 21st and Lewis. As the city grew, the family moved to a new farm at 41st and Garnett. *Courtesy of the Tulsa Historical Society and Museum.*

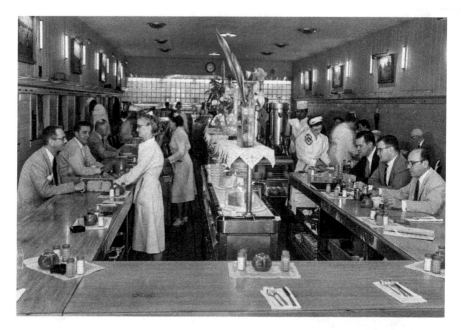

The U-shaped bar and coffee shop at Bishop's. *Courtesy of the University of Tulsa.*

"There just wasn't a whole bunch of different restaurants. And business was downtown then. You didn't work out in the suburbs; there *were* no suburbs." All you had to do was tell someone you'd meet them at Bishop's; everybody knew where that was. A few military men stationed in the region even listed Bishop's as their mailing address, they were there so frequently.

Customers included high-profile oil tycoons like Josh Cosden, William Skelly, J. Paul Getty and Harry Sinclair. On one memorable occasion, famed Italian tenor Enrico Caruso surprised the staff by entering the kitchen to prepare his own spaghetti. People who performed in local plays or musicals headed to Bishop's early in the morning to nervously wait for the first newspapers to the sidewalk, so they could read the review section. Jack Hill, the beloved night manager who had worked for Bishop's since 1919, knew them all by name.

During its around-the-clock heyday, Bishop's employed seventy waitresses. They wore starched uniforms and small caps and sported handkerchiefs in their breast pockets. Presentation was key; no gum chewing was allowed, and if you had a spot on your uniform, you were in trouble. Lydia Ford, who served the buffeteria line in the late 1940s, remembered, "I thought it was ideal. I got 50 cents an hour. And I got plenty to eat."

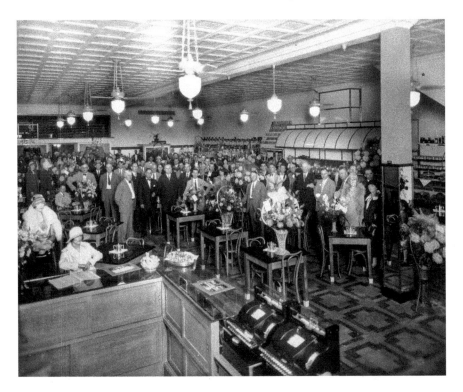

The second-floor buffeteria at Bishop's Restaurant around the opening in 1930. *Courtesy of the Tulsa Historical Society and Museum.*

One of their most popular dishes was the Brown Derby, hamburger steak topped with Sauce Diablo (inspired by the Brown Derby in Hollywood). Don Powers noted the dinner rolls for being "so light you'd have to slap 'em down to keep 'em from floating off." In 1948, when the Philtower and the 320 Boston Building were the tallest buildings in town, a Brown Derby was only sixty-five cents. A steak platter for two (a twenty-four-ounce T-bone, chef's salad for two, two baked potatoes, drinks and rolls) coast less than two dollars.

"It was a lot of food and a real good price...and it was well prepared," Don remembered. The chef's salad was known for a special house wine-oil dressing; the recipe is still sought today. "It was just out of the world," remembered G. Waide Sibley from his youth. "I'd have my mom and dad buy me a pint of it to take home."

In 1936, Bishop opened a second location in Tulsa: a sandwich shop drive-in at 10th and Boston called Bishop's Driv-Inn. It served Route 66

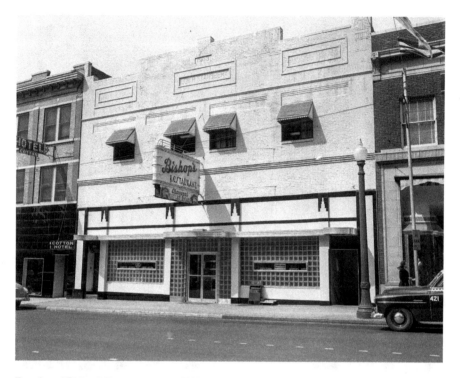

Exterior of Bishop's Restaurant near Fifth and Main with the original neon sign. The larger sign featuring an image of a cow was installed in the late 1950s. *Courtesy of the University of Tulsa.*

travelers and folks in a hurry. Due to the war effort and the impact of gas rationing on automobile use, it closed in 1942. Bishop also opened an Oklahoma City restaurant which was successful for many years.

In 1941, William Bishop Jr. was born; Bill Sr. was fifty-nine years old. Bill Jr. grew up on the stock farm, which by then had moved out to 41st and Garnett to escape the expanding city. Bill Sr. loved to hunt and took his son on annual hunting trips to Canada along with business partners and friends. The restaurant continued to do strong business downtown.

"When I was a little girl, the big deal was to go downtown. The best restaurant to eat at was Bishop's," remembered Theresa Bishop, Bill Jr.'s wife. The first time she went through the doors, her family had come downtown to see Disney's *Snow White* for the first time. "Later, my sisters and I would walk home from the YWCA. We'd all get a nickel apiece to get something on the way, like a candy bar or something. We would put all three of our nickels together because a plate of fries at Bishop's was fifteen cents!"

In 1960, William Bishop Sr. passed away. His namesake restaurant closed for the second time since it had opened. The only other time they'd ever locked the doors had been a two-week stretch during World War II when rationing required them to close overnight. Bill Jr. was at the University of Oklahoma at the time; he dropped out and came back to Tulsa to manage Bishop's.

In 1965, the growth of the city slowed business downtown. Bishop's started closing at 10:00 p.m. every night. The wait staff dwindled to fewer than thirty. The uniforms, once starched so much they could stand on their own, had been replaced by Dacron garb that had to be purchased by the employees themselves. Rent costs were skyrocketing, and people weren't staying downtown after the stores and offices closed. Bishop's lease was coming up, and there were some tough decisions to be made. In the middle of negotiations, Bill Bishop Jr. was drafted and sent to Vietnam.

Early in 1966, developer and building owner Max Campbell told Harry Powers and the restaurant's board of directors their lease would not be renewed. Powers briefly considered relocating but decided it was the end of the road for Bishop's. "We've just had so much trouble recently with costs, employees, and parking that I have decided to close. I don't know…maybe I'm just getting old," he told the *Tulsa World*.

Their last day of business was Saturday, February 19, 1966. The announcement was made in the previous day's paper, and people came out of the woodwork for one last meal. A group of regulars came in early and brought a large bottle of champagne. Their little club had been meeting weekly at the same table in the corner of the dining room for years. After a few glasses were enjoyed, the bottle of bubbly was put on ice so that the closing waitresses could have a farewell toast.

In the back, Sunny Ealom was mixing salads and salad dressing. He was fifty-nine years old and had been working at Bishop's for thirty-nine years, making him the most senior employee on the payroll. "I couldn't believe we were going to close—right here on Main Street," he told the *Tulsa Tribune*. The soft music in the restaurant became a melancholy dirge. "If they don't stop playing that sad music, I'm going to get drunk," said one employee.

After the closure, Bishop's had a huge auction of its art collection. The restaurant contained more than 30 pieces, many of which had been purchased at a New York art gallery. The entire collection was appraised at more than $11,000 (about $85,000 in 2018). The same auction also sold off all of the restaurant equipment, leftover supplies and some Native American artifacts that had been on display.

Three hundred interested buyers showed up: bankers, doctors, lawyers, oilmen, ranchers, former employees—all hoping to take home a piece of Tulsa history. The first picture auctioned, *The Dunes*, hung near the cashier's station and sold for $275. The largest bid ($1,400) came for a pair of Native American paintings by W. Deming that had graced the north wall near the entrance.

The building was torn down in 1969 for parking. Bill Bishop Jr. married Theresa Friedl in 1970; a week after the ceremony, they moved to California, where they lived happily together for over forty years. The neighboring buildings to the south of Bishop's lasted until early 2001 when they, too, were demolished for parking. A small brick archway stands nearby, subtly marking the area that was once so beloved by the people of Tulsa.

MANDARIN CAFÉ

People who moved to Oklahoma during the oil boom mostly came to seek their fortunes. Not everyone planned to strike it rich by discovering oil, though. All of the men working for the oil companies needed goods and services, such as reliable places to eat. In 1919, a few members of the Eng family moved to Okmulgee to open a restaurant and cater to the men who spent their days in the fields.

The Engs opened the Golden Pheasant Café, the latest in a long line of family restaurants going back to Honolulu at the turn of the century. It was a success and operated twenty-four hours a day; in fact, it was doing so well that family members who had been scattered across the United States made their way to northeast Oklahoma. Eventually, they all lived under one roof in a seven-bedroom house on Rogers Street; Albert Eng remembered they had twenty-two place settings for every meal.

In 1929, the oil boom in Okmulgee County waned and the Great Depression hit, causing the Golden Pheasant to close up shop. The family went in different directions to make ends meet. Several family members moved to Tulsa: brothers Phillip "Choy" Eng and Pui Eng; their wives, Elizabeth and Margaret, respectively; Pui's nephew Buck; Margaret's brother Loy Pang; and chef Joe King. They established the Mandarin Café at 118 East Third Street in 1930. It was the first Chinese restaurant in town and was open twenty-four hours a day, right across from the bustling Hotel Tulsa.

The café quickly became a success, but the early years had more than their fair share of loss. In 1933, Pui Eng passed away. In 1938, Pui's brother Phillip died. Phillip's wife, Elizabeth, who had no prior restaurant experience, stepped in to help run the business. Her baby boy Don, who was the first Chinese baby born in Tulsa, was only three at the time.

The Mandarin served Cantonese-style Chinese cuisine; chop suey was prominently featured on the neon sign outside. The top-selling meals were the Chinese dinner plates which featured various combinations of traditional items like egg foo young and chicken chop suey. The café also served American fare like roast beef and mashed potatoes. Rolls were big sellers. Margaret's daughter, Peggy, recalled to the Oklahoma Historical Society in 2007 that she would buy a small bottle of Coke, about eight ounces, and evenly split it between four glasses for her and her siblings. "It was a real treat in those days," she said.

The families lived above the restaurant. It could get crowded, especially when the living areas were full of overflow pantry items for the restaurant. Family members remembered dodging sacks of rice, potatoes and onions while trying to make it to the shared bathroom. Joe, Loy and many of the men on the staff stayed downstairs until early in the morning. "They would play mahjong all night, every night!" Don's wife, Jean Eng, said in 2018.

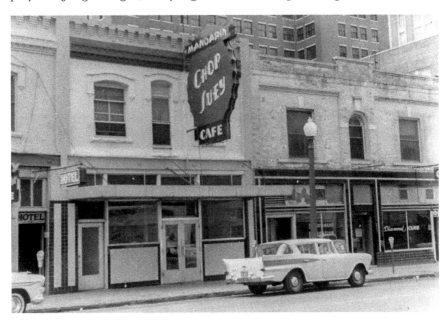

Mandarin Café on Third Street. *Courtesy of the Tulsa Historical Society and Museum.*

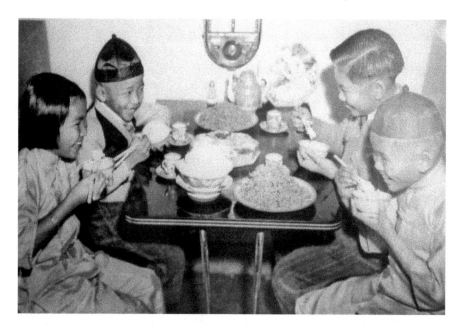

Left to right: Peggy, Donald, Clarence and Lawrence Eng during Chinese New Year at the Mandarin Café. *Courtesy of Jean Eng.*

In 1936, a second Mandarin location opened just down the street at 15 East 15th Street. Loy Pang became known as the "Sage of Third Street," as he walked between the two restaurants to check up on operations. It wasn't profitable enough to run them both for long, and by 1938 the second iteration was gone.

After the bombing of Pearl Harbor, Loy Pang joined the U.S. Navy. By then, Buck had moved away. Elizabeth and Margaret were the only ones left to handle the day-to-day operations of the restaurant while Joe King handled the service in the back. The widowed mothers had a grueling work ethic. They each worked twelve-hour shifts, trading off with each other. The kids helped out when they were out of school. One of the waitresses, Pauline French, said they were so busy all of the time that she didn't think anyone had a key to the place.

Elizabeth was known as a great hostess, patiently explaining the Chinese menu to first-timers. Her son Don remembered in 2007: "At that time, the palettes [*sic*] of a lot of the locals was not familiar with Chinese food. But you know there were sometimes those people who their version of Chinese food was fried noodles and Chop suey."

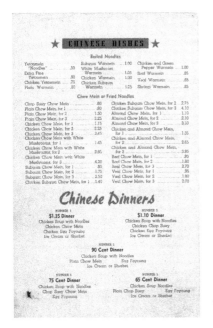

Chinese food section of the menu at the Mandarin Café. *Courtesy of Sui On Jow.*

The Mandarin kept going twenty-four hours a day through the war years. Men working at the bomber plant came in after their shifts for a hot meal; the restaurant filled to capacity at two o'clock in the morning. The long, narrow kitchen only had a two-burner wok, but the cooks still cranked out generous portions and provided excellent service. The Mandarin remained a mainstay of downtown dining through the 1950s with constant traffic from the hotel, the nearby bus station and stumbling patrons from the bar next door.

During this time, Margaret married Joe King. Margaret's daughter Peggy met Jimmy Char in Hawaii and got married. Yuen Pang, another one of Margaret's brothers, came to Tulsa to help with the restaurant. Elizabeth's sons grew up doing their homework in the rooms above the restaurant. Often the kids played on the roof because there was nowhere else to go. More than once they were caught shooting arrows into bags of rice. But it was the family business, and everyone was involved at some level. Life blossomed around it.

Around the time the Mandarin celebrated thirty years in Tulsa, business began to slow. People weren't staying downtown after the workday was over. In 1963, the property was sold to the National Bank of Tulsa to become its new drive-through facility. When the doors closed in March of that year, Elizabeth Eng retired. Though she said at the time her retirement was "just to be lazy," she remained active in her church and among her family and friends until she passed in 1982.

Margaret and Joe King didn't retire. Neither did daughter Peggy Char; Peggy's husband, Jimmy; and Elizabeth's brothers Loy and Yueng. They announced they would be continuing the family tradition with a new restaurant farther south: The Pagoda on Peoria Avenue.

RAY'S COFFEE SHOP

Ray Miller and his wife, Margaret, were managing a little hamburger stand at 15th and Boston in April 1932 when an opportunity came their way. Guy Craven offered to sell them his diner and coffee shop at 1208 East 15th Street. Although it was the middle of the Great Depression, the Millers decided to take the risk. At the end of their first day, Ray wondered if they'd made a mistake; they'd only made twenty-three dollars. But hard work and long hours turned the tiny restaurant into a Tulsa mainstay for fifty years.

Although the Millers had some previous restaurant experience, the diner was on another level. George, Ray's brother and breakfast cook, would lay out eighty sausage patties each morning. "No one in Tulsa cooked as much sausage as he did," remembered Margaret. "And no one could lay out a breakfast like he could."

Space was a premium at Ray's, since the counter had only fourteen stools. "We made more money, per seat, than any other place in Tulsa!" said Charles Miller, Ray and Margaret's son. He described his father as "a gentle touch and everybody's buddy. He was a nice guy." Ray would often take leftover food down to the homeless camp by the railroad tracks. The area churches all knew they could send people down on their luck to Ray's for a hot meal.

George Miller and others at Ray's Coffee Shop in the early days. *Courtesy of Charlie and Norma Miller.*

Though it was tiny, Ray's catered to all kinds. An old pickup truck would be parked next to a sparkling new Mercedes-Benz. "It was quite a place," Charles remembered. He recalled that people from all walks of life sat at the counter; you might even bump into Mr. and Mrs. John Mayo of the luxury downtown hotel. "Always thought it was something for them to eat here and not at their hotel," Margaret proudly told the *Tulsa Tribune*.

Menus were hand-typed and offered simple, home-cooked meals. Entrées included meatloaf, fried chicken, fresh vegetable stew and baked macaroni and cheese. The daily rotation included a different fresh bread offering: hot rolls were made Mondays and Tuesdays, Wednesday was bran muffin day, hot biscuits on Thursdays and cornbread on Fridays.

Customer Charles Harrison told the *Tulsa Tribune*, "It's an institution. They just don't make places like this anymore. Having lunch at Ray's...well, it's like going back home."

Ray's was known for homemade pie with a high meringue. It was proudly displayed behind a glass case—often empty by noon—on the wall. The diner offered chocolate, banana, cherry cream, butterscotch and pineapple cream flavors, as well as a variety of cobblers. You could get a whole pie to yourself if you ordered a day ahead of time, which many did.

Gladys Perrin started working at Ray's in 1943. Her smile became a part of the experience. Longtime customer Diane Kaiser told the *Tulsa Tribune*, "The food? Yeah, it's great. But I like Ray's because no matter how old you are, you go in there and [Gladys] says 'What'll you have, kid.' Doesn't matter how old you are, she calls everybody 'kid.' Makes me feel young."

Ray stayed busy, running a few other small restaurants around town as well as a grocery store. Although the store only lasted a few years, the old cash register he purchased for it in 1945 was still in use at the diner in 1980.

Because of their success, the Millers planned on expanding the diner in 1954. Sadly, Ray passed away suddenly and those plans were shelved. Then, in 1960, when George Miller died, the diner's hours scaled back to lunch and dinner service only. "I'd just as soon not serve breakfast if George can't cook it," Margaret said at the time.

In 1969, Margaret stepped back from managing the diner full-time. Her son Charlie ran the business afterward with his wife, Norma. Although he only expected it to last another year or two, Ray's made into the 1980s. By then, Gladys was working only Mondays and Fridays. Margaret still visited regularly.

"It's just a great place to work," Gladys said in 1980. "That's why I've been here so long. I like the people, I like the work, I like the atmosphere." She wasn't the only one; the line went out the door for lunch.

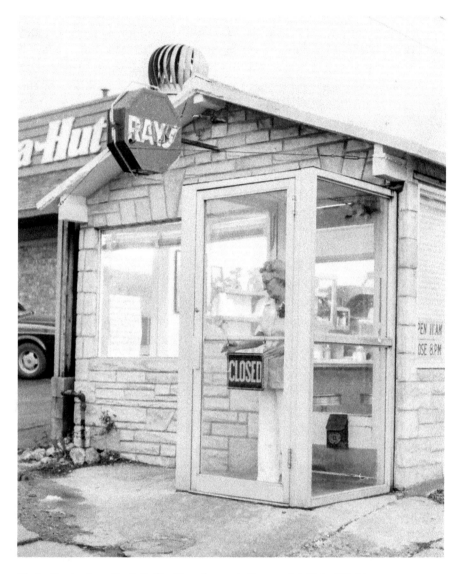

Gladys Perrin closes Ray's Coffee Shop for good. *Courtesy of the* Tulsa World.

In 1982, Ray's announced it was closing. "I'm going to hate it. I'm going to hate leaving," Gladys said at the time. She had served three generations of Tulsans at that little corner café.

"You want to know the real reason, the biggest reason we're closing?" asked Norma at the time. "It was the equipment. It was breaking down and there was nothing else to do. Repair it? We tried, but it was too old.

Replace it? We couldn't. The whole place is so small it is built around all the old equipment."

When the old Coke machine went out, they couldn't find one that fit the space; the new ones were all too large. They kept the old machine and filled it with ice instead. When the stainless-steel double refrigerator died, it was the last straw. "We needed that refrigerator or one like it. We couldn't get it fixed and to replace it we needed to tear down the front counter and knock out the front door. It would have all been too much work. We would have had to rebuild the whole restaurant and it wouldn't be the same."

May 1, 1982, was Ray's last day of business. A sign out front said, "Free Coffee and Ice Tea!" on that final day. Most customers hadn't yet heard the bad news; when they asked what the special occasion was, they were shocked and saddened.

After it closed, a movie production company bought everything in the interior and moved it to a building in the Tulsa Arts District to be used as a set for the film *Rumble Fish*. Today, the land where Ray's once stood now serves as a McDonald's parking lot.

Charles and Norma Miller remember their restaurant family warmly. "They were all such good, faithful people," Norma said. "When you think of all the people that made a livelihood from that little bitty restaurant...it doesn't seem possible today."

DENVER GRILL

The Denver Grill was founded in 1933 by Al and Bud Claybrook, serving the citizens of downtown Tulsa twenty-four hours a day at First and Denver. The restaurant grew as the Great Depression faded and it eventually outgrew its building. After buying out Bud's share in the business, Al built a new diner. Bud went on to operate the Silver Castle at First and Lewis and, later, Claybrook's in Turley, Oklahoma.

In 1955, the New Denver Grill opened next door to the old one at 112 South Denver Avenue; the old place was converted into a Pemco service station. The new diner had terrazzo floors, tilt-out glass windows and satellite jukeboxes at the tables. There were five family-sized booths, four smaller tables and ten stools. Outside, the neon buzzed on the eye-catching sign, which became an icon in and of itself.

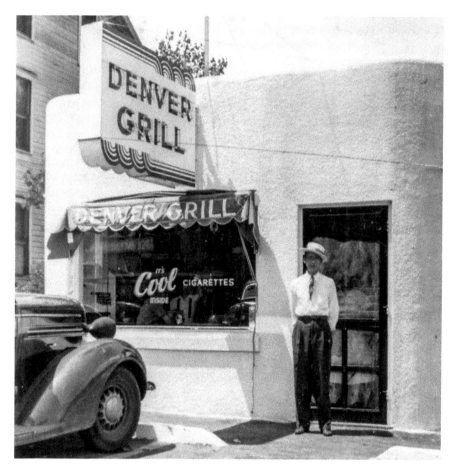

Unidentified man standing outside the original Denver Grill. *Courtesy of Charles Claybrook.*

A year after the move, Al was working on the roof and fell off a ladder. He hit his head and was severely injured; the fall tragically led to his death a short time later. Mary Claybrook, Al's wife, stepped into the business and kept the diner going. She quickly became the face of the Denver Grill. "She was the nicest lady you'd ever want to meet," remembered Rick Morton, whose entire family worked at the Denver Grill at one time or another. He also noted that Mary could be the *meanest* woman you'd ever met, which made her a good businesswoman.

The staff was small and simple: a cook, a dishwasher and a couple of waitresses. Lorrie Gran, Mary Claybrook's granddaughter, remembered, "Cora Platt was the best cook, next to Grandma. Bethel Kinkade was a

lovable woman; she lived close and would always come when someone else didn't. Cora would get mad at me....I deserved it too. I was a terror!" Rick remembered that whenever Cora got tired, she'd just lie down on the floor in the back. "I thought she died forty times, but she was just resting!"

Mary had a strong work ethic. By 6:00 a.m. she was making rolls for the lunch crowd. She cut her own meat in the back and prepared all the side dishes on a daily basis. Everything was handmade, from the French dressing to the noodles for the popular "Hen and Noodles" dish. She didn't own a freezer, so everything had to be fresh.

The Denver Grill served traditional fare: hamburgers, steaks, pork chops, breakfast food and chicken-fried steak. Coke came in a glass bottle. If you stopped by at lunch time during the week, chances are you cashed out with Ann Detherow at the counter. "She was indispensable to my grandmother. Ann would type the lunch menus on an old Underwood."

Louise Morton started as a waitress there in 1958 and worked off-and-on for decades. "Mom came to Tulsa with eight kids and no direction," remembered Rick, her youngest son. "My first job was filling up the pop box

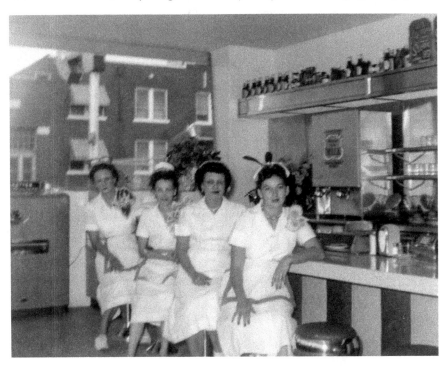

Waitresses at the New Denver Grill in 1957. *Courtesy of Lorrie Gran.*

and turning on the sign every night. I started washing dishes when I was ten and was probably the youngest cook in Tulsa at thirteen," he continued. His elder sister, Peggy Jones, started working at the Grill in the late 1960s and eventually became a fixture.

Lunchtime brought plenty of business from bankers, office workers, public service employees and the like. According to Rick, it was a whole different world at night. "It was all the drunks," he recalled. "And I mean a lot of 'em! I had a world of fun, though. I worked with Peggy; we worked together with my mother at night. We were a team. It was a *family* thing. I don't think it would've made it as long as it did had it not been for this family." He also noted that if someone didn't show up for a shift, all Louise had to do was call home, let it ring once and then hang up. Whoever was home knew they were needed at the diner.

Business slowed down in the 1970s, and downtown Tulsa went through a rough time. The restaurant started closing at 10:00 p.m. every night. The Denver Grill was robbed multiple times. "One week, we were hit twice. I saw Mary cry over that one. They always went for the meat," recalled Lorrie. Very little money stayed in the restaurant, even during working hours.

"The Williams Center was the real death knell for the Grill," remembered Lorrie. "The original food court killed us." In the late 1970s, the Williams Center Forum opened downtown. It included an ice skating rink, a movie theater, shops and a whole host of restaurants. Although the competition was fierce, the Denver Grill held on.

By the 1980s, Mary was in her sixties and ready to get out of the restaurant business. She had tried to sell the Denver Grill several times, but it didn't come together until one of her longtime employees made an offer. In 1983, Peggy Jones became the new owner. Though it was the end of an era, it was the start of another.

Peggy kept the same menu, including the longtime Monday meatloaf special. Although Mary had kept the walls clean and spartan, Peggy added much of the nostalgic décor that the Denver Grill became known for. Eventually, a 1950s-inspired mural was added to one of the exterior walls.

Peggy's charitable nature was well known downtown; she often came down early to take coffee to the homeless camped out nearby. She gave away food, donated clothing, sometimes even offered employment. "I don't know where I'd be if it weren't for Peggy and the Denver Grill," Diana Shuckakosee told the *Tulsa World* in 2005. "My husband and I were homeless, and then one day, while in front of the restaurant, she asked me if I could use a job, and I've been there ever since." She'd worked there for the diner's last eighteen years.

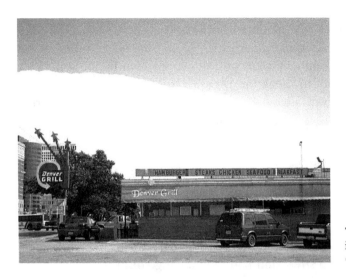

The Denver Grill
in the early 2000s.
Courtesy of Tom Baddley.

Peggy's nature rubbed off on the people who worked for her. "I was about nineteen or twenty years old and was a teen runaway," said Joy Frangiosa. "I was living at the Alden on Denver. When Baker's wasn't open, I would walk down to the Denver Grill. I would only ask for coffee, even though the cook could tell I was hungry. He brought me out a plate of food...a fine breakfast. Just before they closed, I went to photograph the diner and found the cook was still there after all these years. I thanked him and told him how much his kindness meant to me."

The diner hung on through the oil bust in the 1980s. The lunchtime crowd still needed a reliable place to eat. The diner was even used as a movie filming location a few times in the late 1990s and early 2000s. In September 2003, however, the days of the Denver Grill were numbered.

Tulsa voters passed a new tax package. Among the projects funded was a new state-of-the-art sports arena to be built where the Denver Grill had stood for decades. Peggy fought it for as long as she could.

Relocating the diner would be expensive, so she worked with the city on a buyout. "This is the only place I've ever worked, and it means something to me. I want enough money to be able to continue it somewhere else," she told the *Tulsa World* in April 2004. The building was condemned that September and a buyout settlement was reached. The last day of business for the Denver Grill was November 3, 2004.

Peggy reopened the grill on the second floor of the Ramada Inn for a time and made a go of it. Many of her former clients had a hard time finding her new space, though, and the Denver Grill closed for good in 2008.

At the end of it all, the families who worked at the Denver Grill were fused with the history of the diner itself. "Every one of us started at the Denver Grill and eventually went on to own our own businesses," Rick said. Lorrie had a lot to thank the Denver Grill for, too. "Grandma did everything on her own after my grandfather died. She never remarried and was devoted to that business, my mom and me."

THE LOUISIANE

Before it was the Louisiane, the building at 118 East 18th Street was known as Cameron's Cafeteria. Dan W. Cameron Sr. and his wife, Josephine, lived in a house across the street and had the building constructed in the late 1920s to house the restaurant. When the Great Depression hit, Tulsa was affected like everywhere else. Cameron's was able to stay open for a while due to an agreement with Lee Elementary to provide school lunches, but eventually, it had to close.

The Louisiane opened in 1935, run by E.G. Gonzales. Gonzales had been inspired from his time living in Louisiana and wanted to bring an authentic seafood experience to the Oil Capital of the World. In February 1945, Herbert "Herb" Kallmeyer and his wife, Mary Louise, bought the restaurant and turned it into the place that most Tulsans remember today.

The interior featured overstuffed upholstery and padded tables, surrounded by red flocked wallpaper and gilded accents. The copper tree fountain, made locally, was the focal point of the main room. The *Tulsa World* described it as "an elegant old hotel dining room with huge crystal chandeliers and crystal sconces sparkling against the walls." Another room was known as the Cover Girl Grill Room, as the walls were decorated with photos of women featured on the cover of the Tulsa periodical the *Downtowner*. If you opted to dine in the Red Dolphin club section, the red-and-black velvet curtains provided a different mood—especially when a local trio was playing live music.

The food was unlike anything else available in the city. For starters, a relish tray was brought out with a selection of vegetables on crushed ice. It was served with hummus, a dip that many Tulsans had never experienced. Though the Louisiane was known for steaks and salads, fish was the house specialty. According to Herb, fish had once been known as "the poor man's food," but over the life of the Louisiane, its value had surpassed the steak.

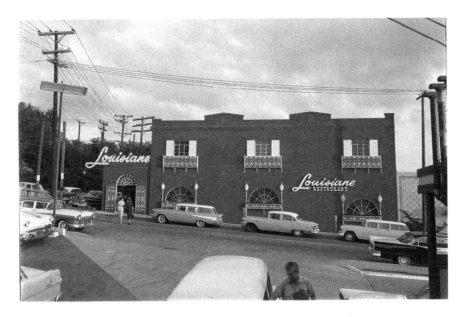

A busy evening at the Louisiane, 18th and Boston. *Courtesy of the University of Tulsa.*

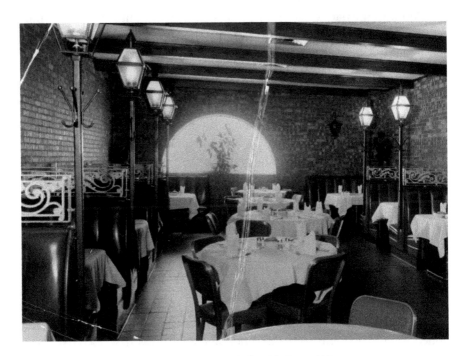

Interior of the Louisiane. *Courtesy of the Tulsa Historical Society and Museum.*

The oysters were fresh, and the Creole gumbo was nationally recognized. "Simple, yet elegant" is how Herb Kallmeyer described it.

It was the upscale destination for many Tulsans and out-of-town guests like John Wayne and Phyllis Diller. Michael Kallmeyer, one of Herb's sons, remembered when pianist and singer Liberace stopped by. "He had these little plastic white pianos that he autographed," Michael said, noting that his family still had one. Herb stoked the high-class reputation of his restaurant by giving out money clips with the Louisiane logo on them. When he gave change, it was with new bills and coins. "He would *never* give you old money," Michael said.

Michael remembered his father as a kind man—a taskmaster, to be sure, but one with a big heart. "In those days, people walking down the railroad tracks…he would feed them periodically, if he saw 'em and he was by the back door." The recipes for the desserts all came from Michael's mother, Mary. Michael himself worked at the restaurant for several years before striking out on his own.

Although the Louisiane was still profitable, Herb Kallmeyer decided to retire in 1983. He was seventy-three and told the *Tulsa Tribune* he couldn't keep up with the pace of operating a first-class restaurant any longer. Many of the employees, including the chefs, had been working at the Louisiane for over thirty years. Everything was auctioned off; Herb wasn't taking any keepsakes. "I've got my beautiful memories," he told the *Tulsa World* at the time. "It's been a very pleasant way to make a living." The Louisiane closed that October, seemingly for good.

In the summer of 1984, however, a restaurateur named Robert Allred announced the Louisiane would be reopening. The building was repainted and renovated; in the two months between the first reports of a revival and the actual opening of the restaurant, people began calling the restaurant daily to make reservations. When the restaurant opened on August 1, it attracted old and new diners alike. Valet parking was offered to help the night feel a little more special.

The large dining room had been converted into a cozy lounge; the club area had been converted into a bright dining room of black, white and chrome. A new private dining area had been created with windows of etched glass.

The menu stayed true to the New Orleans roots of the Louisiane but added some new items too. The Louisiane Salad was described as "Herb Kallmeyer's creation" in honor of the longtime owner. The redfish was cooked in a cast-iron skillet and the shrimp creole had an appropriate Cajun

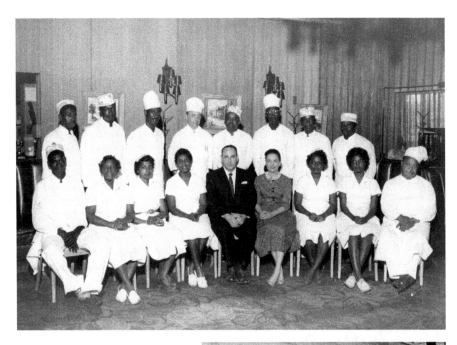

Above: Herb Kallmeyer and staff of the Louisiane. *Courtesy of the Tulsa Historical Society and Museum.*

Right: Herb Kallmeyer closes the Louisiane in 1983. *Courtesy of the Tulsa World.*

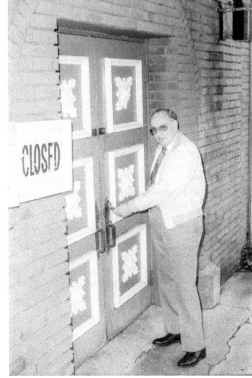

zing. Blackened fish and beef were available, though Bob Allred considered it a trend that would pass.

In 1986, the Louisiane announced a move to 1400 Boston, a nearby seven-story office building that was under construction. Bob Allred told the *Tulsa World* the restaurant had simply outgrown the old space. "Business has been so good since the Louisiane reopened that we need more room. The décor will be quite similar and we'll have the same New Orleans theme throughout. We'll be able to seat about 100 more. We'll also have more parking, something we haven't had enough of."

The new space was made to feel more like a garden setting, featuring wrought iron and brick with street lamp décor and crisp white linens. One area was designed to look like an old library, complete with fireplace. The private dining room had a mural of a Louisiana bayou scene.

The menu had been expanded so much that it now came to the table in a three-ring binder. The lunch menu offered sandwiches and burgers in addition to the traditional specialties of fish, chicken and steak. Another location opened at 82nd and Memorial in 1987 and was managed by Herb Kallmeyer's daughter, Glenda Krisman.

The new restaurants enjoyed positive reviews and steady business. The executive chef at the south Tulsa location was George Weitzel, who had trained in Switzerland and had served President Truman and many stars in Hollywood. There were several transitions of ownership in a short time; combined with a steady influx of chain restaurants, the longtime Tulsa tradition could not survive. By 1993, all that was left of the Louisiane were fond memories of elegance and an unmatched dining experience.

SILVER CASTLE

Ike H. Parkey grew up in Enid, Oklahoma. Though his family was very poor, Ike had a giving heart for all of his life. He played baseball in high school and was offered a position in the major leagues but declined. Ike's sister had helped him complete high school and insisted he go right to work so he could pay her back. He started a small café in Enid and ran a soup line during the Depression. When he moved to Tulsa, he saw an opportunity to provide cheap, reliable food to the masses.

Silver Castle, or the Silver Castle Lunch System, was founded by Ike and partner James W. McCollum. The name Silver Castle came from the

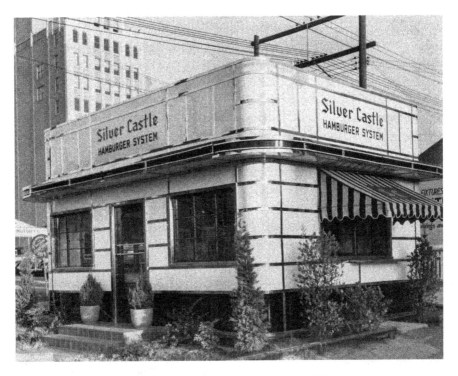

Silver Castle No. 1 at 15th and Peoria. *Courtesy of the University of Tulsa.*

extensive amount of chrome and tin décor that set the diners apart from their surroundings—with a little inspiration from the White Castle diners that had recently opened in Wichita, Kansas.

The first location at 15th and Peoria opened on April 26, 1936 and operated twenty-four hours a day. At the time, the *Tulsa World* reported:

> *The Silver Castle is new and very modern in design and equipment. All shining chromium and white porcelain, the place is exceptionally attractive. The domed ceiling and the walls are of white porcelain paneling with chromium bands outlining the panels. The cooking is done on the latest-type range, in full view of the customers and the place is specklessly and spotlessly clean. The outside finish is silver and the silver, black, and white color scheme is carried out in every detail. The Silver Castle features steaks, plate lunches, sandwiches, and especially good coffee.*

The Silver Castle quickly became known to customers and suppliers alike. Charles "Shorty" Culp was in the vending business throughout the region,

dealing in Chicago Coin machines and Wurlitzer jukeboxes. He talked to Ike regularly, strongly encouraging him to put jukeboxes in his diners, but Ike resisted. After much persuasion, Ike finally relented and the jukeboxes became part of the Silver Castle experience.

The second location was built in 1938 at 19 South Lewis in Whittier Square. Eventually, Tulsa had nine locations scattered around the city, including several downtown and three on Route 66. Collectively, they employed around 130 people.

The operation grew to include locations in Dallas, Texas; Coffeyville, Kansas; Miami, Oklahoma; and Joplin, Missouri. Parkey and McCollum founded the Castle Fixture Company to make their own building materials and various restaurant supplies. Their motto was "The Customer Is the Boss," and those customers kept the Silver Castles going. Ike became a fixture in the community.

"He was wonderful," remembered his wife, Faye Parkey. "He was more giving than anyone I ever knew." Whether it was donating to local causes or

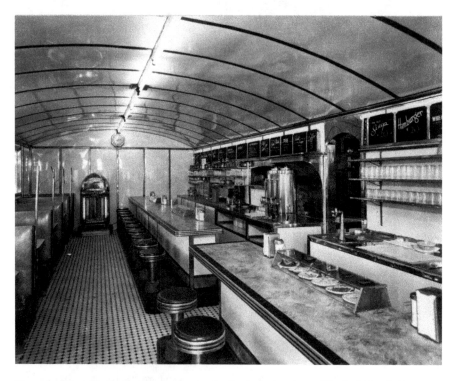

Once the Silver Castle diners became standardized, the interiors all looked identical. *Courtesy of the Tulsa Historical Society and Museum.*

Silver Castle No. 2 at First and Lewis in the Kendall-Whittier neighborhood. *Courtesy of the Howard Hopkins archive.*

giving his time to organizations like the Lions Club and the Shriners, Ike was known as a tender heart. "He helped so many people."

In 1944, James McCollum became ill. That, combined with rationing and material shortages from World War II, forced him and Ike to pivot from total ownership to leasing the Silver Castles to individual operators such as Charlie Warren and Elbert "Bud" Claybrook. In 1946, James McCollum passed away. Not long after, Ike Parkey began selling the Silver Castle diners outright. Many of the managers bought the property they'd been operating.

Bud Claybrook had been in business with his brother Al at the downtown Denver Grill. However, when he had the opportunity to own a place of his own around 1950, he took it. Bud's Silver Castle was in the middle of the Kendall-Whittier neighborhood, then considered the east side of town. Their sign proclaiming "Good Food, 24 hours a day" became a district icon. The neighborhood had a bakery, a root beer stand, a drugstore, a barbershop, the Circle Theater and more. People didn't have to take the bus or trolley downtown to take care of their needs.

Inside the Silver Castle was a familiar sight: vinyl-covered booths and a lunch counter with stools. Each booth had its own jukebox. The aisle was big enough that teenagers danced the jitterbug from time to time, though the management fretted that this kind of activity could cause trouble with the police.

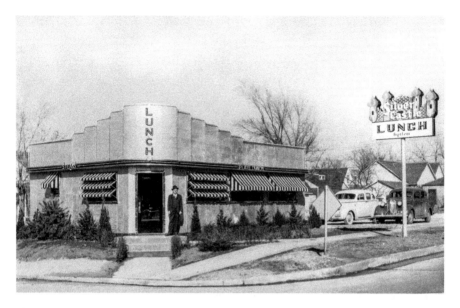

The exterior of the standardized Silver Castle building design with Ike Parkey standing out front. *Courtesy of Jim McCollum.*

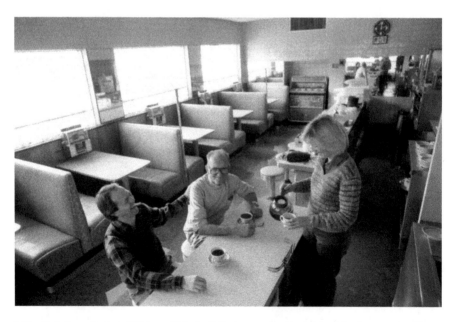

Mike Callahan, George Webb and Linda Callahan on the final day of business at the Silver Castle at First and Lewis. *Courtesy of the Tulsa Historical Society and Museum.*

Bud sold the Silver Castle at First and Lewis, as well as another he operated at Admiral and Harvard, around 1969. He went on to open Claybrook's in Turley with his sons, which became a popular North Tulsa restaurant.

By the early 1980s, the Silver Castle at First and Lewis was the last one open. The Kendall-Whittier District had dramatically changed. The movie theater showed questionable films. Many small businesses were shuttered, some having been replaced with adult bookstores. Silver Castle, though, still had its regulars.

"When I was not busy, and I would get the heebie-jeebies or somethin', I'd run over there and get a cup of coffee," barber George Webb told the *Tulsa Tribune* in 1983. "I'd spend a little time there, and I'd come out of there and come back to work fresh. I guess when they tear it down, a lot of memories will be destroyed." Linda Callahan, the wife of final owner Mike, remarked that many of their patrons were elderly and walked to the diner from their nearby homes.

The Silver Castle on Lewis was demolished on March 1, 1983, to make way for a convenience store. Although the Kendall-Whittier District has enjoyed a tremendous renewal in recent years, the Silver Castle exists only in memory.

Ike Parkey's legacy can still be felt today in many family-owned operations that continue to serve Tulsans. Faye named several restaurants whose original owners worked at Silver Castle first, including Johney Harden and Claud Hobson, who each opened hamburger restaurants in their own name that are still operating today.

EAST SIDE CAFÉ

The Ellis family entered the local restaurant scene early. Brothers Aaron and Floyd Ellis owned a café on Boston Avenue next to the train station; it was so busy that nephew Harvey Ellis came down from Missouri to help in 1925. In 1937, Harvey and Rhoda Ellis opened their own place, the East Side Café, at 3021 East Admiral Place in the Kendall-Whittier neighborhood. It was a simple operation: wooden tables, cotton tablecloths and a metal ceiling. They had a lot of customers from the nearby Douglas aircraft facility during World War II and became a fixture of the city's first suburban shopping district.

The café was an early adopter of television, before the technology became a part of everyone's home. Patrons came in to experience the fuzzy

The famous East Side onion rings. *Courtesy of the* Tulsa World.

picture on the black-and-white technological marvel. On Mondays, the restaurant closed to allow neighborhood kids to come in and watch *Kukla, Fran and Ollie* or any number of other programs.

East Side Café's claim to fame was its onion rings, which were cut fresh each morning. Fried chicken was often touted as the house specialty, and the café had a rotating daily special menu with items such as chicken and dumplings or homemade noodles. Steaks were available during dinner service.

In the mid-1950s, a fire ripped through the place, but the original barstools and wooden pie case survived. The East Side Café kept going. John Ellis, Harvey's son, helped run the business and met his future wife, Shirley, who started as a waitress in 1955. Ten years later, John took over operations entirely, though he said his father never really retired. "He continued to bake pies after I took over," John told the *Tulsa World*. "He had baked pies up until the morning he passed away."

In 1968, John remodeled the restaurant by adding air conditioning and paneling in the dining room. By then, fast-food competition was starting to stir in the city. "When I was growing up we had hardly even heard of pizza. Someone might say, 'Let's go get some pizza,' and we would think, 'Pizza, what's that?'"

By the 1970s, the Crosstown Expressway had cut off customers to the south and Admiral was a one-way street. "We thought the expressway would hurt, but it really didn't seem to hurt us too bad. Our customers still knew we were here and found a way to get here," John remembered. Though business had dwindled, the café still had its share of regulars. Decades passed and not much changed.

In 1995, John told the *Tulsa World*, "I believe we're Tulsa's oldest restaurant owned by the same family in the same location." Retired couples from the nearby neighborhood still stopped in frequently, and businessmen and women still came from downtown Tulsa for onion rings and fried chicken.

John retired in 1999 and handed over operations to his grandson, Atticus. The third generation of the Ellis family co-owned the restaurant with twenty-two-year-employee Eddie Boysel. "The restaurant isn't far east at all today, but back then it was. I am told there was a lot of pasture land east of Rogers High School," Atticus told the *Tulsa World* that year.

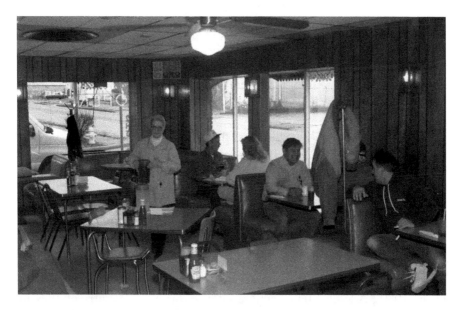

Interior of the East Side Café. *Courtesy of the* Tulsa World.

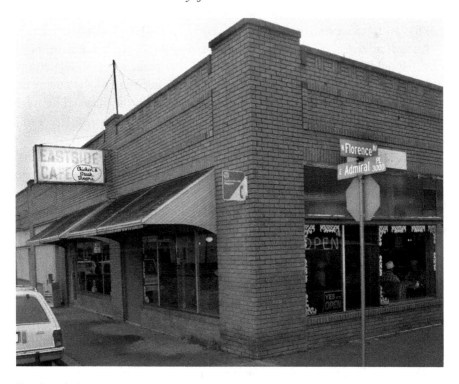

East Side Café on Admiral. *Courtesy of the* Tulsa World.

He and his partner reminisced about the 1970s, when the sidewalk was lined with customers on the weekend. "We don't have those crowds anymore, but we still have a lot of loyal customers," said Boysel. They came for the food and the atmosphere. Ruby Rogers, a longtime waitress, was in her seventies when Atticus took over operations and she still put in three hours every day.

After nearly seventy years, the Ellis family was ready to move on. The East Side Café closed in late 2005. It's not completely history, though. The recipe for its famous onion rings is kept alive by the Freeway Café, a local chain with three locations in Tulsa as of 2018.

ITALIAN INN

In the 1930s, Adolph Menca emigrated from his home country of Italy to Tontitown, Arkansas, where he worked at an Italian restaurant. When he was ready to open a place of his own, he moved to Tulsa. In 1942, he opened the Italian Inn in a converted house at 1604 South Main Street.

Adolph added an awning onto the house to make it look a little more professional and filled the house with artwork to make it more welcoming. Tulsa was dry in the 1940s and he was known for serving little decanters of "wine"—little more than sparkling grape juice—with his meals. The food was superb old-world Italian cuisine, with Adolph's "Tontitown Chicken" dish at the top of the list.

Business was good, but in the mid-1950s Adolph wanted to retire and move back to his home country. He sold the restaurant to longtime cashier Maxine Gibson and her husband, Robert. The Gibsons ran the Italian Inn for about a decade. In 1968, they retired and turned operations over to their daughter Betty and her husband, Donald Funston.

As a teenager, Funston had worked in his father's place, Don's Restaurant. Don's had been a fixture downtown for decades on Fourth Street across from the Orpheum Theater. He had gone to school for hotel and restaurant management at Oklahoma State University and was eager to add his own flair to Tulsa's culinary landscape.

No sooner had the Funstons taken over than they realized they needed a bigger space. The old London Inn at 5800 South Lewis was up for sale, so Don and Betty relocated. The new space had a big fireplace and a large kitchen, making it a perfect fit for their needs. It was there that the

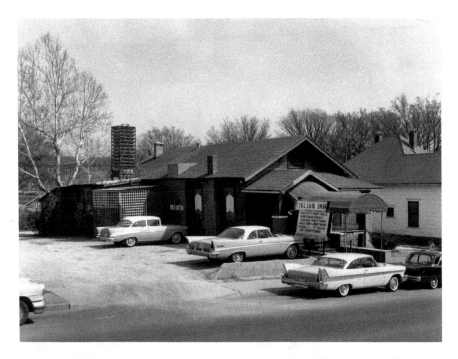

The original Italian Inn on Main Street. *Courtesy of the Beryl Ford Collection/Rotary Club of Tulsa, Tulsa City-County Library and Tulsa Historical Society.*

restaurant became a proper Tulsa institution—the setting for many prom dates, proposals and celebrations. In fact, the night they opened in their new location there was a line of eager customers down the sidewalk.

The interior was intimate and romantic, described as "dark as a coal mine" by Connie Cronley of the *Tulsa Tribune*. White lattice-work walls were adorned with faux grapes and leaves to transplant of the old-world ambiance from the old space. The wait staff wore tuxedos and were held to the highest of expectations. Don was known to his employees for his dry wit and deadpan delivery, but that didn't always go over well. One night, he and chef Jack Reavis had a disagreement in the back that escalated to the point where Jack picked Don up and sat him down on the griddle.

The menu expanded over the years, adding seafood and a lunch buffet at one point. The Italian Inn's most beloved item, according to many, was its cheese spread. It was served before every entrée with antipasto and fresh breadsticks, which were baked in a small Italian bakery in Henryetta and driven into town twice a week. The cheese spread was so popular that the family sold it in local grocery stores.

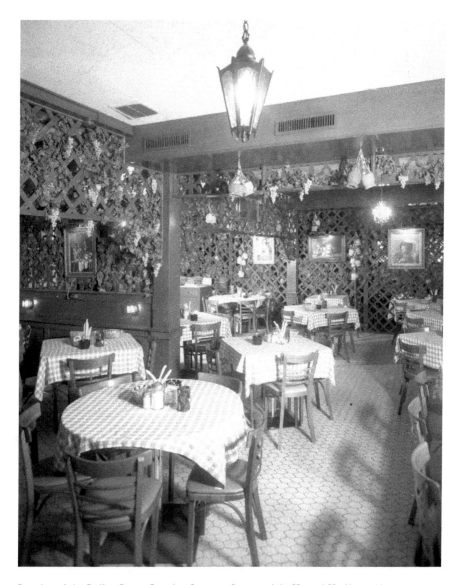

Interior of the Italian Inn at London Square. *Courtesy of the Howard Hopkins archive.*

The Italian Inn survived the recession and the oil bust of the 1980s. In 1989, Don Funston passed away and operations passed to his children. In early 1990, a fire tore through the London Square Shopping Center and caused some damage to the restaurant. The Italian Inn was only out of commission for a couple of days, but the story in the *Tulsa World* caused a

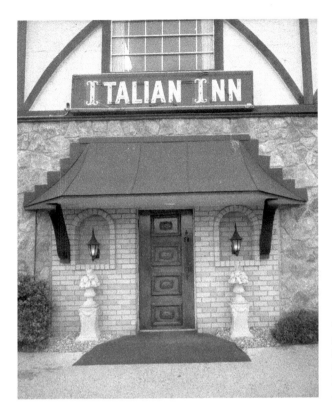

The Italian Inn relocated to the London Square Shopping Center on Lewis in the late 1960s. *Courtesy of the Howard Hopkins archive.*

spike in business. People had faced the idea of Tulsa without the Italian Inn and came out in droves to support the longtime establishment.

In September 1992, the time of the Italian Inn in Tulsa ended. Lori Williams, one of the owners, told the *Tulsa World* that an increase in rent, the age of their building and increased competition drove the decision. Lori, along with her brothers Eric and Don, moved the restaurant just east of Claremore. The new place lasted a few years before it, too, was history. Betty Funston later wrote a cookbook of her favorite recipes, including the beloved cheese spread. The *Tulsa World* republishes that particular recipe from time to time as people still write in with fond memories.

PART II

POSTWAR PROSPERITY

As the Greatest Generation entered an era of prosperity, Tulsa continued to grow and mature. *Reader's Digest* called out the city as a prime example of beautification done right. Oil was still the major player in the local economy, but aviation remained strong, too. The Tulsa Urban Renewal Authority was formed in 1959; over the next few decades, the march of progress claimed many architectural treasures and historic sites around the metro area. Downtown was especially hard-hit by the wrecking ball.

As the city evolved, so did the food. People began to expect more variety on the menu, and continental cuisine was introduced. The traditional diner remained popular, however, and as some tastes evolved, others gravitated to the familiar.

The Spice of Life

STEVE'S SUNDRY

Francis W. "Steve" Stephenson was born in 1918 in Billings, Oklahoma. He came to Tulsa, married Hazel Wheatly in 1940 and worked for S.H. Kress variety stores before joining the U.S. Navy. He returned to work for Kress in 1945 after his service, managing different store locations around northeast Oklahoma. Steve was eager to open his own place, though, and after a few years he did just that.

Steve's Sundry opened in November 1947 at 12th and Harvard, sharing a building with Ernest Moody's first jewelry store. Steve described it as "a drugstore without the pharmacy" to *Voices of Oklahoma* in 2009. You could buy a lawn mower, sewing notions, candy, china, greeting cards and fishing supplies. It was the only store of its kind in town. Their motto was simple: "If we don't have it, we can get it. If we can't get it, they don't make it."

In addition to a wide variety of goods, Steve's also had a soda fountain, a lunch counter and a row of stools that had been acquired from Quaker Drug downtown. A grill in the back was used for full meal service on real dishes. Ice cream sundaes, shakes and malts made with Hawk's Ice Cream were available. Hazel, and later sons David and Rick were at the store regularly.

Books and magazines weren't a focus in the early days. "I didn't even know how to open a bookstore, but a newspaper distributor here helped me put it in. He just came in one day and he said, 'Did you know we

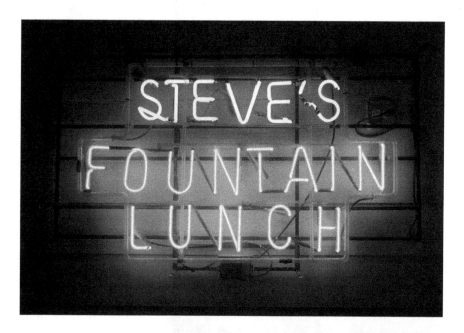

Above: The glowing neon from Steve's Sundry. *Courtesy of Cloudless Lens Photography.*

Right: The famous soda fountain at Steve's Sundry. *Courtesy of Joan Stephenson.*

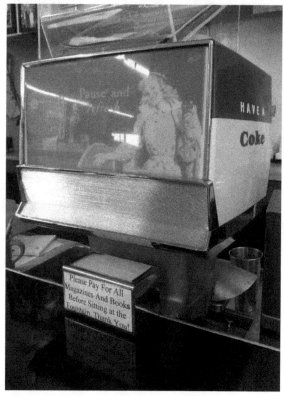

carry books?' I said, 'No.' He said, 'Well, we do and we can put them in your store on consignment. You get the books in your store and they are guaranteed. What you don't sell, you send back. You should sell books in here'," Steve recalled.

When Steve decided to expand and move to 2612 South Harvard in 1958, he took the twelve-stool counter and soda fountain with him but scaled back the meal service. "I had to get back there and wash dishes with the rest of them. That's what the boss always does. So I decided when I moved to this location I wasn't going to do that. Well, that business followed us, and I was back to washing dishes and doing the same lunch-hour stuff." Breakfast and sandwiches continued; a bite at Steve's became a longtime tradition for generations of Tulsans.

Daily specials were still available for a time, but the egg salad sandwich was easily their most popular item. People bought a book, grabbed a seat at the counter and read while munching on a grilled cheese sandwich with tomatoes and onions.

In the early 1970s, the rise of discount stores like Oertle's prompted Steve's Sundry to transition the goods offered just as it had the food. Steve began to lean more toward books and magazines, but the shop didn't lose its eclectic variety. "You could damn near find everything at Steve's," said Michael Wallis, local historian and author. "Periodicals, magazines of every description…as well as Band-Aids, jigsaw puzzles, cough drops, and horse racing forms. And, of course, plenty of books." Sometimes you had to move something to find something.

You would find people of all kinds at the counter in the back, drinking a cherry Coke or a limeade—families on the weekends or business people during the week. "Parents would bring their kids' teams in after soccer, baseball, whatever. They'd just line up," said Steve. The LaFortune or Keating family might drop by and discuss the news of the day over a cup of coffee. Steve was always there. "Pick a vocation you love and you will never have to work," he said.

Many of the employees were regulars before they were on the payroll. "You better be careful if you stop in to visit; you might end up working here," said Teri Castillo, the kitchen manager, in 2011. She had been working down the street at Village Inn and just stopped in one day before taking the job. Customers and staff were on a first-name basis; everyone knew Opal behind the counter just as they'd known Rosie before her.

Steve and his store had become a fixture of the neighborhood and the city at large. It became a must-stop shop for people visiting or coming home

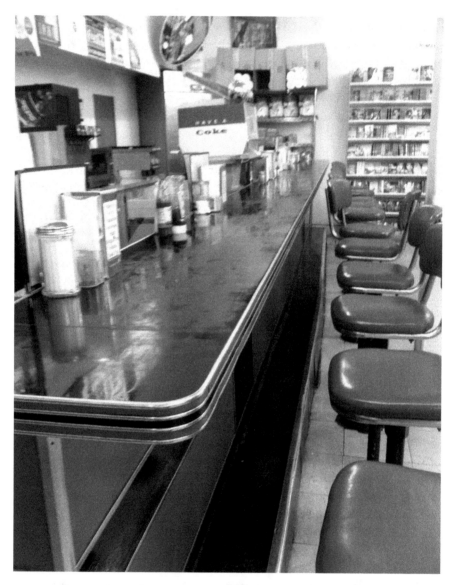

The lunch counter at Steve's Sundry. *Courtesy of Joan Stephenson.*

for the holidays. It also became a magnet for local authors, as Steve's prided itself on carrying native works. And of course, if you came in for a book, you had to get a soda or a sandwich too.

"Dad would stay open until ten o'clock on Christmas Eve," remembered son David. "After six, we were the only store in Tulsa open. Guys, always guys,

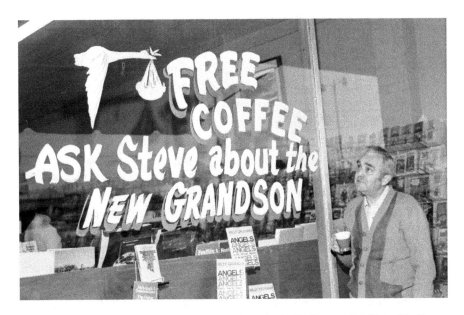

Signage from when Steve's first grandchild was born in 1976. *Courtesy of the* Tulsa World.

would show up between six and ten, and we could sell them anything at any price." He recalled a time when a customer couldn't find the right gift; his brother Rick scoured the back room for alternatives. He found a brand-new electric blanket, and the customer was pleased. But Steve's didn't carry any electric blankets. It turns out that Rick had found one of his own Christmas presents that had been stashed away and sold it out from underneath himself.

Steve's was open on Christmas Day for many years, providing a respite for people to escape holiday stress or a resource for parents to buy forgotten batteries. When Steve's announced it would no longer be open on Christmas in 1988, Jay Cronley of the *Tulsa World* wrote that it was like "being told Casey struck out with the bases loaded."

In 1993, Steve told his daughter-in-law Joanie he needed family in the store. She'd been going to Steve's her whole life, riding down to the store on her bike with friends as a kid before marrying Steve's son David in college. Joanie started helping out on occasion, and before long, she was at the store full-time. She eventually ran the place on her own; as was tradition, her two children Brooke and Drew worked in the store alongside her.

Book signings became a bigger part of the experience. Local authors like Michael Wallis or Ree Drummond, better known as the Pioneer Woman, proudly promoted and displayed their works at Steve's before they reached

the national stage. You could bump into Elmore Leonard or David Baldacci enjoying a cherry phosphate at the fountain after a book signing.

Steve passed away on November 22, 2011, at ninety-three years of age. In September 2013, the culture of bookselling was changing. It was harder for independent sellers to survive in the era of internet purchases and e-books. The family thought about expanding to offer more food, but Steve's had been in place so long the kitchen would need significant updating. Joanie Stephenson made a difficult decision: after sixty-six years of business, it was time for Steve's Sundry to close.

The announcement tore a hole in the fabric of the city; Steve's was like a member of the family. Generations of Tulsans had grown up at the lunch counter or expanded their horizons with a handful of used books from the shelves. "From shakes to Shakespeare," Joanie said, Steve's was the place.

The last day of regular business was Christmas Eve 2013. "Pretty much that entire Christmas week, we had people waiting at the front door to get to the fountain. They knew that part of Tulsa was going to be gone," said Joanie. The line stretched down the sidewalk and around the side of the shopping center. "It was very sad, but very humbling," said Joanie.

A sale of final products and fixtures occurred the following week. The famous soda fountain, however, wasn't for sale unless it continued to serve the people of Tulsa. It was donated to the Tulsa Historical Society, where it has been featured in various displays. As of 2018, there are plans to return the fountain to regular service at an upcoming attraction of Americana called the Route 66 Experience.

GOLDEN DRUMSTICK

Route 66 has been an important part of Tulsa's development since the highway was established in 1926. It was the path west for all kinds of people for decades. Businesses sprang up along the Mother Road catering to the needs of the traveler, primarily eating and sleeping. The Golden Drumstick was an iconic stop for locals and travelers alike.

The restaurant was built at 4903 East 11th Street, the northeast corner of 11th and Yale, by Milton and Lemuel Stroud of St. Louis in the late 1940s. The white adobe style mirrored their Park Plaza Courts motel chain. The site was owned and operated William F. Latting. The Golden Drumstick opened its doors in December 1948.

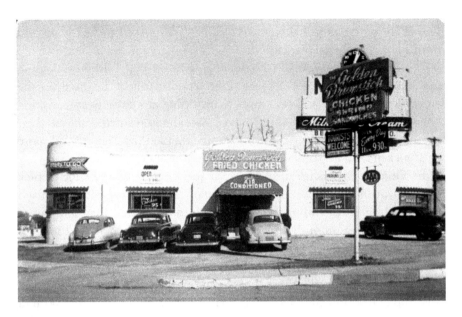

Postcard image of the Golden Drumstick at 11th and Yale. *Courtesy of Joe Sonderman.*

The restaurant was an immediate hit, with lines out the door to try the delicious fried chicken. Bill Latting was a lawyer by trade and quickly needed help to keep the restaurant running smoothly, so he reached out to his brother Bob. Once Bob came to Tulsa with his wife, Marion, their success reached a whole new level.

Bob Latting had been a radio personality in Hollywood, interviewing movie stars at the famous Brown Derby. He had a keen sense of promotion and became an early Tulsa television personality on KOTV. Every Saturday morning, he hosted *The Kids Karnival*, which featured the Golden Drumstick as a sponsor. Homes all around the area learned about the restaurant on each broadcast; kids dragged their parents in to eat and perhaps meet the famous Bob Latting.

A row of clocks on the wall showed the time in various locations around the United States, a reminder that the restaurant catered to people from all over the country. Tables were set with crisp, white napkins and small jukebox selectors. There was a wishing well in the lobby where children who cleaned their plates could win a prize, such as a toy plane or a doll. You can bet that brought a lot of families back through the door of the Drumstick.

After the meal, you were brought small bowls of warm lemon water so you could clean your fingers. "I'd never seen anything like that before; we

were from the country. I thought it was just water, so, I picked it up and drank it!" remembered one customer.

Kids from nearby Franklin Elementary crossed under Route 66 using a pedestrian tunnel to get a snack after school. Athletic teams from the University of Tulsa would stop in, perhaps sitting at a table next to visiting rodeo performers from the fairgrounds. Everybody wanted some of their famous fried chicken. By 1953, the Lattings claimed that they served more fried chicken than any other establishment in the state.

The Golden Drumstick also offered a special area of their lot to pick up to-go orders, a relatively new concept. Folks could get their fried chicken, onion rings and biscuits and take it to the park if they so desired. A Brookside location on South Peoria opened for a few years in the early 1950s, and a drive-in restaurant operated on Sheridan for a while, but neither store ever matched the business of the original restaurant.

In 1958, the Lattings retired. The restaurant was purchased by Lee and Lois Apple, who ran the place with their son Ed. Although Route 66 had officially moved to an interstate bypass by that time, the local popularity of the Drumstick continued. Their success allowed them to open a small satellite location offering counter service and carryout at 26th and Sheridan in 1969. It ran for a few years, closing when Lee Apple passed away in 1971.

The Golden Drumstick once again passed to new ownership. Traffic along 11th Street dwindled, and in 1975 the once popular restaurant closed its doors. The building remained, though, and would soon be occupied by another popular Tulsa eatery: The Middle Path.

BUNDY'S BURGERS

Ruth Bundy came to Tulsa from Kansas in the early days, supposedly in a covered wagon. In 1932, she and her husband, Elbert, opened a grocery store/gas station at 3213 West 48th Street in Red Fork.

After twenty years, Ruth converted her business into a café. It was a small place with a few tables and a short counter. People lined up out the door during the lunch rush; Bundy's became a landmark in West Tulsa.

Bundy's Burgers catered to everyone: school kids, truck drivers, lawyers, construction workers. Its six stools and three tables were occupied by patrons wearing business suits and overalls alike. Even famous locals like singer Patti Page and actor Gailard Sartain stopped in for a bite from time to time.

A Bundy family portrait—high on the wall—overlooked the dining area. Ruth's daughter-in-law Jewel and her husband, Willard Bundy, worked the grill for decades. The food was simple but good. Nothing was frozen, and no filler was added to the hamburger meat. Ruth retired in 1985 at eighty-seven years of age, but Willard kept the grill going. It was still going strong, too. He estimated they sold between two hundred and four hundred burgers a day in 1988.

Bundy's was a constant. The chili was still made from Ruth's original recipe. The marble cutting board was worn in the center from decades of use. Even the old 3-V Cola thermometer on the wall had been there for all of Willard's thirty-five-plus year tenure. A small, treasured box under the cash register was filled with photographs of customers. It didn't take much encouragement to convince Ruth's granddaughter Jean Bundy to bring it out.

Willard and Jewel Bundy of Bundy's Burgers. *Courtesy of the* Tulsa World.

IN 1991, RUTH PASSED away. She was remembered as feisty, happy, energetic and honest—as well as passionate about the family business. The restaurant continued forward with the help of her grandkids, but disaster struck a few years later.

A grease fire in the early hours of Monday, February 15, 1993, severely damaged the building. Longtime patrons were equally gutted. "That's where we got our local news," Norman Lary told the *Tulsa World* a few days after the fire. "We'd go by and talk to Jewel [Bundy] and she usually told us what was going on in the neighborhood, and everything about everybody."

Joe Morgan, dubbed "The Mayor" by the owners due to his frequent visits, said, "I don't know what we'll do for coffee. Probably have to make our own pot at home now." Even today, if you ask anyone who was around when Bundy's was open, they'll smile and tell you about the good times they spent at the counter.

VILLA VENICE

Thomas J. "Tommy" Alessio was born in San Giovanni en Fiore, Italy, and moved to America at a young age. As was common at the time, he ended public schooling in the eighth grade and entered the workforce to help support the family. He worked primarily in Chicago restaurants, notably the famous Waldorf Astoria, where he worked his way up from waiter to cook. He watched and learned from the esteemed master chefs there, absorbing their techniques and learning the secrets of good food. In this way, he learned the basics of becoming a chef himself.

Upon the outbreak of World War II, Tommy enlisted and served as a sergeant in the Seventh Army Rainbow Division. He was originally stationed at Fort Gruber in Braggs, Oklahoma. On a trip to Tulsa, he dined at Bishop's Restaurant downtown. Nora Lee McCombs waited on his table, and it was love at first sight. They soon married and, after the war, moved to San Francisco together.

While in San Francisco, Tommy further honed his skills at various restaurants, including the historic Fairmont. After several years, he returned to Chicago to spend time with his family. In 1950, he and Nora moved to Tulsa. He had enjoyed the friendliness of the people while stationed in Oklahoma and saw an opportunity to establish a new type of restaurant in the city.

Tommy's first restaurant was LaScala at 234 West 11th Street, where he introduced the city to continental cuisine. Most Oklahomans at that time were used to traditional comfort foods such as meatloaf, chicken-fried steak and catfish. Tommy brought new flavors to the Magic City: flambé desserts, tableside service, Caesar salad and cooking with wine.

It's hard to imagine a time when pizza wasn't a culinary staple in America, but it didn't become widespread until Allied veterans returned from the war. Tommy installed the first pizza oven in the city and introduced Tulsa to "Italian Pie." He believed in giving his guests "a little something extra" and served pizza as a complimentary appetizer. First-time customers were often puzzled when served this new dish along with their water, bread and butter—but they were thrilled to receive it gratis. As you can imagine, it caught on quickly.

The LaScala was a great first restaurant, but as its popularity grew, the small size was a challenge. Tommy decided to move south, outside the city limits at the time, where he anticipated future growth. On September 4, 1953, ground was broken on Tommy's Villa Venice at 6625 South Lewis Avenue. Though there was concern the restaurant would not be a success because it was so far away from the center of town, there was no need for worry. Tommy was gaining quite the reputation, and the food he served at Villa Venice was authentic old-world Italian; many of the recipes came from his mother, Filomina Alessio.

Many of the basic food elements were made from scratch, such as the tomato sauce, pizza dough, salad dressings, cocktail sauces and noodles. The food won high critical praise, including a five-star rating from the Mobil (now Forbes) Travel Guide. In 1963, the restaurant's recipes for chicken au sec and lasagna were included in the book *Famous Foods of Famous Restaurants*.

"The Old Place," as his family refers to it today, mostly catered to businessmen and their clientele. Toni Hile, one of Tommy's daughters, remembered that it wasn't a place people brought their children because the prices were high and the atmosphere was formal. "It was the kind of place you'd see Tulsa's businessmen, politicians and celebrities. Herman Kaiser, Raymond Kravis, Bruce G. Weber and the LaFortunes were all regular customers. Important meetings that would affect Tulsa's growth and all kinds of deals were sealed with a handshake across the table."

The Villa was beautifully designed. Fine art adorned the walls, including a room-length mural of Italian foods and ingredients. A large painting of a Venetian gondola making its way down the Grand Canal hung on

The original Villa Venice, known to the family as "The Old Place." *Courtesy of Toni Hile.*

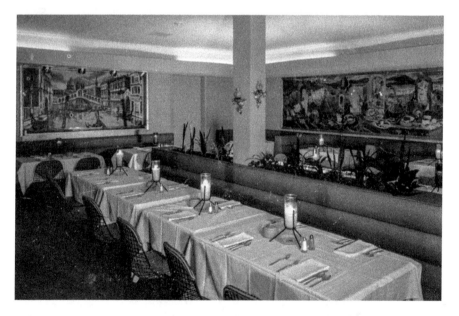

Interior of the original Villa Venice as featured on a postcard. *Courtesy of Toni Hile.*

another. One painting was particularly special; it featured a mandolin player wooing a beautiful woman. The subjects were modeled after Tommy and Nora Alessio.

The entire family pitched in at "The Old Place": cooking, cleaning, running food to the tables. Tommy was often on the floor himself, preparing flambé desserts, serving specialty steaks and making Caesar salad tableside for his customers. He regarded them as his guests, often sitting with them at the table and engaging in conversation. He was gregarious and charming, sometimes asking, "Are you going to eat that?" before taking a morsel of food off of someone's plate. The guests loved it, as it was all in good fun, and Tommy cultivated a loyal following.

To get around the liquor-by-the-drink laws, many restaurants had clubs on-site that required membership. Membership allowed patrons to bring their own bottles of alcohol for storage and use. Villa Venice was no different; the club membership was twelve dollars a year. Legality was still an issue, however, and the ABC Board conducted periodic raids. On one memorable occasion, Tommy was arrested for cooking with liqueurs in his cherries jubilee dish. At the hearing, Tommy prepared the flaming dessert for the judge right in the courtroom, explaining that all the alcohol was cooked off in the process. He added that he would be comfortable feeding the dish to his infant daughter, Toni, present in her mother's arms in the back of the courtroom. The judge sampled the dish for himself and dismissed the charges.

A few years later, Tommy was approached by golf course owner Seth Hughes to open a grill at the clubhouse of the Par 3 Golf Club nearby. He opened Tommy's Patio Grill on September 1, 1956, and became known for a completely different cuisine: charbroiled hamburgers. Again, wanting to give customers "a little something extra," he established the Pickle Bowl, served with every meal. His coleslaw (with the secret ingredient of pickle juice) was popular as were his steak sandwiches. Toni Hile recalled her dad's favorite menu item at the grill was Eskimo Pie.

Tommy continued opening other restaurants during this time, too. Mayor Robert LaFortune asked him to establish the 19th Hole at LaFortune Park. Tommy's Downtown Villa Venice at Fifth and Boulder offered a glitzy dining atmosphere, serving brunch and featuring an oyster bar in addition to the normal dinner service. David Williams of Williams Companies asked Tommy to take over the Villa Fontana at 51st and Memorial. Tommy's other daughter, Diane, operated the Fontana location.

In 1962, Tommy was operating multiple diverse restaurants in the city. Sadly, the challenges of juggling these businesses were too great and he

Tommy and Nora Alessio on the stairs at the new Villa Venice in the Country Club Plaza Shopping Center. *Courtesy of Toni Hile.*

had to scale back. He sold Tommy's Patio Grill to one of his waitresses, Goldie Crow. (Although the golf course closed in 1968, Goldie's Patio Grill, as it was renamed, flourished and expanded to at least twenty locations in Oklahoma and Washington State.) Over the next few years, he closed Tommy's Downtown Villa, turned the 19th Hole over to his associate Nick Costas, closed "The Old Place" and filed for bankruptcy.

A local businessman, Ira Sanditen, had fallen in love with Tommy's continental cuisine and offered to rebuild Villa Venice as an anchor of the new Country Club Plaza Shopping Center at 3324 East 51st Street.

The new building was designed by architect Frederick Vance Kershner. Katy Bruce of Oklahoma City and Van Childress of Tulsa designed the interiors. It was beautiful and extravagant; Tommy estimated the cost of the dining room worked out to roughly $3,000 a seat. In May 1966, the new Tommy's Villa Venice opened and served Italian, French and American foods.

The new restaurant had seating for 92 with a connected cocktail lounge for 70 more. An elegant spiral staircase led to a banquet room on the second floor that seated an additional 250 and could be divided into six separate rooms. "I will have a little bit of [my previous restaurants] in my place," Tommy said before opening. The ingredients were sourced nationwide and internationally. Dungeness crabs were flown in from Alaska; specialty ice creams, cannoli, and biscotti came from Chicago. Dover sole came in from England, and sand dabs were shipped in from San Francisco.

The new club, Caesar's Den, was designed by Nora and featured a sunken bar with a stage behind it; a piano and small dance floor completed the room. It was a beautiful space with an exquisite mural featuring *The*

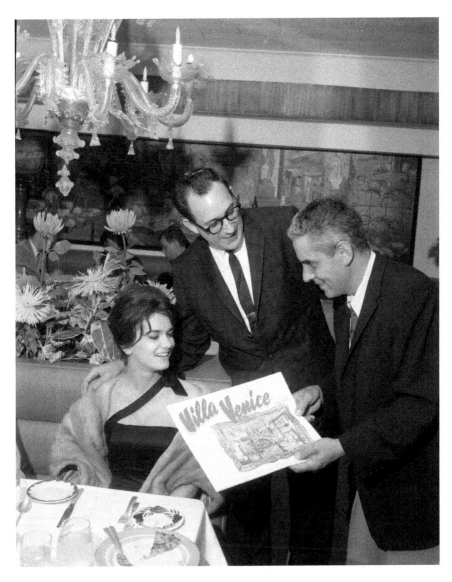

A Playboy model dines at Villa Venice. *Courtesy of the University of Tulsa.*

Birth of Venus on one wall. Nora had always wanted a place people could go, have a drink and dance the night away. Live entertainment was featured on the weekends.

Villa Venice was once again a hit. Mayors, councilmen and all manner of local celebrities dined at the Villa regularly. Entertainers such as Andy

Williams and Henry Mancini stopped by when they were in town. The restaurant was open until 11:30 p.m., yet the club often stayed packed until it closed at 2:00 a.m. When the International Petroleum Exhibition was in town, the entire place was overrun with oil executives, so much so that Tommy would set up regular tables on the second floor to handle the crowd.

For seven years, the Villa prospered. Everything changed in 1973 when ongoing health issues forced Tommy to retire. "I hope in several months to open a smaller place, likely a club, which will serve wonderful food and which will be easier for me to manage," he said at the time. He entertained the idea of opening a cooking school to help train the next generation of Tulsa chefs. Neither of these things came to pass, unfortunately; Tommy passed away two years later.

The Villa Venice name lived on for a while longer. It reopened under the management of several longtime employees Tommy had trained in the early years. Zeke Campbell (cook and kitchen manager), Lily Doty (waitress for eighteen years) and Sammy Whiteneck (former waitress) took over and ran the establishment under the ownership of the building landlord. The second-floor banquet room continued to operate, as did the Forum Club, the newly named cocktail bar. The menu didn't change; cracked crab and Dover sole were still served.

"I remember when Tommy used to bring us here while they were building the new place," Lila Doty remembered at the time. "He wanted us to see his special staircase. He loved that staircase. We made a go of it because of Tommy," she said. "He taught Zeke and me everything we know. We ran the place just as Tommy had. We used his menu, his favorite recipes, his ideas."

But with Alessio himself gone, the magic had dissipated. Three years after Tommy passed away, the landlord sold the site to a Japanese restaurant chain. On Tuesday, August 15, 1978, the Villa Venice closed for good and merged with Tulsa's history.

POWERS RESTAURANT

In 1950, Bishop's Restaurant downtown was still going strong under co-founders Bill Bishop and Harry Powers. Harry had two sons: Joseph H. Powers Jr. and Donald G. Powers. Joe Jr. was an ace fighter pilot in World War II, and Don had enlisted in the navy. In early 1951, Joe was tragically

declared missing in action over Korea. Don came home shortly afterward and entered the family business.

After graduating from the Culinary Institute of America in New Haven, Connecticut, he partnered with his mother, Ruth, and his uncle William "Bill" Powers to found the Powers Restaurant Group. They would go on to establish several beloved eateries in Tulsa. Their first, at 2745 South Harvard, was aptly named Powers Restaurant. The site had previously served as the A.Q. Chicken House and Herbie's Steak House before being totally remodeled for the new Powers place.

It opened in September 1955. The front room featured a spacious dining area with enlarged photographs of the city and Oklahoma ranch land on the walls. The most defining feature of the room, however, was a large brick hickory wood and charcoal broiler.

The grill was right in the middle of the front room, and it was the first thing patrons saw upon entering. After selecting a specific steak from a case, customers could watch it being prepared from their table. The grill

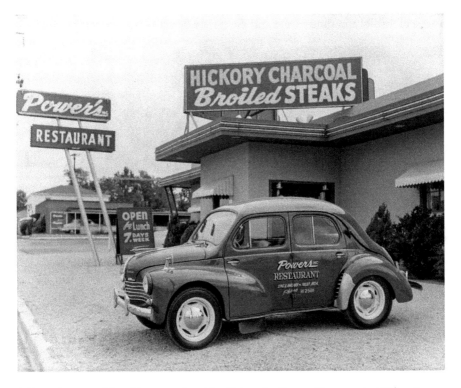

A Renault automobile adds some advertising flair to the Powers Restaurant at 27th and Harvard. *Courtesy of the Tulsa Historical Society and Museum.*

chef kept buckets of ice chips on hand to help control the heat from the coals. Tommy Gibson and Chuck Cather were the main chefs, but Don Powers was often seen personally tending the steaks.

The dining room in the back, known as the Western Room, was a little more formal. The far wall featured a large crest stating "Semper Optimus," meaning "Always the Best." People loved to come in, bring their families and visit with Don. "Everyone loved to be in his presence," remembered son Clark Ferguson. "He seemed to be in a happy mood all the time." Up front, Ruth Powers ran the cash register. Though she was initially reluctant, she came to love getting to know more people in the community. "Grandma was the Boss around the restaurant," Clark continued. "Grandpa and Dad called her the 'Dragon Lady', in a good way!"

The operation was touted as a "model of efficiency in equipment" with stainless steel throughout the kitchen and preparation methods referred to as the "acme of culinary art." The steaks were highly rated; the *Tulsa World* described them as "so delicious that you are not satisfied until you have returned for more of the same." The restaurant also grilled up fish, chicken and seafood. Homemade rolls and desserts were also big sellers.

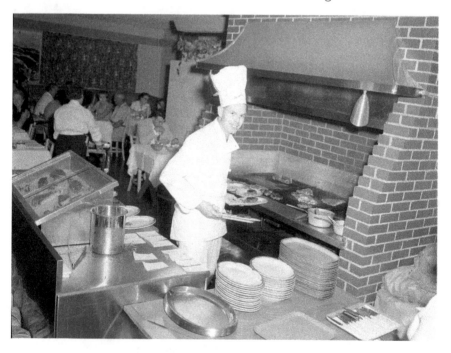

Food being prepared on the charcoal grill at Powers Restaurant. *Courtesy of the University of Tulsa.*

Harry and Ruth Powers at Powers Restaurant on Harvard. *Courtesy of the Tulsa Historical Society and Museum.*

In 1961, the Powers group bought The 1800 Restaurant in Utica Square and renamed it Powers 1800. Bill became the active manager there while Don stayed on at Powers Restaurant on Harvard. Their attention to quality was noted by Walter Powers, Bill's son: "Dad always stressed that the coffee had to be perfect, along with the hot rolls. His words, best as I can remember, 'All the restaurants can get the big stuff right…it's the attention to details that make the great restaurants…Great!'" It was another success, especially with the Thursday night dinner buffet and Sunday brunch.

By the mid-1960s, the costs of running multiple restaurants combined with the balancing act required to cater to very different types of customers took its toll. The 1800 was sold in 1967 and became The Garden. Powers Restaurant closed just a year later when it was faced with a daunting total kitchen re-build. The location on Harvard was bulldozed and went through several iterations, including Kip's Big Boy and Helmut's Alpine Kitchen. Today, the site is home to a Village Inn.

Bill Powers entered semi-retirement after The 1800 closed, helping out at the Golden Drumstick and Borden's Cafeteria on occasion. Don Powers followed in his father's and uncle's footsteps by serving as the president

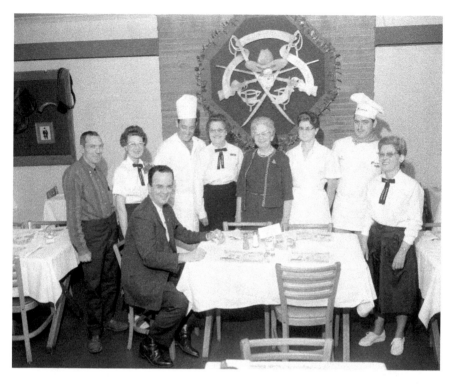

Don Powers and staff celebrate Christmas in the Western Room at Powers Restaurant. *Courtesy of the Howard Hopkins archive.*

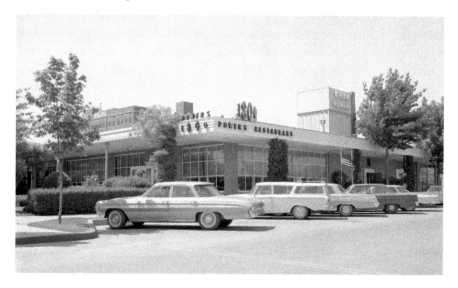

Powers 1800 at Utica Square. *Courtesy of the Howard Hopkins archive.*

of the Oklahoma Restaurants Association. In later years, he worked for Prudential Insurance before passing away in 2004. Although he had not been in the restaurant business for decades, he was remembered for his kindness and generosity. Of note: when he operated the Powers Restaurant, he started the Greatest Guy in the World Club, which gave certificates to fathers who brought their families out to eat. It was such a popular program that it was picked up nationally.

EDDY'S STEAKHOUSE

Eddy's Steakhouse started in 1956 near 27th and Harvard when Eddy Elias Sr., his wife Violet, and his brother Gary took over a restaurant space vacated by his brother Jim Elias. Lebanese steakhouses ran in the Elias family; at one time, there were three operating within Tulsa city limits: Jamil's, Silver Flame and Eddy's.

Two years after taking over Jim's operation, Eddy (with the help of architect Ted Murray) remodeled an old house a short distance away at 3510 East 31st Street and moved his restaurant there.

A simple neon sign sat next to the street, encouraging locals to stop in at the windowless building. When you walked in, you were greeted with sparse artwork, wood paneling and a portrait of Eddy Sr. Before the meal, the table was served tabouli, hummus and cabbage rolls. Waiters came out in jackets.

Eddy Elias's son Eddy Jr. remembered, "There was a time we ran two thousand people a week through this restaurant. Dad had as many as seventeen waitresses, all carrying trays of drinks, even before liquor-by-the-drink [was legal]."

In those days, customers brought their own bottles to enjoy with their meal. When Eddy Jr. first started working at the steakhouse, his father told him to come in late, around 11:00 p.m. "That seemed kind of odd because there was hardly anyone there then. I asked him about it, and he said not to worry, the crowd was coming," Eddy Jr. remembered. "And sure enough, it started hopping about 1 a.m."

"Sometimes he wouldn't shut it down until 4:00 or 5:00 a.m.," Eddy Jr. continued. "Then he would sleep a couple of hours on a table in the kitchen, get up and go to the bank, then come back and start cutting steaks for that night. He was unbelievable." When the liquor laws changed in the mid-1980s, Eddy's adopted a more normal schedule.

Eddy's Steakhouse neon sign.
Courtesy of Cloudless Lens Photography.

Eddy Elias, Sr. passed away in 1996, but his restaurant lived on. Eddy Jr. ran the grill and his brother Steve prepared the tabouli and cabbage rolls.

In 2011, Eddy's steaks were still lauded, even if business had slowed down. Drinks were still written on the ticket as "setups," harkening back to the days when it was illegal for restaurants to serve alcohol. Eddy Sr.'s portrait still hung inside the entrance, next to University of Tulsa football coach Glen Dobbs and a photo of Eddy Sr. with University of Oklahoma and Dallas Cowboys coach Barry Switzer. Eddy Sr. had always been a friend to many local football coaches. "Dad sent me to school to be a coach," Eddy Jr. remembered in 2011. "But I wound up in the restaurant instead. That's probably best. Coaching looks like a tough business."

Eddy's closed in May 2016. George Younas, a server there for nearly thirty years, continued working as a pastry chef at Tally's Good Food Café. Eddy Jr. retired, and his brother Steve moved over to Jamil's, where the tradition of Elias steakhouses lives on.

McCOLLUM'S

Before he founded the namesake restaurant that Tulsans remember on Route 66, Dale McCollum leapfrogged from one place to the next in service to his family. He moved to Tulsa in 1935 at seventeen years of age from Grannis, Arkansas, to work for his uncle James. The elder McCollum was a partner in the local Silver Castle diner chain that had just been established. While working for his uncle, Dale learned how to butcher and ended up as the meat supplier for the growing chain of diners. Eventually, he also began managing operations at several locations.

On Christmas Day 1942, Dale married Mary Jane Brodie. The very next day, he shipped out for the war and was gone for four years, working as a cook in the U.S. Army Air Forces. In 1947, a year after Dale's return, they

purchased the Crosstown Grill at 15ᵗʰ and Peoria with a partner. This lasted a short time, however, and Dale found himself back under the roof of a former Silver Castle with a relative—this time his aunt Irma.

The diner at 1915 East 11ᵗʰ Street was called Miss Tulsa Lunch. Over the next few years, Dale lived with his wife Mary in a house behind the diner. It was there that their son Jim (named after Dale's late uncle) was born. On September 25, 1958, Miss Tulsa Lunch suffered a devastating fire. When the decision was made not to rebuild, Dale looked for something a little bigger. He found it three miles east at 5717 East 11ᵗʰ Street.

Burt Creech was selling the restaurant that bore his name. Although Creech's had enjoyed local and tourist traffic alike on Route 66, a new bypass was starting to impact business. Dale seized the opportunity to own his own place and named it McCollum's. Dale came in early to meet the milk man and other salesmen before opening, went home to take a nap around 1:00 p.m. and returned in the evening. Mary helped during the midday hours while Jim was at school.

McCollum's Restaurant on 11ᵗʰ Street. *Courtesy of Jim McCollum.*

The previous owner, Creech, and Dale McCollum shared a love of fishing. For the first few years, Dale added to the trophy fish collection that adorned the walls of the restaurant. He also promoted a little cardboard device that calculated when the fish would be biting according to the almanac. This led to the diner being billed as "Where the sportsmen meet and eat!" on the *Don Devore Radio Show*.

McCollum's sat between two motels: Will Rogers Motor Court to the east and the Tulsa Motel to the west. The restaurant had a separate phone line tied to switchboards at the motels to provide room service.

The dining room had a wealth of natural light thanks to the large number of windows. There was an island counter in the middle of the dining room and a tall glass case offering views of fresh salads and pies. There were two chefs on the payroll: "Dub" Harrison cooked in the morning and Claude Forte manned the grill in the evening. Under the counter, a small display featured magazines, newspapers and cigars for sale.

McCollum's offered a variety of meals, from hearty steaks to fried chicken. The menu also offered domestic rabbit, turkey and lobster. Sandwiches were served on homemade bread, and the slaw (made with apple, carrot and cabbage) was popular. Late at night, the smell of cinnamon filled the air as Claude prepared rolls for the next morning's breakfast. The food brought people back through the door for decades, such as the owners of nearby Whitaker Glass.

"Every morning, my dad would call Mom before we went to school. He'd tell her what they were having that day. She typed it out on a typewriter, ran it on the mimeograph and put it in the menus for the day." Jim said. He fondly remembered the jumbo hamburgers and chicken-fried steak. He didn't eat everything they offered, though: "It freaked me out when I was a little kid, seeing calf brains and scrambled eggs."

When Dale bought an airplane in 1965, the fish décor was slowly phased out and replaced with photos of airplanes, donated by Gail Clark of Tulsair Beechcraft. Everything else remained the same. Michael Wallis, Tulsa author and historian, was especially fond of their Waldorf salad. He remembered it as a "Mother's Day place," where the waitresses wore starched handkerchiefs, folded to resemble flowers, in their pockets

When the Lloyd Stephens of the Oklahoma Fixture Company bought the nearby Tulsa Motel, Dale went in with him. When the motel was demolished, they left a few rooms standing so that Dale could add on to the back of his restaurant. He turned the expansion into a walk-in meat cooler for dry aging. "He always wanted a steakhouse!" Jim McCollum remembered.

Right: Dale and Mary Jane McCollum. *Courtesy of Jim McCollum.*

Below: A waitress stands behind the counter at McCollum's. *Courtesy of Jim McCollum.*

Dale and Mary Jane McCollum retired in 1986. The building was purchased by the Oklahoma Fixture Company, which leased it to various operators for a time and kept the name the same; even longtime chef Claude Forte ran the place for a while. Nothing quite stuck, unfortunately, and the growing number of chain restaurants led McCollum's to close a few years later. The building is still there as of this writing and serves as an auto dealership.

KAY'S RESTAURANT

Ruby G. Gibson worked in the restaurant business all of her life. She started as a waitress in her family's café on Main Street in Broken Arrow. Later, she served breakfast inside the restaurant portion of Pennington's No. 2 on Admiral. Eventually, she wanted a place of her own.

In the late 1950s, 31st and Yale was a quiet part of town with a four-way stop. The Broken Arrow Expressway had not been built yet. Ruby and her husband, Glen, picked a space in a shopping center a few blocks west of the intersection at 4622 East 31st Street. Kay's Restaurant, named after their daughter Kay Watkins, opened in 1958.

Kay remarked that it was a blessing that the owner of the shopping center took a risk on Ruby's restaurant. "He more or less gave my mother a chance; she wasn't experienced other than being a waitress. He was the only one in town that would have given her that chance." Kay was there on that first day. "[My mother] had me miss school the day they opened so I could hand out menus and seat people."

Kay's was a home-style place offering simple food cooked well. It sold well, too. Kay's became so popular that people stood in line out the door and down the sidewalk. The owner of the TV shop next door told Ruby that her line of customers was the best advertising he ever had. Even in the winter, people waited outside for a seat.

The interior matched the food: simple but satisfying. "When my mother opened it, she had a counter, five booths and a smaller dining room you could go into for lunch or dinner," Kay said. It had a black-and-white tile floor with turquoise and black accents. It was remodeled a few times over the years but always retained that classic diner flair.

Solitary men drank coffee at the counter while waitresses buzzed around the room, taking orders and delivering food. Kay herself worked there off-

and-on when she wasn't in school. "We had all women servers; they wore starched white uniforms and were *not* allowed to sit down in them. They'd have to take them off on their break." In fact, Ruby instructed her waitresses to take their uniforms to a specific cleaner down the street; they knew exactly how she wanted them. "She personally inspected each girl before she went out," Kay said.

Of course, it was the food that brought people back again and again: Salisbury steak, fried chicken, meatloaf, real mashed potatoes, okra with tomatoes. The pink applesauce was a popular side dish; the color was simply a little food coloring, but it made the dish memorable. Kay's chicken-fried steak was grilled, not deep fried. The first Wednesday of every month, the restaurant served a pulley bone special—that is, the V-shaped bone in the center of the chicken breast. There was never enough to serve the crowd. And you couldn't go home without a piece of homemade pie, which Ruby made by hand.

But the part people loved the most were the yeast rolls, originally handmade by Ruby daily. When Glen quit his job at the airplane plant, Ruby gave him that sacred duty. At its peak, Kay's Restaurant was estimated to have made eighty dozen rolls a day.

Business was going so well, the restaurant expanded to roughly double the capacity. Eventually, Ruby and Glen bought the whole shopping center. Kay, along with her husband, Mark, opened Kay's Too at 6926 South Lewis in 1978 and ran it for a few years.

Ruby sold her restaurant in October 1979 and retired. The space was purchased by Susan and Louis Fenster, who were personally trained by the Gibsons for several months before the transition. Part of the contract stipulated that Ruby couldn't open another restaurant for five years. The version of Kay's Restaurant operated by the Fensters lasted until 1984.

Retirement didn't stick for Ruby. In January 1986, Ruby bought an old service station at 4634 East 31st Street, just a few doors down from the original Kay's location, and remodeled it. Ruby's Restaurant was born and continued the tradition from the original diner. "I hated retirement," Gibson said. "I like to be where there's people. All I did was mow the lawn and clean the pool. This place keeps me young, and I don't have to think about getting old."

She continued to make the pies, tend the cash register, serve as hostess and help in the kitchen. Son Marc and daughter Kay helped manage the restaurant. Kay ended up in the kitchen most of the time. "I'm not sure if that was a punishment or not," laughed Kay; the water steam table kept the kitchen sweltering even on the coldest of days.

Glen and Ruby Gibson of Kay's Restaurant and, later, Ruby's. *Courtesy of the* Tulsa World.

Ruby's, like Kay's, was a place where the diners knew one another. The staff called people by name when taking their orders. "Nothing to confuse the palate," described Suzanne Holloway of the *Tulsa World*. It was just good, simple food.

"Business-wise, she was very strict…a very strong-willed lady. Especially for her day," said Kay. "She just made her own way. She was very religious; went to church every Sunday. That's why we weren't open!" Kay thought for a moment and reflected that if her mother were around today and younger, she'd be out marching for women's rights.

Ruby's Restaurant was a success and served loyal Tulsans for many years. In 1994, she told the *Tulsa World*, "You have to love the food business to stay in it this long. I don't like to be idle." Eventually, though, it was truly time to retire. Ruby's Restaurant closed in June 2001, and Ruby passed away a few months later. The memory of her food and service live on in her grandchildren and the stories from her many customers.

3

The Drive-Ins

As the 1950s transitioned into the 1960s and beyond, the automobile was having a real impact to the food culture. Teenagers began to spend a lot of time in the car—not heading off to some distant destination but weaving endless circles in popular districts. Being seen in a beautiful car with your friends was the ultimate social stamp. Many drive-in restaurants enticed the younger crowd to grab a cherry Coke and a basket of onion rings. Kids from each high school used a specific honking pattern to signal to their classmates from behind the wheel.

There were two main drags in Tulsa: Admiral Boulevard and Peoria Avenue. Peoria eventually came to be known as the "Restless Ribbon" and became the city's most popular cruising corridor. The Ribbon ran along Peoria Avenue from roughly the Safeway parking lot at 41st Street south to the Bellaire Village Shopping Center at 51st Street.

Some say the northernmost spot was the car wash parking lot next to the Del Rancho at 36th Street, yet others insist the Ribbon ran all the way to Admiral. In any case, Peoria Avenue was *full* of teenagers. It might take forty-five minutes to an hour to drive a single mile on a Friday or Saturday night. Your home base depended on which group you were in: the Safeway parking lot was known to be full of greasers while the socs filled the stalls at Pennington's Drive-Inn.

THE ADMIRAL CIRCUIT

The west end of the Admiral cruise of the started near Harvard Ave at MILLER'S DRIVE-IN. As you cruise through this chapter, the restaurants are mentioned in the order you might encounter them on a Friday night. The quotes come from Beverly Salley, a regular on that four-mile stretch.

The drive-in at 3319 East Admiral wasn't always known as Miller's; in fact, it had been a drive-in for twenty years prior. It was first known as Lindy's Drive-In, owned and operated in 1948 by Archie and Lola Pennington.

Waller Miller, who was married to Lola's sister Kate at the time, was a partner with Archie when their new restaurant opened on Peoria: Pennington's Drive-Inn. It was a hit; in fact, the new restaurant was so busy that Lindy's was sold to Nick Duvas, who was known for his restaurant at the Loraine Hotel in Sapulpa. In 1956, Nick sold the restaurant back to Archie. It was renamed Pennington's No. 2 to capitalize on the runaway success of the Brookside drive-in.

Miller managed Pennington's No. 2 and ran the kitchen for two years. When he had the opportunity to run his own buffeteria in Joplin, Missouri, he sold his share of Pennington's and moved. In 1962, Archie had a heart

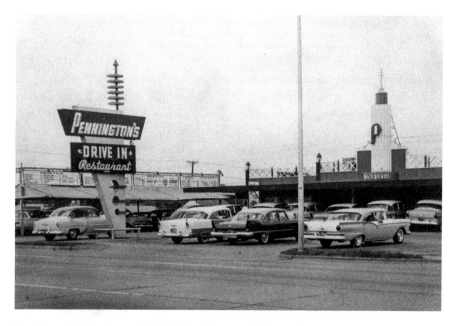

Pennington's Drive-Inn on Admiral, later known as Miller's. *Courtesy of Mark Messler.*

attack and decided to sell the Admiral location for good. Miller bought the place, moved back to Tulsa and changed the name to Miller's Drive-In. Over the years of change, the food stayed pretty much the same—and the kids loved it. Miller's lasted until 1971, when the newly completed Crosstown Expressway killed a lot of businesses on Admiral Boulevard. As Beverly recalled:

> Before pulling into a parking spot, we drove through looking for friends, which were recognized by their cars. Once that initial circle was completed a parking place was chosen. At Miller's one either pulled into a parking place, or if you chose to park along the outside row of speakers, the preference was to back in. Cars driving through were more easily seen. A food and/or beverage was ordered through a speaker and soon delivered by a young lady. The order was on a tray that she placed on one's front window. One soon learned to roll the window up a couple of inches to accommodate the tray. When we'd seen and been seen enough, we left and drove further east on Admiral.

A mile to the east, the intersection of Admiral and Sheridan had two drive-ins that attracted a host of teens. JACK HORNER'S DRIVE-IN sat on the southeast corner and WYNN'S was to the northeast. Beverly continued:

> There was a large parking lot [at Jack Horner's] as well as the usual drive-in lane. I don't recall ever parking there to place an order. Rather, one parked his or her car on the "lot" and waited for friends to pull up alongside and see what, if anything, was happening. Or, one driver would leave their car there and ride around in the other car.
>
> Wynn's was a great drive through because there were two (maybe three) lanes for parking. That meant there were six lines of parked cars. Again, we recognized cars first, then the driver, then the passengers. The mix of kids at Wynn's leaned a little more to the less popular crowd of kids. Once the drive-thru was finished, some kids headed further east on Admiral to Cotton's Drive-In. Others went on back to Miller's and then [later] on to Pennington's in Brookside.

As Admiral Place crested Memorial Drive, it sloped downward to reveal the edge of the city. At the top of Avery's Hill was NORMAN ANGEL'S AUTO CAFÉ. It opened at 8101 East Admiral in 1954. It was owned by Norman Angel, Marvin Morrow and Dan Downey. Prior to the drive-in, Norman

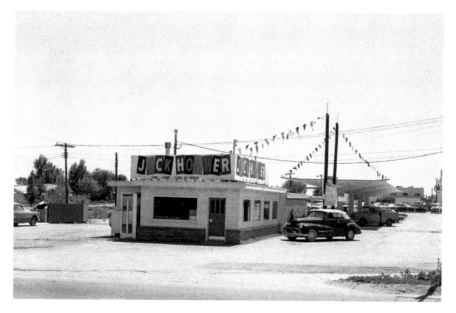

Jack Horner's at Admiral and Sheridan. *Courtesy of the Beryl Ford Collection/Rotary Club of Tulsa, Tulsa City-County Library and Tulsa Historical Society.*

Angel had managed a country club and a local hotel for several years. He brought that experience to the new drive-in market and created a restaurant like no other at the time.

Angel's employed sixty people at opening and offered a whopping seventy-two stalls for cars; it advertised itself as the "Largest and Most Unique in the World." Two parking lanes were covered, while others remained open; Norman said that some diners preferred shade while others desired sunlight, so he gave them both options. The lanes provided ten feet of space between cars and had them parked at an angle, so diners wouldn't sit opposite one another, to give the feeling of privacy.

It was the "jet age," and Angel's provided a view unparalleled to any of its competitors: cars could park with a direct sight of the main runway of the Tulsa International Airport. There was constant activity from civilian and military aircraft for customers to observe while dining.

A Tulsa invention powered the drive-in: the "Orda-Phone" ordering system. It was the first of its kind in the country, invented by co-owner Marvin Morrow of the Midwestern Geophysical Corporation. A speaker, not unlike one people knew from the drive-in movie theater, was available to hang inside the car window. You'd press a button, and an operator at the

exchange inside took your order. The speakers would play dinner music after your order was taken. The order boards also had vents that blew cold air into your car during the summer months when air conditioning was not as common as it is today.

The restaurant specialized in barbecued and charcoal-broiled meats. It also served hamburgers, fried chicken and shrimp dinners. During the summer, lighter fare such as salads and vegetable plates were available. It even featured a variety of baby food on the menu. Of course, the drive-in staple malts and milkshakes were top sellers. Supposedly, Norman Angel's was the first food establishment in Tulsa to use microwave ovens.

In 1964, a fire broke out in the exhaust system of the restaurant. Although it reopened, it wasn't the same. The once-revolutionary drive-in was eventually demolished. A McDonald's sits at the corner of Admiral and Memorial today.

COTTON'S DRIVE-IN served as the easternmost destination on the Admiral strip. The owner, Melvin "Cotton" Biggs, started driving a cab when he returned from service in 1949. After a few years, he traded his cab for a café near Admiral and Hudson. When he moved to a second location at 9201 East Admiral, he expanded his operation to include a drive-in. It served steak, chicken, shrimp, burgers and barbecue ribs. Beverly remembered:

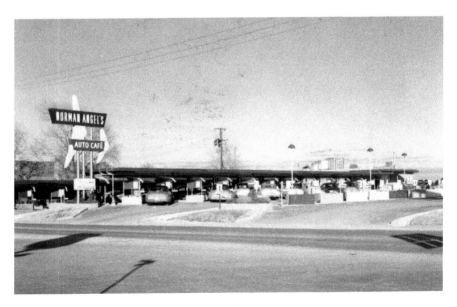

Norman Angel's Auto Café at Admiral and Memorial. *Courtesy of the Beryl Ford Collection/ Rotary Club of Tulsa, Tulsa City-County Library and Tulsa Historical Society.*

Cotton's was located just before the traffic circle at Admiral and Mingo. This was the favored hangout of the "hoods" or "greasers." Those guys wore longer hair often slicked back in a "ducktail." Many "hoods" wore leather motorcycle jackets (made famous by Marlon Brando) and wore Levi's, boots, and T-shirts under those black leather jackets. Beer was served inside the restaurant to those old enough to buy it. The rest of us parked and ordered from speakers or just drove through.

The dining room sat sixty and had enough parking to accommodate fifty cars for dine-in and another fifty for drive-up. It was a twenty-four-hour joint and became known for typically housing a rougher crowd. The surrounding businesses (a bar, a club and a pool hall) added to that reputation.

After leaving Cotton's, the circuit began once more at Miller's, and this continued until someone's curfew required returning home. Generally, we girls just drove around—drove the above-mentioned circuit.

A typical scenario was to be asked to "hop in, and let's drive around in my car." We girls would park our parents' car someplace safe (like Jack Horner's) and get in the "good looking car." A good-looking car was a "muscle car," usually an older model, some much older. Older cars were made to go faster, customized cars with paint, upholstery, tires, and wheels. Mag wheels if you were fortunate.

Cars were so important to girls. If a guy didn't have a good-looking car, she didn't ride around with him and his friends. A lot of times these "ride around with us" scenarios were with guys the girls didn't even know. We were safe. The most dangerous thing was to go way out on north Mingo to drag race.

Outside of the Admiral strip of restaurants, there were several more drive-ins that were popular with their own high school crews. Teens in those areas incorporated them into their weekend drive time, serving as a start or end point for their cruise to Admiral or Brookside.

BOOTS DRIVE-IN

Boots at 1701 South Sheridan opened in 1962 under the ownership of Brad Sheer. It had two sections: a traditional dining room and a drive-in area with sixty spaces. Basil Blackburn, who had been operating the Town

Talk Snack Shop on Harvard, bought Boots in 1968 when Sheer ran for police commissioner. Basil ran the operations and the drive-in section while his wife, Arlene, worked the dining room. The three lanes at Boots were constantly busy, mostly with cars full of young people.

"Will Rogers and Hale High Schools were on opposite sides of the drive-in," Basil recalled in 2018. "Those teenagers…they were my main customers. They kept Boots Drive-In packed." At the time, Basil had two sons going to Hale, which was within walking distance. When a football or basketball game was on, people flocked to Boots both before and after the game. Basil even had to hire police officers to direct traffic on Friday and Saturday nights; traffic backed up to 21st Street in one direction and to 15th Street in the other.

"Kids knew they were welcome and would be served by somebody at once," Basil proudly said. "The way we treated these kids, I treated them all like they were my children." In fact, Basil said he received calls from parents trying to get in touch with their kids; they knew they'd be at Boots. "Parents knew the kids were in good hands when they came in there." He took care of the kids, and they took care of him. Basil recalled:

> There was this one incident. Three boys pulled in one night; they were in their twenties and pretty well sauced. They started getting out of the car, which we didn't allow. They were making trouble….One of them got out and dumped a bunch of trash in the parking lot. I seen 'em from the front windows and made a trip out there to tell them to clean that mess up. They just flat told me to Go To! A few other kids, boys, about sixteen years old… about ten of them got out of THEIR cars and said, "Mr. B, would you please go back into the store? We'll take care of this for you." They made these boys pick up the trash with their bare hands and leave the lot.

All of the kids called him Mr. B and knew that his office door in the back was always open. They'd have something to discuss and want advice or just wanted to talk. In 1971, Basil renamed the drive-in Mr. B's in honor of the nickname the kids had given him.

The next year, the land that the drive-in sat on was sold. Blackburn considered relocating but ultimately decided against it and focused on a floating restaurant he also ran at Fort Gibson Lake. In the late 1970s, he partnered with Roy Human and Charles Epperson in the Argentina Steakhouse on Lewis. In 1981, he took the steak finger recipe he created and opened the Steak Finger House on Sheridan, which eventually

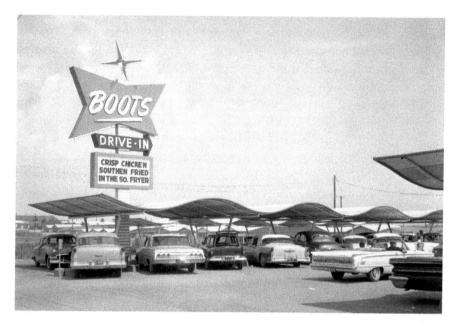

Boots Drive-In at 17th and Sheridan. *Courtesy of the Tulsa Historical Society and Museum.*

moved downtown. "Last trip I made into Tulsa I ran into several of the kids as adults at the Steak Finger House. They would bring their kids in and introduce them to me. It made me so proud; they were wonderful kids," Basil fondly remembered.

He didn't retire until 2015 at eighty-nine years of age. The Steak Finger House is in still operation—under new ownership—as of this writing; the sign for Mr. B's still stands, too, next to a closed restaurant in Chouteau, Oklahoma.

SHAW'S DRIVE-IN

John and Naomi Shaw opened their drive-in on April 18, 1967. John had worked at a Howard Johnson's in the 1940s and worked his way up from the counter to supervisor, managing a dozen stores in the Boston area. When Cook's Drive-In at 3121 South Yale came up for sale, a friend told the Shaws about it and they moved to Tulsa to operate it.

"We were the only drive-in on this side of town, back in '67," John told the *Tulsa Tribune*. Yale was a two-lane street and hamburgers were a quarter.

John and Naomi Shaw at their drive-in on Yale. *Courtesy of the Tulsa Historical Society and Museum.*

Shaw's became known for its quarter-pound Dixieburger ($1.95 in 1985) and onion rings. You could order at the drive-through and chat a bit with Naomi at the window or dine inside. The window sills were ringed with African violets.

After twenty years, almost to the day, the Shaws decided to retire. "It isn't like somebody told us we have to quit," John Shaw told the *Tulsa Tribune*. "We could have stayed another five years. But we both would be close to 68 then, and we decided to sit back and relax."

An auction was held, and everything was sold off in late April 1987. The building was converted into a Daylight Donuts shop and fully renovated in 2017.

GREEN'S DRIVE-IN

In the early 1940s, Warren and Betty Green bought property at 4208 South Peoria to build a home. By the time they had enough money to start construction, however, the area had been rezoned for commercial use. They opted to take advantage of the urban sprawl and build Green's Dairy Store, which opened in 1950.

Two years later, they expanded the operation and changed the name to Green's Drive-In. They had a dining area as well as a drive-up lane where a carhop came out and took your order. An order of onion rings, a hamburger and a shake all cost a quarter each. Hawk's Dairy, a local operation in Owasso, provided the milk and ice cream.

Many of the customers at Green's came from the nearby John Zink Plant. Betty Green handled the store during the day, and Warren worked at night, as he still worked at the Fred Jones auto dealership. Their daughters helped out, too, by serving food and assisting with operations.

With the restaurant going well, Warren and Betty expanded into something new. On the back of the property, they built an auto shop and started Green's Auto Service in 1954. After a few years, Betty wanted to transition to bookkeeping at the garage (something she had gone to school for) and the decision was made to lease out the management of the drive-in.

Unfortunately, shortly after the first manager took over in 1959, a grease fire burned the restaurant to the ground. Warren and Betty decided not to rebuild but kept the garage going; Green's Auto Service continued for another thirty-eight years. The site where the restaurant stood went through

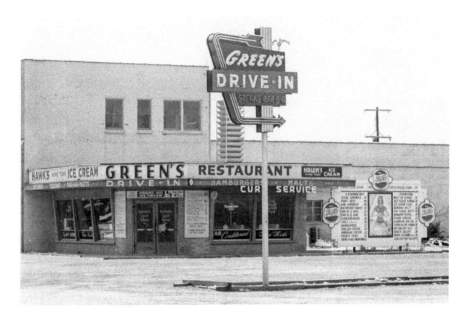

Green's Drive-In at 42nd and Peoria. *Courtesy of Marilyn Trout.*

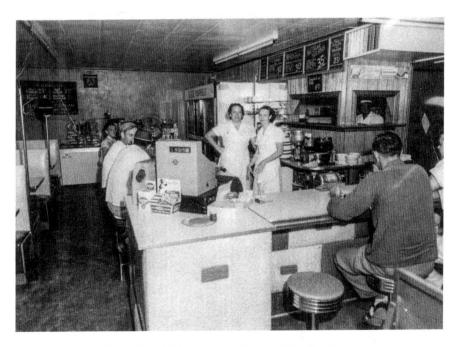

Interior of Green's Drive-In at 42nd and Peoria. *Courtesy of Marilyn Trout.*

a rotation of businesses, including the first Hahn Appliance Store and a Renault dealership.

Although the Greens never owned another restaurant, Warren went on to great success as a politician. He was elected to the Oklahoma House of Representatives in 1964 and served six terms. After that, he served three terms in the state senate. During his tenure in the state legislature, he introduced the bill that designated the Golden Driller as the official state monument.

PENNINGTON'S DRIVE-INN

The story of Pennington's starts in 1934. Archie and Lola Pennington's first restaurant was a typical dine-in restaurant called Lindy's in Broken Arrow. It became so busy that customers would come in and ask Archie to bring their meal to them in their car outside. This, along with a trip Archie took to Florida where he saw his first drive-in restaurant, spawned the idea of creating a Tulsa dining location built around the automobile.

Lindy's Drive-In opened near Admiral and Harvard in 1948. It had a dining room as well as curb service to appeal to the growing number of diners in a hurry. It was a big success, so much so that Archie started planning something even bigger that appealed to *only* the drive-in crowd.

Pennington's Drive-Inn on Brookside opened in October 1951. Archie opened the restaurant with a partner: Waller C. Miller, who was married to Lola's sister at the time. A few days before opening, Archie turned the exterior lights on to show a friend how close they were to completion— before he could get the lights off, five cars had pulled in for service. Archie said at the opening he wanted to specialize in evening family service; he'd found that families wanted to eat an evening meal away from home but didn't want to take the trouble to dress up for eating out in a restaurant. Serving them in their cars circumvented that issue entirely.

The drive-in was noted by the *Southside Times* for having "the most modern equipment for food preparation." A giant meat grinder was used in conjunction with another machine that was capable of turning out 1,700 hamburger patties an hour if need be. The barbecue ovens were designed to house hickory wood shavings in the bottom to flavor the meat. Frying chicken remained an old-fashioned process; one cook devoted his or her entire shift to the process, using a cast-iron skillet. A motor-driven

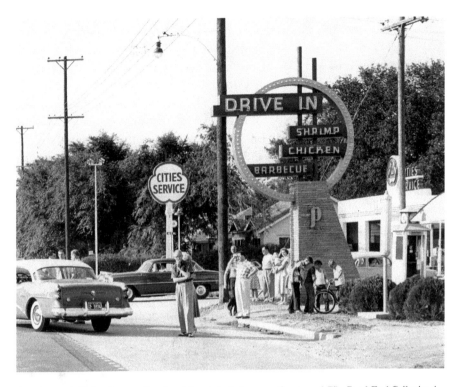

Pennington's Drive-Inn on Peoria with original signage. *Courtesy of The Beryl Ford Collection/ Rotary Club of Tulsa, Tulsa City-County Library and Tulsa Historical Society.*

belt carried the orders to the counter and the carhops delivered the food to waiting customers.

The carhops, mostly girls in red-and-white satin uniforms, buzzed around the sixty-plus stalls delivering food. Water came in actual glasses and steel silverware was provided. Orders were placed using a system that was not unlike those used at the drive-in movies; however, people accidentally drove off with the speakers still attached to their cars. In the mid-sixties, the ordering system was revolutionized with a new invention.

Pennington's was an early adopter of the Order-Matic, a speaker/ intercom system that was invented in Oklahoma City. A custom-made tube amp switchboard linked all seventy-five stalls; it took something of a "sixth sense" to answer the calls in order and hand-write the tickets. The CEO himself, Bill Cunningham, would come up from Oklahoma City with his son Greg to work on the switchboard, help with the menu boards or work on the custom-built wavy awnings. Order-Matic went on to become a premier

name in the industry, innovating the ordering systems of businesses like A&W and Sonic Drive-In.

A red-and-yellow striped awning shaded the center row of eighteen spaces from the afternoon sun; kids later called that area "soc row," inspired by the social moniker made famous in S.E. Hinton's novel *The Outsiders.* One longtime patron recalled, "When I got my first driver's license, I went to Pennington's. I had my dad's big Lincoln, and I couldn't get it in the stall. I hit the car next to me, and the guy didn't do anything. His wife asked him if he was going to, and he just kept eating black bottom pie."

Black bottom pie is perhaps the most famous dish that Pennington's served. The head baker, Willie, collaborated with Archie on the recipe. The pie was actually red in color due to a splash of food coloring added during the baking process, the details of which remained elusive for years due to a few strategic missing ingredients that were kept from curious recipe-seekers.

The drive-in was also known for its shrimp baskets and dinner rolls with honey butter. The baskets were red and white and had small holes to allow steam to escape—perfect for the softball-size rolls to cool. Of course, there also were the drive-in staples: burgers, milkshakes and

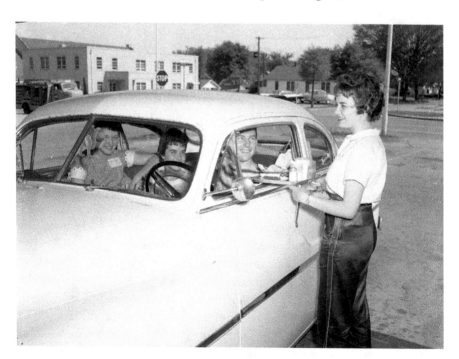

Car hop and customers at Pennington's Drive-Inn. *Courtesy of the University of Tulsa.*

onion rings cooked light and thin. "My grandfather had a theory," said Mark Messler. "He wanted the shrimp, the fried chicken, and that stuff so Mom and Dad would come down and have dinner. He banked on the fact that the kids would have cheeseburgers, onion rings and shakes. He didn't believe you could make money unless you sold hamburgers, you just *had* to in order to offset the other costs." Archie was right; Pennington's became very successful.

In 1956, Lindy's Drive-In on Admiral became Pennington's No. 2. Two years later, Archie and Lola bought out their partner Waller and continued their upward momentum. Archie came in early in the morning and ran the day shift; Lola came in around 3:00 or 4:00 p.m. and ran the place until close. The operation was a family affair; all the kids (and eventually grandkids) pitched in to help. In 1962, the stress of operating two restaurants and a triple-bypass convinced Archie to focus on the Peoria location. The original Admiral location was purchased by their old partner Waller and became Miller's Drive-In.

Kids simply called Archie's place "Tons" and cruised the Restless Ribbon, driving slowly and crowding the lots. In fact, several businesses along the ribbon employed the services of off-duty law enforcement to help manage traffic. Officer Jake Biggs was a fixture at Pennington's, often seen walking the lot to make sure rowdy teenagers behaved themselves. It wasn't uncommon to see famous locals like musician Leon Russell stop in for dinner, either.

In 1973, a fire ripped through the drive-in. Over half of the restaurant burned to the ground, causing $25,000 in damage. Pennington's closed for the first time since 1951 (save Thanksgiving and Christmas) but it was able to partially reopen after only two weeks. In 2017, Mark Messler said he could still remember the smell of the burnt wood when he and his grandparents arrived on the scene.

The Pennington family ran the drive-in until 1974, at which point it was leased to other operators. It was during that time that Jeff Alexander worked for Pennington's. He was in his teens, but he observed that many of his co-workers were more than twice his age. "They kept the traditions alive," Jeff recalled. Although Archie and Lola had leased the operation out, they still regularly stopped by to visit. "They would pop in to do a tour regularly, just to see how things were going. Everyone was always so appreciative and respectful toward them."

Jeff left for college in 1978, but not before putting plenty of time in at the grill. "John Zink's operation was next door, and sometimes they'd call us around opening to order 250 sandwiches. It was all hands on deck!"

Pennington's Drive-Inn around 1963. *Courtesy of Mark Messler.*

In 1982, Connie Cronley of the *Tulsa Tribune* wrote, "Pennington's is so old it is practically a Tulsa landmark." Regardless of age, the drive-in was still known as one of the best places to eat. "If we had gone back any further into our youth," she wrote, "we would have sat on the hood and watched the cars go by." By then, a fried shrimp basket was $6.29 and still came with a fresh salad, fries and a hot, homemade roll. One of the carhops, Dorothy, had been working there for thirty years. "Pennington's is a classic drive-in, with exceptional food and a full-time shift of arrogant cats waiting for leftovers," Connie concluded in her article.

Lola and her daughter, Judy, took back operations of the drive-in in 1983. One night not long after that, Lola had closed up and was getting ready to leave when she heard a knock on the door. When she looked through the window, she was surprised to see a familiar face behind a pair of sunglasses: actor Gary Busey. He had just flown into town and driven straight to Pennington's to get a piece of the black bottom pie. Lola gave him a hug and a whole pie.

On April 25, 1985, Pennington's closed for the first time since the fire to mark the passing and funeral of Archie Pennington. Tom Carter of the *Tulsa World* wrote, "Pennington's Drive-In Restaurant is like the Golden Driller or Chandler Park. No matter what your opinion, you know where they are. All are true Tulsa landmarks." By that time, business at Pennington's had reduced to about 50 percent of the traffic it saw in its prime. Drive-in restaurants had mostly been supplanted by drive-through operations throughout the nation.

In January 1986, Pennington's Drive-Inn Restaurant Inc. filed for Chapter 11 bankruptcy. Amid the bankruptcy proceedings and dwindling business at the still-open Brookside location, a sit-down franchised restaurant opened at 8112 South Lewis Avenue. The grand opening in October featured a ribbon-cutting from Tulsa mayor Dick Crawford and a ticketed fifties-themed party benefiting the Brush Creek Ranch. The new restaurant was operated by Bud Barnes, who had been a regular customer of the classic drive-in. He worked out an agreement with Lola to use the name and recipes.

When the new place opened, the seating for two hundred wasn't enough; people waited in line for half an hour or more. The interior included booths of dark wood with red upholstery while waitresses sported pink or white blouses with black skirts, oxfords and bobby socks. Clientele ranged from senior citizens reliving old memories to young families making new ones.

Lola Pennington passed away in 1987; the drive-in on Peoria closed that October, nearly thirty-six years exactly from opening day. In June 1988, after settling the estate, Lola's daughter Judy and Judy's son Mike Messler reopened the original drive-in. Just like back in 1951, people tried to pull

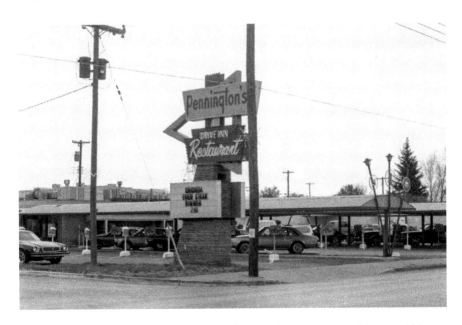

Pennington's Drive-Inn from the early 1980s. *Courtesy of the Tulsa Historical Society and Museum.*

in and grab a bite before they officially opened. "We had to run people out of here by the hundreds all day long," Mike told the *Tulsa World*. But the rebirth was short-lived. In 1989, the drive-in closed for the last time; it was torn down, and a piece of Tulsa history was lost. Today, a Kentucky Fried Chicken stands in its place.

The franchised location on Lewis Avenue operated until 1991, when the franchise agreement dissolved. Bud Barnes changed the name of the place to the DooWop Diner and it continued for a time.

The Pennington family revived the restaurant again in 1994 at a different location at 6104 East 71st Street. The hot pink, turquoise, and black color scheme took diners back to the fifties and a mural on the south wall did what it could to replicate the drive-in experience by featuring the old drive-in and cars of the era. Of course, the food and soda fountain brought back memories, too. It closed in 1995.

Yet another Pennington's-related restaurant came on the scene in 2009. In Bixby, Kari Okie's Café and Bakery opened with a few Pennington's items on the menu. It was run by a carhop that had worked at the original drive-in in the 1960s and '70s. The restaurant relocated to Kiefer at one point and survived until June 2015.

As of 2018, Archie's grandson Mark Messler was working to reopen Pennington's once again. Time will tell if nostalgia and commitment are enough to bring Tulsans back one more time to experience a part of their past.

Urban Sprawl

ST. MICHAEL'S ALLEY

St. Michael's Alley started as a coffee shop in 1960, owned by James "Cy" Kelly. James worked at coffee houses in California for a year before bringing that West Coast experience to Tulsa. It was named for London's first coffee house, founded in 1652. Those early shops were sometimes referred to as "penny universities"; for a penny, a cup of coffee came with conversation in which the new generation could sit and talk to the older generation and learn about the world. It's a great description for the people who became regulars at the Alley. "I never had to advertise," Kelly said. "It attracted a full spectrum of types, but mostly the young. One society editor came in all the time in the early sixties to report on who was there."

The interior was designed to foster those long conversations. Once customers made it past the heavy door, it took a few moments for their eyes to adjust to the darkness. The cedar-paneled walls and low lighting gave the place a personal feeling that became popular for first dates and special occasions. The five booths were the most coveted seats in the room: tall, dark oak walls made diners feel like they had the place all to themselves. The drinks were popular, but the restaurant was not as successful as James had hoped. By 1962, he was ready to sell.

Dick Greenwood was dining there for lunch one day and learned it was for sale. He quickly decided to make an offer. He got the money together and

went into business with a friend who could run the day-to-day operations. After only thirty days, however, the friend decided running a restaurant wasn't for him. Dick was left with a difficult decision but made the choice to quit his day job selling insurance and go into the restaurant business full throttle. Dick and the head cook "Big Jim" Hardy quickly turned the place from a bar that served occasional food to a real restaurant that became a beloved Tulsa institution.

Like many restaurants of the day, St. Michael's Alley was a family operation. Various members helped bake the German chocolate cake and chocolate torte. One of the most popular desserts was homemade cheesecake; Dick estimated he made over twenty thousand of them over the years.

Dick's father, Ed Greenwood, came on board a bit after opening. Ed had been trained by his uncle, an executive chef who had worked aboard the famous Super Chief and El Capitan trains out of Chicago with the Fred Harvey Company. The rest of the staff was long-term; many of them were still employed twenty years later.

Ed Greenwood helped develop many of the beloved menu items, like the German potato salad and the Drip Beef sandwich. "To my knowledge, we were the first to bring the drip beef sandwich to Tulsa," Dick Greenwood told the *Tulsa World*. "We were the only ones making Reuben sandwiches with a tomato-base horseradish sauce." For both sandwiches, Ann's Bakery made the bread special. The chili-cheeseburger was cooked over charcoal; in fact, the charcoal grill in the back was used for a great many items. "The fire

St. Michael's Alley in the Ranch Acres Shopping Center. *Courtesy of Catherine Burton.*

Espresso coffee

CAFFE' ESPRESSO	Large cup of dark roasted coffee, blended in the Italian manner	.40
ESPRESSO ROMANO	A single espresso with twist of lemon for piquadce.	.40
ESPRESSO ROYALE	A single espresso topped with a mound of whipped cream.	.40
ESPRESSO MANDARINO	Caffe' espresso and the essence of the mandarine orange.	.40
CAPPUCCINO MILANO	A double espresso blended with sweetened steamed milk and blanketed with steamed milk, a very popular interpretation on espresso.	.55
CAFFE' CORRETTO	A demi-tasse of dark Italian roast with the essence of RUM	.45
CAFFE' BORGIA	The time honored recipe of the Borgia family. Sweetened Italian chocolate blended with dark roasted coffee and topped with whipped cream.	.55
CINNAMON COFFEE	A large espresso with whipped cream topping and cinnamon stick stirrer.	.70
CAFFE' LATTE	Our dark Italian roast infused with steamed milk.	.55
CAFFE' SAN FRANCISCO	"Specialty Of The House"—Beneath a thick cloud of whipped cream is Espresso Gajeste blended in our machine with sweetened Italian chocolate, rum, and milk	.75
ICED ESPRESSO	Our dark Italian roast over ice.	.50
ICED CAPPUCCINO	Espresso over the rocks, topped with steamed milk and a sprinkling of cinnamon.	.60
The management warrants the above espresso menu to be in accordance with the existing nationally and internationally accepted recipes for these drinks		
CAFFE' GLACE	One dark Italian roast over a scoop of French vanilla ice cream.	.55
FROZEN BORGIA	The warm weather version of our popular Caffe' Borgia is blended with cracked ice and essence of the mandarine orange	.80
PLANTATION CAFFE'	An unrivalled espresso drink for your around enjoyment. Our dark Italian roast blended with fresh bananas and French vanilla ice cream	.40

The coffee selection at St. Michael's Alley. *Courtesy of Michael Greenwood.*

went out only once in nineteen years," Dick Greenwood remembered with a smile and a proud glint in his eye.

The fresh coffee and tea selection brought a West Coast vibe to the heartland of America. Espresso and specialty drinks were made with the La Pavoni machine behind the bar. Fruit drinks were popular, too, and all made with fresh or frozen fruit—no flavorings added. Alcohol was still a player in the menu. The Oklahoma Martini, one of James Kelly's original contributions, was a glass of Schlitz beer with a green olive. For a few years, Dick said the restaurant was the biggest seller of Schlitz draft beer in the state.

As you might imagine, the varied and exciting selection inspired crowds to line up for a seat. On any given night, the restaurant was packed with people of all kinds, snacking from the little bowl of potato chips that all customers received as an appetizer. Smooth jazz from Dave Brubeck or "Scotch and Soda" from the Kingston Trio wafted through the air from the jukebox, mixing with the tantalizing scents from the kitchen.

An antique 1849 coffee bean grinder sat in one corner and beer steins hung around the ceiling. The walls were adorned with a variety of odd items: hockey sticks from the local team, a pair of curved swords and an odd musical instrument called a ukelin. The latter was a gift from a customer who'd found it in a barn. It turned out to be a somewhat-rare hybrid ukulele/violin. By 1975, Dick had expanded the kitchen and added another dining room.

Things continued going well until a fire ravaged the Ranch Acres Shopping Center around 1980. Dick recalled that he sat on the curb as the firefighters worked to extinguish the blaze, sure that his livelihood had gone up in flames. As soon as the smoke cleared, though, he was relieved to find the restaurant had escaped with only minor smoke damage. The next year, after a few break-ins, Dick decided it was time to move on and sold St. Michael's Alley.

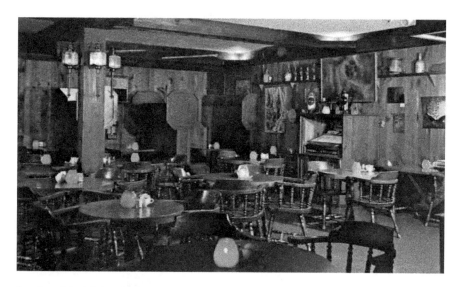

Interior of St. Michael's Alley. *Courtesy of Michael Greenwood.*

Shortly afterward, the restaurant reopened under new ownership as the Glen Again, a successor to the popular Glen restaurant from Utica Square. It closed in early 1988. Later that year, another restaurant opened under the original name, this time with a new owner.

The new incarnation of St. Michael's Alley was operated by Michael Lavelle and opened on June 10, 1988. Michael had previously managed Hoffbrau Bar & Grill and decided to bring back the old favorite. "You wouldn't believe the response we've had," he said at the time. "People are sentimental about this place…it is really tied up with a lot of people's feelings about growing up in Tulsa."

Longtime customers and newspaper critics happily reported that very little had changed with the décor or the menu. The burgers were delicious, the gazpacho was sublime and the cappuccino was a delight. Michael had been a chef at Nicole's in Utica Square and at Pablo's Bistro in Brookside. In addition to the classic drip beef sandwich and variety of fruit drinks, he added pâté, salads and pasta to the menu. The white chili became a top seller.

The new St. Michael's Alley made it for ten years before closing. Rick's Café Americain opened in the space afterward, but it closed in 2011. The Alley, named in honor of the original establishment, opened in 2012 but made it only a few years. Although the space has been through many transitions over the years, the mention of St. Michael's Alley brings to mind smooth music, great food and the best of times.

MILLER'S KORNER SHOPPE

Before Miller's opened, the building on the northeast corner of 21st and Memorial was Sontag's Market. The Sontag family owned the land from 19th to 21st on Memorial. Paul Miller, a longtime employee of airplane manufacturer McDonnell-Douglas, remodeled Sontag's into a restaurant along with his wife, Genevieve.

The Korner Shoppe started as a simple walk-up window with a small eat-in area. There were ten old wooden school desks to sit in. The exterior of the building was painted orange and white to match the Sweetheart brand cups; "It's a Humdinger!" they exclaimed, referring to the soda or malt you were about to enjoy. The food on offer was simple: hamburgers, hot dogs and Frito chili pie.

The Millers opened for business in May 1961. Paul and Genevieve's son Joe was twelve years old when the Korner Shoppe opened and started working on opening day. The first night was a Saturday. Paul was finishing up some last-minute interior work that evening and cut his thumb on a table saw. It was bad enough that Genevieve had to take him to the emergency room. Joe and his elder sister Margaret (aged fifteen) had to run the place on their own for hours. Their parents didn't return until after they'd closed for the night.

The nearby Nathan Hale High School had an open campus; Margaret remembered that many students had standing orders for lunch, which allowed them to eat quickly and return to school. Several of her classmates worked at the Shoppe with the family and still thought of it as the most fun they ever had on the job. They could eat or drink whatever they wanted, as long as they made sure the store's inventory counts were updated. In 2018, Margaret was proud that she could still make the perfect ice cream cone.

After less than a year, the Millers opened up the back room and added a juke box along with two pinball machines. On Friday and Saturday nights after 8:00 p.m., they allowed the teenagers to move

One of the handbills that Joe Miller distributed throughout the neighborhood for his father's restaurant. *Courtesy of the Tulsa Historic Society and Museum.*

the tables to the side of the room to have an area to dance. Paul patrolled the parking lot and asked loitering drinkers to leave, which allowed the place to avoid big fights that occasionally broke out at other popular spots around town.

To promote the business, Paul printed handbills. Joe and his friends distributed them to front porches for miles around. The area was still partially undeveloped; Leisure Lanes and Michael Heights neighborhoods were still under construction at that time. Several of the arterial roads were still dirt lanes. Miller's place provided a place to eat for this growing part of the city.

"Our meat supplier raised prices one time and, not wanting to increase *our* prices, decided to go down a level in quality. Dad came in from Douglas one evening and put a burger on the grill; when it was done, he took one bite and threw it in the trash. He went to the refrigerator, pulled all the meat out, and threw it in the trash. 'We are not serving this crap.' he said. We ate the cost for a couple of months and finally raised the price a few cents," remembered Joe.

The Shoppe closed in June 1965 when the property was sold to Texaco. Although that meant service stations would occupy all four corners of 21st and Memorial, the increase in automobile traffic supported the duplication.

AL'S HICKORY HOUSE

Although the intersection of 81st and Memorial is a busy place today, not so long ago it was considered the country. Before the Tulsa city limits stretched south to Bixby, there was a little Middle Eastern barbecue joint at those crossroads called Al's Hickory House.

Al Saab considered his little corner of Tulsa County "the best place on earth." He was a Lebanese man from Porter who was raised during heyday of Tulsa's oil wealth. After a bit of international travel, he returned to Tulsa and started his first little restaurant in the 1940s.

It was called the Candle Light Inn at 27th and Harvard, situated next to a little tourist court. After about a decade, urban sprawl had taken over the area. Al preferred the countryside, so he relocated to 51st and Hudson—far outside of Tulsa's boundary at that time. Another decade passed, and once again, the city was encroaching.

Al was tired of moving; he looked for a place he felt would meet his desire for country living without the threat of the city on his doorstep. He purchased

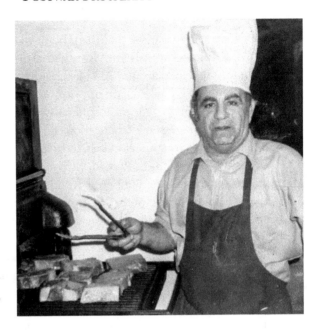

Al Saab at his grill. *Courtesy of Joe Saab.*

a chicken farm at the southwest corner of 81ˢᵗ and Memorial, convinced that customers would make the trip out to eat his food even though it was a bit of a drive. It was on that property that he opened Al's Hickory House.

He converted the old white clapboard farmhouse into his restaurant and lived out of a mobile home in the back. Great pecan trees shaded the lawn. In those days, Memorial was better known as Highway 64, a quiet two-lane passage between Tulsa and Bixby. In fact, two miles south of Al's place was a sign that pointed the way to Memphis. Al's Hickory House was a best-kept secret.

There was no written menu; Al told each customer what was on offer. "Club steak, sirloin strip and ribeye" were the only entrée choices at first, eventually expanding to include ribs, pork shoulder and turkey. He cooked meats in a stone two-chamber smoker he built himself in the backyard, with well-seasoned hickory in the pit. He squeezed fresh lemon over his steaks to give them a bit of zest. True to his heritage, he also offered chickpeas, tabouli and cabbage rolls. The vegetables he served, such as the cold green bean and tomato dish that came out as a free appetizer, were grown right on his property,

"I've never eaten a steak anywhere in my life that's been anywhere *near* as good as Al Saab's," remembered Tulsa restaurateur Ron Baber, a frequent diner at the Hickory House. "It was always cooked perfectly; nothing but choice and prime beef. He'd even bring it out and show it to you before he

cooked it." Ron also remarked that the tabouli was "the best I've ever had" and that he still makes it at home. Ron had a dream of opening his own place one day and helped around Al's place for free, cleaning up and making sure the customers were taken care of.

The food was great, but the atmosphere was the real treat for customers. Diners entered through the kitchen; if Al didn't like you, you would go no further. If he *did* like you, he was likely to break down in happiness. "Every time [my wife] Nancy and I would visit, he would cry when she came in and demand a hug," remembered Randy Stainer, whose family was a mainstay at the Hickory House. "For years, I recommended his place to my friends and told them to mention they knew me so Al would let them in and serve them."

Businessmen brought clients out to the Oklahoma countryside for a meal experience they couldn't get anywhere else. Regulars included lawyers, football coaches and musicians. Men of position, such as Congressman James Jones or Judge Allen Barrow, were big fans of Al's dry-aged steaks. "By odd coincidence, Al's place was never raided by the ABC [Board]," Randy added.

Al was not only the cook and manager but also the entertainment. He talked to everyone about the news of the day or complained to them about business being too thin (or too busy for that matter). Supposedly, he even kicked customers out who asked for ketchup with their steak.

Al's farm was home to many animals: horses, pigs, chickens, ducks, turkeys and sheep. He had a spring-fed pond that he stocked with fish. Under one of the pecan trees, an old mattress was laid for the occasional outdoor nap.

By the 1970s, the city was once again encroaching. Al received offers on his land, but he waited until he got an offer from "the right people, who would develop it properly." In 1981, he finally sold to a developer that wanted to build a retail center. "This shopping center will be one of the most unique anywhere," Al told the *Union Boundary* newspaper. "There will be nothing like it." The Echelon Shopping Center still stands on the corner today.

With the sale, Al retired. He moved far into the country once again, this time to a place where the city wouldn't reach. The money he made from the sale supported him for the rest of his life. Ron Baber, the young man who worked for Al for nothing, went on to found the beloved Ron's Hamburgers and Chili chain in Tulsa.

CONNORS' CORNER

Connors' Corner in Tulsa was John Connors' second restaurant; the first one was in Bartlesville. In 1961, John and his wife, Janet, brought a unique restaurant to the northeast corner of 31st and Harvard. Pat Cremin, who had been taken to Connors' Corner on many occasions with his grandfather, called it a "once in a lifetime kind of place."

Their "steakburgers" were made from beef that was packed in dry ice and shipped directly from Kansas City. The patties were precisely charcoal-broiled on custom Hasty-Bake ranges, which took about twenty minutes. This was a long time even in the 1960s. The back of the menu alerted customers to the wait, noting, "Please do not become impatient. This slow service is economically unsound but my wife, Janet, and I are too old to be rich anyway."

Burgers were available in four sizes: Eenie (a three-ounce patty for "skeptics who just can't believe that food can be so good"), Meenie ("twice as good because it was twice as big"), and Meinie (a nine-ounce patty created for those who "would be embarrassed to order two Meenies"). You could

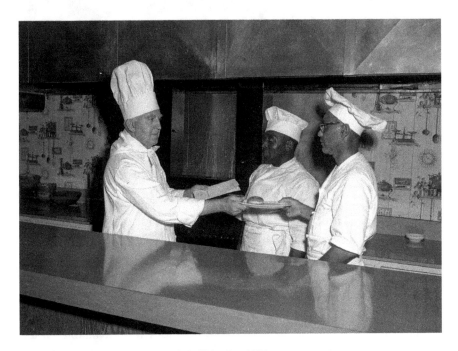

John Connors and chefs. *Courtesy of the University of Tulsa.*

Connors' Corner. *Courtesy of the University of Tulsa.*

also order Mo, which was a nine-ounce patty with an apple dumpling, handcrafted by Janet, for dessert. Dumplings could be topped with a scoop of Burt's Ice Cream for an extra fifteen cents.

Burgers were *never* served well done, and each one was meticulously seasoned. The menu continued, "It is requested that you do not embarrass us or yourself by asking for additional seasoning. Under no circumstances will mustard, catsup, or onions be served!" The topping selection was similarly restricted. No french fries or other sides were available either. John expected the burger to stand on its own, and they did. There was often a line out the door.

The tables were set with bowls of small pickled green tomatoes. Several customers recalled an ongoing contest for the longest squirt from biting into a tomato. "It was the first place I had a hamburger with sesame seeds," recalled Tulsan Gary Reynolds.

Gary continued, "One thing I clearly remember is being at Connors' one night with my parents. I was a young pup then. My dad always ordered iced tea with lemon. The waiter told my dad they were out of lemons. No big deal; we ordered anyway. Then, about ten minutes later, we see one of the chefs walking through the front door with a sack of lemons! He had gone across the street to the Safeway to buy some lemons. Talk about customer service."

In addition to the food, Connors' was also known for its radio advertisements that extolled the virtues of a simple burger. Jim Wheaton, the voice on the radio ads, was also used in the popular "UNeedUm Tires" advertisements. Interestingly, the radio ads rarely mentioned their address. It was up to the listener to find Connors' Corner, which gave the place a cult-like status.

At the end of the hand-written menu, there was section that said a lot about Connors' in just a few words: "Times have been both good and bad but all happy. We've already made most of our mistakes…made the most of our experience, lived the most of our lives. Now, in Connors' Corner, if we can bring to you a few moments of gracious dining pleasure, we'll be truly happy."

Although it had a lasting impact, the Corner wasn't around for a long time; it closed in 1967. When you mention Connors' Corner today, there aren't a lot of people who remember it…but those who do come forward with fond memories and a wish to have just one Mo.

BLACK GOLD BUFFET

When Edgar Brown and his wife, Velda, came to Tulsa after World War II, there was a housing shortage. Edgar decided to build his own house and found that he could sell it for a profit as soon as it was finished. This became a pattern and Edgar found himself in the property development business. He contracted work all over the region, including building much of the utility system when the entire city of Mannford relocated in the early 1960s.

In 1963, Edgar finished building Memorial Center, a shopping plaza at 2114 South Memorial. Since it was situated on a hill, the north end had two

levels. The upper section was home to a few offices, but Edgar wanted to do something with the lower level himself.

Edgar had been inspired by dining at the famous Gold Buffet in Kansas City. Since the city of Tulsa didn't have any full-time buffets, he decided to open one himself. Thus began the Black Gold Buffet.

"You went in through the doors at the north end and then down the stairs," remembered son Darrell. "We had a little pond underneath the stairs with fish in it; people would throw in pennies."

The Browns employed several full-time chefs to prepare food. "We hired Glen, who had been the chef of the Bartlesville Country Club, a fry cook named Harold, a pastry chef and a salad person. Harold was your mind's picture of a French chef—a thin moustache, that hat. He did a good job."

The chefs would arrive early and prep all morning. The buffet was open a few hours for lunch and then again for dinner service. It was also open for every holiday. "We had a big roast and a big ham every Sunday. Mom would stand at the end of the line and carve for folks." Steak was on the line once a month. "We always had fried chicken, always had baked beans."

Darrell remarked that they only advertised a few times early on; after that, word of mouth was strong enough that it wasn't necessary. Edgar Brown was a member of the local Optimists Club and was connected to many social organizations. As such, the restaurant became well known as the site of many gatherings and events: school graduations, father/daughter dinners for the Girl Scouts, club banquets. In 1965, the buffet hosted the Ninety-Nines organization of women pilots.

Sign for the Black Gold Buffet on Memorial. *Courtesy of the Tulsa Historical Society and Museum.*

Interior of the Black Gold Buffet. *Courtesy of Darrell Brown.*

Several things happened around 1970 that marked the end of the Black Gold Buffet. Velda had an accident that broke several bones and put her out of commission for a while. Edgar got involved in building another shopping center farther east. The Browns decided it was time to move on and sold the restaurant. Shortly afterwards, the shopping center as a whole was purchased outright. The space that had been the Black Gold Buffet was converted into a bar.

THE PAGODA

When the Mandarin Café downtown closed, the family continued the tradition of operating Chinese restaurants in Tulsa. Margaret King operated the Pagoda along with her husband, Joe, her daughter Peggy and son-in-law Jimmy Char and her two brothers. They took everything they'd learned from running the original Chinese restaurant in town and brought it to the Bellaire Shopping Center at the south end of the "Restless Ribbon." The Pagoda opened at 4971 South Peoria in April 1963.

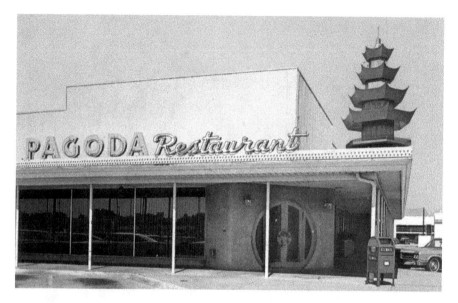

Postcard for the Pagoda. *Courtesy of the Tulsa Historical Society and Museum.*

While the Mandarin was established in the spartan years of the Great Depression, the Pagoda was designed with much more Chinese cultural influence in mind. After entering the unique circular door, the first thing that grabbed your attention was a shrine on a raised platform in the back. The shrine itself was made in China and dated to the mid-1800s. Beautiful Asian-style light fixtures hung overhead and throughout the three dining rooms. Meals were served on stainless-steel platters family-style, which encouraged conversation and sharing.

Their egg rolls became a staple item, but many young Tulsans cruising the "Restless Ribbon" had never seen one before. Bennie McCormick remembered:

> *I went there on a date when I was a teen. I had never eaten Chinese food before. I saw the egg roll on my plate and thought it looked kind of like a corn dog so I thought it needed mustard. It was larger than one bite but smaller than two. I didn't know if it would be proper to cut it in half so I decided to eat it whole. There was a container on the table that looked like mustard so I drenched the egg roll in it. I then took an enormous bite and thought I was going to die. I could not spit it out because of my date so I chewed and swallowed. It was the hottest thing I ever ate in my*

Although there was a small selection of soups and sides like German potato salad, the sandwich selection was tough to beat. The menu featured options like the Rueben, oriental chicken and hot ham and tomato. The Diamond Jack was a beef knockwurst, sauerkraut and Swiss cheese combination with house-made mustard and mayonnaise. The sandwich that tends to get mentioned the most in conversation, though, is the dripped beef.

Ann was known for putting her all into her cooking. "She always liked to tell how businessmen would come in from out of town and say, 'Ann, make us one of those heart-and-soul sandwiches,'" Sean Burgess told the *Tulsa World* in 2010. "She put that into every one of them—her heart and soul. Everything from the portion and slice to the presentation was important. There was definitely no slapping meat on bread with Ann."

In 1967, they opened a second location at 5309 East 41st Street. The Appletons had many years of success, and after more than twenty years, they wanted to retire. Larry and Nancy Zankel bought Diamond Jack's in 1989.

Ann had known Nancy for many years, and the transition was seamless. Shortly after the purchase, the original location was closed, and all of the Zankels' focus was at 41st and Yale. Nancy sewed all of the waitresses' uniforms, which were still modeled after late-1800s dresses. The passion the owners had for the business kept customers coming back, regardless of location. "There are no strangers here, just people we haven't met," said Larry.

More circumstances beyond the Zankels' control required additional moves. In 1994, the Southroads Mall was threatened with demolition, so the restaurant relocated to 3609 East 51st Street. In 2008, 51st Street was widened and it eliminated most of their parking. Diamond Jack's moved to 7031 South Zurich. Two years after that final move, Larry passed away.

A year after Larry's passing, Nancy Zankel announced the restaurant was closing. "Three generations of our family ate there," remembered Diane Stamm. "When we found out they were closing, I called my cousin Vicki, and she flew up here. We ate there for three days during their last week of being open."

Diamond Jack's closed for good on June 29, 2012. To this day, you can't mention a dripped beef sandwich within the city limits without someone lamenting the loss of Diamond Jack's.

to be watered, rinsed and drained twice a day. Even on Thanksgiving and Christmas (the only two days a year that Pagoda closed), someone went in to tend the sprouts."

As time wore on and the Torreses entered their sixties, the demands of running a restaurant were becoming too much. They sold the restaurant in January 1994 with the condition that the buyer could not keep using the Pagoda name. "My parents probably knew the restaurant was unlikely to return to its former 'glory days' and thus did not want the name to continue," Angela said.

John Siu also remarked, "I think I can speak for most Chinese restaurant children that there is a piece of the experience that doesn't leave you. You appreciate food. You love cooking for your family. Eventually you find that you were well prepared for life and you hope to pass the lessons onto your children." The legacy of the families behind the Mandarin Café and the Pagoda is tied to many beloved eateries in Tulsa.

Wai Han and Leung Foo Jow, of the King family, opened Ming Palace at the Mayo Meadow Shopping Center in 1969 before moving to Houston in the late 1970s. Sui On and Ken Jow of the King family opened the Golden Palace at 51st and Peoria in 1979, and it's still operating in 2018.

Peggy Char founded the Oklahoma Territory Film Commission in the 1980s. The Eng and King families carry on their traditions with pride and fond memory. Their contributions to Tulsa culture, both in art and in cuisine, cannot be overstated.

DIAMOND JACK'S

Ann and Jack Appleton opened Diamond Jack's in the Country Club Plaza at 3344 East 51st Street in 1965. It began as a small bar that offered a few food items. Soon, however, the sandwiches became the main attraction.

It had an 1880s-saloon motif with red-and-gold flocked wallpaper. Gold-rimmed mirrors hung on the walls and the sconces looked like old gas lanterns. Hostesses wore floor-length dresses. A curio cabinet displayed a selection of dolls Ann had made herself. The Diamond Jack's logo was simply a photo of Jack with sideburns and a moustache added for frontier flair.

Jack Appleton played the piano under the ornate chandeliers, occasionally joined by someone with a guitar or other live entertainment.

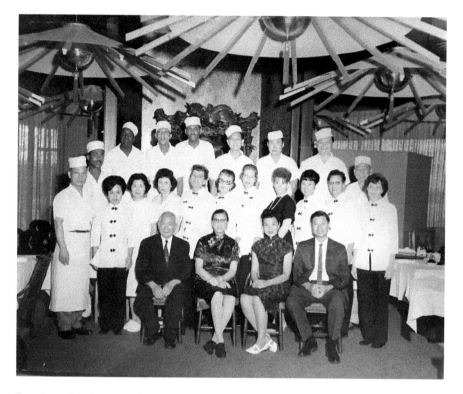

Pagoda staff and owners. *Courtesy of Angela Kantola.*

"Restaurants have a way of owning you, rather than the other way around. It was both a delightful and demanding business," remembered Angela Kantola, daughter of Ben and Virginia Torres. "The delight was in serving terrific food to faithful Tulsa patrons, working with wonderful people, and making a reasonable living." She spoke of her father's strong work ethic and her mother's "tremendous capacity to focus on the bright side and energize those around her."

Angela worked there herself during her high school years doing a little bit of everything: kitchen prep, serving, hostessing and cashiering. It was the family business. "My family was only one of many who loved Pagoda's delicious Cantonese-style Chinese food," she said. "I've pretty much given up ordering chow mein since no one makes it like the Pagoda."

The chow mein they served was notably full of bean sprouts, which were sprouted on-site. "We had a small room off the kitchen devoted entirely to sprouting mung beans, so we always had plenty of bean sprouts for chow mein, chop suey and the famous Pagoda egg rolls. The bean sprouts had

life. Afterward I looked like my dog had died. My eyes were crazy red and my tears covered my entire face. Evidently it was hot *mustard with horseradish in it.*

Many families made the Pagoda a tradition after church on Sunday, in large part due to the generous lunch buffet. The line to get in often went down the sidewalk. Cashew chicken, wontons and moo goo gai pan were listed on the menu alongside hybrid dishes like garlic chicken and steak Kew (sirloin stir-fry with Chinese vegetables). The restaurant served burgers, fries and chicken-fried steaks to those who didn't care for Chinese food, just as the Mandarin Café had. "Everything was done by hand," remembered Lynne Bennett, Jimmy and Peggy Char's daughter. "There weren't any fancy machines or choppers. Just a couple of big butcher blocks!" She recalled how they became sloped in the middle over time due to their constant use.

The families of Tulsa's Chinese restaurants were close-knit. "Whenever one opened up, all the existing restaurants would go into a chatter and the opening of a new Chinese restaurant was fodder for the local Chinese gossip," remembered John Siu, whose father was a chef at the Pagoda in the 1970s. "We actually knew most of the owners, and though we competed for Tulsa's dining pool, we were all friends, borrowing supplies from each other and paying visits to each other's restaurants to try the fare or chat while observing how busy you were." John's parents later opened the Eastern Chinese Restaurant at 31st and Sheridan. Over the years, the Pagoda family helped sponsor several families into the United States.

By the late 1970s, the older members of the Char family were ready to retire. Rather than simply hire out the management of the restaurant, the family decided to sell to someone just as dedicated as they had been. In the spring of 1979, the Pagoda was sold to longtime customers Ben and Virginia Torres.

Virginia was a music teacher at nearby Eliot Elementary and was known to many of the kids cruising Brookside. Ben was of Puerto Rican descent and loved to cook; he was looking for something new and different from his work at McDonnell-Douglas. Many of the original staff stayed on for years after the sale; in fact, Margaret King herself continued to work at the Pagoda until shortly before her passing in 1993. "This is my life," she'd told the *Tulsa Tribune*. "I work in my yard sometimes. But, I wouldn't know what to do if I had more time off." Her favorite thing to do at the restaurant was teaching people how to use chopsticks.

SHOTGUN SAM'S PIZZA PALACE

The idea for Shotgun Sam's Pizza Palace began with salesman Doug Jones and Jack Mills, an Oklahoma City man who had been in the restaurant business for a time. They envisioned a pizza and entertainment restaurant called Pistol Pete's. They enlisted a real estate friend named Tom Winslow to help them find the right location in Tulsa and found it at 1905 South Sheridan.

While negotiating their lease with landowner Ramon King, Jack backed out as a partner and took the Pistol Pete's name with him. Since Doug had no experience in the restaurant industry, he turned to Tom, who had a degree in restaurant management from Oklahoma State and had managed a Borden's Cafeteria previously. The two men, along with Ramon, moved forward with a new name for the place: Shotgun Sam's.

Doug spent months developing the pizza recipes. Terry King, Ramon's daughter, recalled the excitement before opening day. "I remember going over to Doug's house and tasting pizza recipes. I was so sick of pizza before the restaurant opened!" she said with a laugh.

"The meats and cheeses all were scaled so each pizza was as identical as possible," Doug said later. "For instance, on a ten-inch pepperoni pizza we had twenty-eight pepperonis. You could count them. And our crusts were thin and crispy. They wouldn't fold over when you picked up a piece, and they had lots of cornmeal on the bottom." The sauce was a rich blend of tomatoes, tomato puree, tomato paste and eleven spices.

Shotgun Sam's also offered seasonal varieties of pizza, such as an Oktoberfest version with sauerkraut and green tomatoes. "It was the first place I had pineapple and ham on a pizza," said Terry. "Back then, that was a big deal."

Shotgun Sam's Pizza Palace opened for business on August 4, 1967. "I told Tom that we need to be prepared to not break even for a while until we get this going," Tom Winslow recalled. But none of them expected to be profitable in the first month, which is what happened. It was a phenomenal success.

Doug, with his outgoing personality, was there every day and became a draw in and of himself. He had grown a handlebar moustache for the grand opening of Sam's to fit the western theme; it became a trademark to match his nature. He even brandished a little gold comb for it.

Radio advertisements for the place featured the Yosemite Sam lookalike mascot and his "horse of a different color": "I'm Shotgun Sam the pizza

Shotgun Sam's Pizza Palace on Sheridan. *Courtesy of Tulsa Historical Society and Museum.*

man, I run the Pizza Palace. Shotgun Sam, that's who I am, and my horse's name is Alice!"

People came out for family reunions, graduation parties or get-togethers after a race at the fairgrounds. Families crowded the picnic-style tables and kids waited in line to ride the mechanical bull.

Shotgun Sam's was doing so well, Ramon King approached the others and suggested they expand to Oklahoma City. They all agreed and became equal partners in the venture. It, too, was successful from the start when it opened in 1969. From there, they continued to expand to other parts of Oklahoma as well as Texas and Missouri. A second location was opened in Tulsa near 51st and Yale.

In addition to the food, Sam's had live entertainment five nights a week. It could be a banjo player and a player piano, a barbershop quartet or country and western music. "I've heard Garth Brooks on the 'Tonight Show' say his first professional job was at our restaurant in Midwest City," Doug told the *Tulsa World.*

For several years, Shotgun Sam's offered a scholarship program for its employees. "We had some really, really good employees," remembered Tom. "Some were trying to work and go to school at the same time and were struggling. We saw a need and wanted to help out."

The generosity toward the staff was one of the many indicators that Sam's was "all company owned. And we might have been the first pizza place in the country to offer a lunch buffet, around '70 or '71. We had been mostly a dinner place, but when we put in the buffet, it really boosted lunch for the first time," Doug Jones told the *Tulsa World*.

"We started catering to local businesses in the early seventies," said Terry King. They had a van outfitted with an oven to keep the pizzas warm, which was driven to places of business for meal service. Terry's first job was taking the van out to businesses around break or lunch times, often late at night, and serving customers on-site. "It lasted maybe a year or two."

Things continued to go well until 1984, when Ramon King was tragically killed in an automobile accident. The shattering of the partnership changed the whole dynamic of the company. That, combined with a slowdown in business, lead to Jones and Winslow selling off locations. The Tulsa stores were sold in the mid-1980s. The last Shotgun Sam's location, in Oklahoma City, closed in 1992.

Doug Jones owned and operated the Cheers Bar on Mingo Road for twenty years before he passed away in 2015. Tom Winslow looked at reopening the restaurant in 2013, but it didn't come together. Although a Shotgun Sam's opened the following year in the London Square Shopping Center for a brief time, the original owners were not involved.

"The first 10 to 15 years of Shotgun Sam's were the most fun I've ever had in my life," Tom told the *Tulsa World*. "Doug and Ramon and I had a great time."

THE GARDEN

Before it was The Garden, the restaurant at 1800 Utica Square had been through several iterations. When the suburban shopping center first opened in 1952, it was called simply The 1800. Dorothy Carter operated the restaurant; her husband, Dale, was a co-developer of the square. "[The 1800] was a very exclusive restaurant," said Jan Gaines, whose mother worked there. Jan remembered hearing stories from her mother about serving movie stars Jane Russell and Ava Gardner.

In the early 1960s, the Powers Restaurant Group purchased The 1800 and changed the name to Powers 1800. "Mr. Bill" Powers managed the space until it closed in 1966. Walter Helmerich III, the new owner of Utica

Square, had an idea for something new in its place that would entice people to come for an enjoyable lunch and stay to shop a while. "He was very clever," said wife Peggy Helmerich. "We went down to Dallas, and one of the great restaurants we visited was the Little Mushroom." The Helmerichs convinced one of the chefs, Marilyn Romweber, to come to Tulsa to help them get started. "We did the menu on our own. When I say 'we' I'm talking about one of my very best friends: Gerri Freeman."

Although Gerri had not managed a restaurant before, Peggy asked her to handle the day-to-day operations. Gerri was surprised but was up to the challenge. "She just went to the library and checked out books on how to run a restaurant!" remembered Gerri's daughter Linda Redeker.

Walt wanted to create a unique dining experience, complete with elaborate décor. He hired a man named Jack Wagor to totally renovate the restaurant. "Jack was *the* premier decorator in town," Peggy explained. The space was divided into uniquely decorated rooms around a specific theme. "In the west room, he wallpapered the walls with stylized tulips… sort of contemporary. And then, he made chandeliers…that brought the colors together. He did sconces on the wall…It was sort of fabulous. It just knocked your socks off." Another room was a stylized iris theme with purple, blue and lavender. "The middle room was for men," for a period of time. "It had beautiful fixtures with great big copper plates….It looked very masculine. That was the Geranium Room."

In 1967, The Garden sprouted at Utica Square. It was a "riot of color," per the *Tulsa Tribune*. Pink, gold, orange and green colors coordinated across the draperies, table settings and wicker furniture. The restaurant became a social hub for many Tulsans. It was the site of wedding showers, bridal luncheons and fashion shows. Ladies came in for tea and would play bridge all afternoon. Even Helen Corbitt, the nationally recognized chef from Neiman Marcus, stopped by to experience Tulsa's beloved tearoom. Peggy Helmerich added:

> The most important piece of equipment [in a restaurant]…is the dishwasher. You could tell a lot by the dishwasher, because you could see if people left food, what they didn't like…if they mopped up their dishes and what they did like. That was really important."

In the center of each table sat a bouquet of paper flowers made by a local Tulsan. Gerri Freeman would plant something of her own in each pot: a tiny scripture. She credited The Garden's success to her faith and held a

devotional with the staff every morning. When asked how the food quality was kept up at the restaurant, Gerri simply said, "We pray over it every day." She worked at The Garden for twenty-five years and became a community fixture. "She was such a great manager," Peggy said. "Everyone worked so well with her."

The menu was another way The Garden stood out. "They had one or two entrées...that's it," said Linda Redecker. "Everything was made from scratch. No fried foods and no heat-and-eat!" Although the selection was limited, the quality was top-notch. One of Peggy's favorites was the Chicken Plantation: a soufflé with a cornbread base with creamed chicken poured over the top. "It was just to die for," she said. The restaurant's biggest seller was the garden salad, which consisted of a bed of lettuce with a hollowed-out orange in the middle; the orange could be filled with a variety of ingredients from cottage cheese to sherbet.

A signature item was broth and herbed toast served as a starter. "We had what we called toasties, which were long baguettes, sliced very thin. We'd put spices in the butter. They'd be crispy, warm, and buttery...They were really good," remarked Peggy. Of course, there also was dessert.

Gerri Freeman, manager of the Garden. *Courtesy of the* Tulsa World.

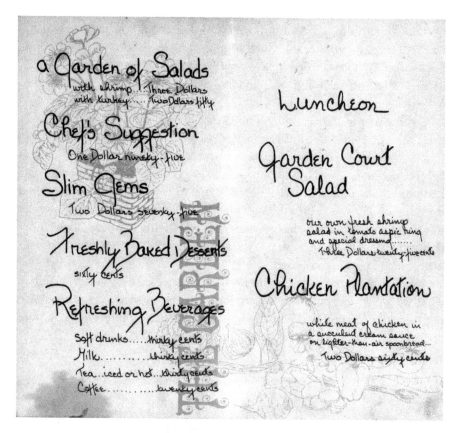

a Garden of Salads
with shrimp... Three Dollars
with turkey.... Two Dollars fifty

Chef's Suggestion
One Dollar ninety-five

Slim Gems
Two Dollars seventy-five

Freshly Baked Desserts
sixty cents

Refreshing Beverages
Soft drinks.....thirty cents
Milk..........thirty cents
Tea..iced or hot..thirty cents
Coffee...........twenty cents

Luncheon

Garden Court
Salad
our own fresh shrimp
salad in tomato aspic ring
and special dressing......
Three Dollars twenty-five cents

Chicken Plantation
white meat of chicken in
a succulent cream sauce
on lighter-than-air spoonbread...
Two Dollars sixty cents

The menu at The Garden. *Courtesy of the Tulsa Historical Society and Museum.*

The Garden had a selection of fruit pies with a tall meringue called Angel Pies. One time, when Peggy was helping at the restaurant, she was taking a slice out to a table and the dessert fell over. "I went over to Miss Freeman and said, 'Oh what am I going to do!' She said 'Just tell 'em it's a Fallen Angel.'" The dessert that won most people over, however, was the baked fudge. Although it wasn't an original creation (it had carried over from The 1800 restaurant), it became best known at The Garden. "My husband was the official baked fudge tester," Peggy said fondly. "Every morning he would go over and get a bite."

Over the years, all five of the Helmerich sons came through the doors of The Garden to work as busboys. "I'd come in, and they'd be sitting at the table," Peggy remembered with a laugh. When she asked what they were doing, they told her, "If we don't, we forget which side the forks go on!"

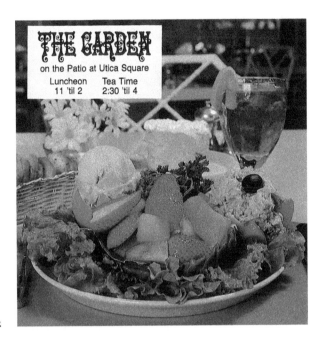

Advertisement for the
Garden in Utica Square.
Courtesy of Helmerich & Payne.

By the mid-1990s, competition had increased tremendously. Gerri Freeman was considering retirement, The Garden lost a cook, and a lot of the kitchen equipment was beginning to break down. After nearly three decades, it seemed like the right time to close. Upon the restaurant's last day of business in 1995, the *Tulsa World* wrote, "The closing of The Garden restaurant last week signaled the end of an era: a time when women wore white gloves and hats and had the leisure to dawdle over demitasse cups of that wonderful consommé, served with herb toast."

"Everything about it was special," Peggy Helmerich said. "I guess it meant success. It was popular, the food was marvelous…it was a worthwhile endeavor. It was always fun." After The Garden closed, the space evolved once again. Today it's known as the Wild Fork and still serves refined food in an upscale atmosphere.

THE BOOM GOES BUST

The 1970s brought an increasing amount of competition to Tulsa. Fast food was on the rise and national chains started to gain a foothold in the city. The march of progress claimed many historic buildings downtown and forced a lot of small businesses to either move or close up shop completely. The increased availability of ingredients from around the world gave birth to even more varied food options and niche markets.

When the recession hit in 1982, many Tulsa restaurants were able to weather the storm. After all, the oil business was still booming. The same could not be said after the crash of the oil industry in 1986. The boom finally went bust, and it took a great many other businesses with it. Although some restaurants remained open through the downturn, it changed the makeup of Tulsa's restaurant scene for decades. The chain restaurants took over and dominated the popular shopping districts. Mom-and-pop restaurants and farm-to-table operations wouldn't regain popularity until the late 2000s.

Chain restaurants weren't *all* bad, however. A few entered the city and became so beloved that people still clamor for their reconstruction decades later.

5

Expanding Horizons

CASA BONITA

Casa Bonita is one of Tulsa's most beloved and memorable eateries. Though some people think it's a Tulsa-based establishment, it was actually one of several that were once in business around the country. The first one opened in Oklahoma City in 1968, the creation of Oklahoma native Bill Waugh. In 1971, Bill brought Casa Bonita to Tulsa; though sister restaurants also existed in Abilene and Little Rock, Tulsa's was set to be the largest yet at twenty-four thousand square feet with seating for nearly eight hundred.

The former Fleming's IGA grocery store at 2120 South Sheridan Road was made to look like a colorful Mexican village; even the concrete supports were reborn as trees and monuments. Remodeling costs were originally estimated around $100,000, but the developers had spent more than six times that amount by the time the doors opened. The entire space was lavishly decorated and the kitchen was all-modern, set up for buffet-style serving. It opened for business on December 16, 1971.

The blinking *Casa Bonita* lettering on the front of the building was magical to young eyes. When you passed under the archway at the entrance and walked through the distinctive wooden doors, you were transported into another world. A maze-like cafeteria-style line led you to a spot where you took a tray and selected your meal. Paper menus had a map on the back that helped you select which one of the themed rooms to sit in.

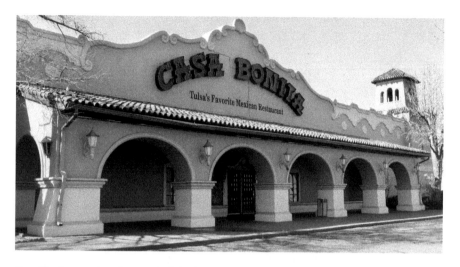

Casa Bonita exterior after a refresh in the 2000s. *Courtesy of the* Tulsa World.

The Acapulco Room looked like a forest, complete with an eighteen-foot waterfall. There was a room designed to mimic an outdoor market. The one that gets mentioned the most in fond recollections today is the Cave Room. The two-level room was lit with lanterns and provided a somewhat quieter respite from the elevated noise level in the rest of the restaurant.

"There are a lot of hidden things customers may not see the first time," manager David Anderson told the *Tulsa World* in 1975, noting the "village laundry and clothesline, the animals perched above the cave and the church front with stained-glass windows."

Casa Bonita claimed to be "Tulsa's Favorite Mexican Restaurant," but it never claimed to be authentic. It was all Tex-Mex cuisine, and all-you-can-eat was the name of the game. When you wanted more, you just raised a little table-top flag to get the attention of wandering wait staff. Once you were finished with your meal, you raised your little flag again for complimentary sopapillas.

A mariachi band was often heard throughout the restaurant, playing tableside for excited families. A magician performed in a special theater where automated marionettes danced about. Kids marveled at the puppet shows featuring "Russel and the Hand," performed by Richard Eschliman (known as Mr. E). You might also see Bananas the Monkey wandering the rooms.

Lynn Lipinski vividly remembered her time in the monkey suit. There were three rules for Bananas: never take the head off in public, Bananas does not speak and if a child starts crying, you must leave the room. A

human-sized monkey waving and dancing near the table was not always received with open arms.

Eventually, Casa Bonita even featured an arcade complete with Skee-Ball and an operating carousel. When diners were ready to leave, kids could get a free prize from a large chest in the treasure room. If you looked up, you'd see Curious George going back and forth on a high wire. "It's like Disney World," Kathleen McDole remembered. "When I was a little girl, I took my mother here for Mother's Day. Everyone has a story about Casa Bonita."

After Bill Waugh sold the restaurant to British food company Unigate in 1981, the quality of the food was generally considered to have gone downhill. Ownership changed hands several times through mergers and spin-offs over the years. By 1997, the Tulsa location and a store in Colorado were all that remained when Star Buffet took ownership.

In 2003, the Colorado restaurant was featured in an episode of Comedy Central's *South Park* TV show. The creators and many of the other members of the show's staff had memories of visiting the restaurant. The episode even caused an uptick in business in Tulsa.

Tulsa's Casa Bonita closed on September 30, 2005, due to a breakdown in lease negotiations. In May 2006, it reopened as Casa Viva and was once

The interior of Casa Bonita. *Courtesy of the* Tulsa World.

again owned by Bill Waugh. Although the tables, chairs, kitchen equipment and most of the decorations were gone, Waugh Enterprises were able to take a lot of material from the closed Little Rock location to make the place look much like it did in the restaurant's heyday.

It closed briefly in 2008 but reopened under the ownership of Star Buffet once again. The interior was completely restored at that time. Spokeswoman Kathleen McDole told the *Tulsa World*, "We want to open it right. We feel honored to bring this back to fruition. We want to make it the way people remember it the best we can." The new general manager had worked at Casa Bonita as a teenager as his first job. When the doors opened in August, the line went out the door.

As excited as everyone was to re-live their childhoods and share the Casa Bonita experience with a new generation, it was generally felt that the food had not aged well. Many who were new to the experience didn't understand what all of the fuss was about. Sparse advertising and lack of ongoing maintenance caused business to dwindle.

In early 2011, Star Buffet had some financial troubles. The restaurant closed in late January due to a severe snowstorm and never reopened. On February 17, the *Tulsa World* reported that a sign had been posted on the door that read, "We thank you for your years of visiting and dining with us. We are sorry to say that we are closed for business."

The restaurant was then turned into a nightclub called the Caves and opened in April 2012. The owners kept much of the decorating theme *and* the kitchen, advertising itself as "three clubs in one building." The turnout was huge, with nearly one thousand people showing up the first night. It was rebranded as Club Rio a few years later but had its share of problems, including a shooting and a DEA raid. In spite of that, it remained popular until it closed in 2017.

As of 2018, former employees were seeking investors to reopen Tulsa's Casa Bonita once again. The Lakewood, Colorado Casa Bonita is still in business and has been designated as a historic landmark in the city.

CRYSTAL'S PIZZA & SPAGHETTI

Crystal's was another restaurant that didn't start in Tulsa but became a much-loved family eatery. Not coincidentally, it was founded by Bill Waugh, the same man who started Casa Bonita in the same shopping center. The

Crystal's Pizza & Spaghetti. *Courtesy of Linda Kelley.*

original Crystal's was in Abilene, Texas; the Tulsa location at 2187 South Sheridan Road opened in March 1975. Like its restaurant kin, it was a huge space: seating for three hundred in a fourteen-thousand-square-foot facility. It also mixed food and entertainment in a way that made children want to return again and again.

"Our management believes that eating out and entertainment are either-or choices for many families," manager Dwayne Marrs told the *Tulsa World* a few months after opening. "We try to give them both."

The whole place had a turn-of-the-century grandeur. Diners walked in and were greeted with antique furniture, a gazebo, wrought-iron balconies and even an aquarium with a glass-enclosed gasoline pump. One wall sported an impressive twenty-five-by-nine-foot mosaic tile mural of a New Orleans scene; supposedly, it came from a Borden's Cafeteria that occupied the same space years before. The employees referred to the row of booths beneath it as Bourbon Street.

The restaurant was set up with speed in mind: pizza could be delivered in ten minutes, which was a big deal in the mid-1970s. In addition to pizza, Crystal's served sandwiches and spaghetti. A salad bar was available, as was an ice cream sundae bar where kids could pick out their own toppings.

Live entertainment featured piano players, singer Hank LaCroix and Whiskers the Clown. The Theater Room featured Looney Tunes cartoons and old movies, and the attached arcade gave kids something to do when they were finished eating. On the weekends and Thursday evenings, Wiley Coyote (not to be confused with the Warner Bros. character, of course) danced and entertained the youngsters.

As you might imagine, all of this added up to a lot of business. Crystal's employed more than seventy people. Waiters were equipped with two-way radios to help customers find available seating during their busiest times. "Most of us were high school students," remembered Michael Harbour. "We were totally committed to excellence, to fast, friendly service, and top-quality fresh food." Even today, former staff members keep in touch. "We loved each other. We loved the managers. We loved what we were doing. It was an amazing season in our lives," Michael said.

Michael wasn't the only one that felt that way. "We were required to answer the phone by the second ring," added Linda Kelley, another former employee. "It didn't matter if it was swamped and the line was out the door." She fondly recalled the times she and her co-workers visited the Children's Hospital in costume.

Wiley Coyote during a car show in the parking lot at Crystal's Pizza. *Courtesy of Linda Kelley.*

Crystal's remained popular throughout the 1980s. Due to the increased demand for delivery and high amount of competition in Tulsa, Crystal's closed in July 1995. Many items, including the iconic sign, were auctioned off.

Over the years, many Tulsans have inquired about the seventy-year-old tile mural of New Orleans that used to hang in the restaurant. It was displayed in a Burger Street Café in Richardson, Texas, for many years but its current whereabouts are unknown.

NINE OF CUPS

The name "Nine of Cups" brings to mind tarot cards and fortune-tellers. According to the menu of the restaurant that once sat near 17th and Boston, it came from an ancient symbol of feasting, merriment and the fruit of success and benevolence.

The restaurant was planned and built by a group of friends from the University of Arizona: Robert Crockett, Bryant Burns and Timothy Stillwell. For financial assistance, they brought in Faust Bianco and Callie O'Keefe to help. They chose Tulsa because it had a "beautiful downtown that people should enjoy" and the city was noted for its affluence and sophisticated, cultured tastes. "We all come from the east and you can't enjoy downtown sections in our cities," Bianco told the *Tulsa World* in 1975.

They turned the back half of the old Safeway grocery store at 48 East 17th Street into a unique dining hall. Robert Crockett was a chemical engineer-turned-carpenter and cut the railing designs by hand. The ceiling was raised to make room for a balcony. The lamps were designed and made by the employees. The ceiling beams and bar were both oak. A giant aquarium separated the bar section from the restaurant side. All-in-all, the dark wooden booths and tables seated about 175. "We made everything but the rugs and chairs," Crockett recalled. Connie Cronley of the *Tulsa Tribune* described the place as "snug as a hobbit's den."

When the restaurant opened on Friday the 13th of April 1973, Bianco said it was "to show that we aren't superstitious." The place was perpetually busy, yet the direction of the menu morphed multiple times over its life span.

"We started as a gourmet restaurant with emphasis on vegetarian foods, but we've become a sandwich and steak place," said Bianco a few years after opening. "We're all into health foods and meditation, but I now find myself eating meat like mad. We're trying to temper the ideals of youth

Nine of Cups from Boston Avenue. *Courtesy of Joe Kifer.*

with the practicalities of reality." Great attention was paid to the quality of the ingredients; the turkey was roasted in-house, and the pastrami came from Chicago. Sarah O'Keefe, Callie's sister and their first cook, established many of the recipes that became traditions at the Nine of Cups.

The menu stated, "All that we serve was created for your enjoyment entirely by our own hands. We strive to be unique, original, and something out of the ordinary." As such, the dishes had creative names. The Abundance was a ham-and-turkey sandwich with two cheeses, tomato and onion topped with sour cream and "grilled with diplomacy." The Well Being was a hamburger, covered with sour cream and Swiss cheese, topped with sliced mushrooms. If you ordered the Perfect Contentment, your server delivered a New York strip.

Some of the restaurant's other specialties: Wheel of Fortune (a cheeseboard of six varieties, salad, homemade bread and fresh fruit) and the Nine of Cups sandwich (ham, turkey, swiss and American cheese, tomato, sour cream and onion). Tabouli was a popular side, and homemade ice cream was on the menu for dessert.

The recipe that people most often requested was the Potato Supreme. Bianco admitted to the *Tulsa World* that the recipe was a "vegetarian survival dish" that was born during the building phase of the restaurant, an easy meal that that didn't cost a lot of money. Measurements weren't exact, either; the cooks were said to be guided "by vibrations."

When the restaurant opened, the owners hoped that it could help bridge the generation gap; the lunchtime crowd was mostly business-oriented, but in the evenings the place came alive with young energy. The story of Nine of Cups cannot be told without mentioning the Devil's Triangle. That is, three establishments around 18th and Boston that formed a musical and counterculture union: Boston Avenue Market, Magician's Theatre and the Nine of Cups.

Nine of Cups had a stage for live music built on top of a walk-in refrigerator. It was added as an afterthought but turned out to be a great idea; the jazz nights packed the place out. It was said that it was Eric Clapton's favorite place when he came through town. Mike Bruce, J.J. Cale, Leon Russell, the Gap Band, Emmylou Harris, Arlo Guthrie—there's no telling who you might bump into.

"It just happened," recalled Joe Kifer, a former kitchen manager and one of the first hires at Nine of Cups. "Magic just happens. Everyone tries their best to make it happen, but for magic all the pieces just have to fall together." He started as a dishwasher shortly after opening and quickly worked up to kitchen manager. He received the keys at nineteen years

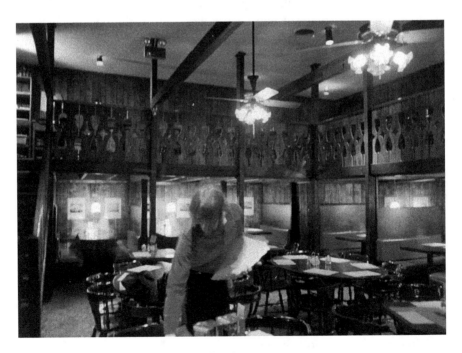

Interior at Nine of Cups. *Courtesy of Gene Pounds.*

of age because "I was the only one that would wake up in time to let the delivery guys in!"

He fondly recalled how the owners didn't care what you did as long as you did your job. There were often gatherings in the alley just outside the kitchen door, where employees and customers of like minds mixed.

"There was a whole world in that alley. All of our regulars knew about the kitchen door," Joe remembered with a laugh. "All the employees liked each other. It was so different than anything that had ever been here before, the public wanted in, too."

One night, Kifer was in the kitchen and looked out the window to see a stream of water coming from the aquarium. The bass player from the band on stage had hit *just* the right note, putting a hole in the aquarium. Its contents were pouring right onto two suit-and-tie customers. "We immediately came running out of the kitchen with bowls of water, trying to pick up fish." The aquarium was then converted into a terrarium, which Joe admitted "wasn't very impressive."

By 1983, Nine of Cups was owned by the Fazzani Bianchi family and had evolved once again. Although sandwiches and American foods were served during the lunch rush, at night, it transformed into a gourmet Italian experience with recipes that had been handed down through the Bianchi family. The matriarch was said to visit the kitchen once in a while to ensure the family recipes were still old-world authentic.

Nine of Cups closed in 1989. As of 2018, the old gang and a few of their loyal customers still get together for reunions.

RAZOR CLAM

When a little pancake house was built at 2777 South Memorial in the early 1960s, nobody had any idea that the site would become home to one of the most well-known fine-dining experiences in Tulsa. In 1973, the pancake house was gone and the Razor Clam opened.

George Suppes opened the Clam with chef Rick Kamp. Rick had been cooking since he was a child at his grandfather's grocery store in Oklahoma City. He worked alongside world-class chefs at the Cellar Restaurant and Chez Vernon before being lured to Tulsa by George, who wanted to create a dining experience unique in the city. Together, they offered one of Tulsa's first tastes of upscale French cuisine.

Rick brought with him several waiters with whom he'd worked in Oklahoma City. George gave him a wide berth in creating the experience at the Clam. "He treated me like a son, or a brother. He allowed me to use any product that I could purchase. If I wanted to use Irish salmon, I could get that brought in. Squab, rabbit, all this stuff." Anything was possible. "With that type of backup, you don't have anywhere to go but forward." Each day's menu was written on a blackboard, allowing day-to-day changes to fit the weather and seasonal changes and the chef's mood.

The goal was for people to "get involved and actually discuss the meal instead of who won the last ballgame," said George. "We tried to have things that were interesting in and of themselves." He was happiest when people shared food with one another at their table because it was so good. It encouraged people to surprise themselves with something new. Above all, George was committed to providing truly fine service:

> *It's not just putting a bow tie on somebody and telling them to be nice to the customers. They need to know what to do and how to do it. If we were going to do something, we were going to do it* correctly. *You would be taken care of. One of the things that* [one of the waiters] *Billy did one time…we kept fruit around. A lady saw an apple that she wanted, so he went over, got it and brought it to her. But she said, "Oh, yes, but I eat my apples peeled." He took a knife and fork and peeled this apple without breaking the skin and presented it to her. That's just an amazing thing to have happen and have people with talent to do something like that. Like it was no big deal.*

Shortly after the restaurant opened, Rick was working in the kitchen when he heard a knock on the back door. He opened it to find himself face-to-face with a freckled girl named Maurie Short. "She said, 'I've just gotten out of the Le Cordon Bleu in London, and I want to come here.' I told her to come back tomorrow and bring her favorite dessert…and she came back with a crème brûlée." Maurie's dessert became a signature dish at the restaurant. "That recipe is forever and always," Rick said. "To this day, I have not tasted one as good as hers."

White linen adorned the tables, which were topped daily with fresh flowers. Antique chairs were set about the dining room, and an English standing desk served as the host table. Metalwork from New York City hotel elevators had been fashioned into doors near a distinctive light fixture from an East Coast library. The décor established the Razor Clam as a special place for celebrations and a fine meal.

Inside the Razor Clam on Memorial. *Courtesy of the* Tulsa World.

Rick left the Clam in 1977 to pursue some of the many consulting opportunities that came his way due to his success. He didn't stay away from Tulsa long, however. The next year, James Leake Jr. purchased the Razor Clam from George Suppes. Jim asked Rick to come back and become a managing partner.

"It was a hobby, frankly," Jim remembered. Jim practiced law and he liked to cook. So did the rest of his family; he had essentially grown up in the food industry. He was a customer of the Clam and, when it became available, figured, "Why not?" It had become one of the premier dining locations in the city. With the oil industry going strong, it got even better.

"Our mission statement, if we'd had one, would have been 'Fresh ingredients cooked in traditional recipes.'" Fresh cod came from Turner's Fishery in Boston, and the halibut came from the West Coast. Veal came from a dairy farmer in Wisconsin, and the occasional game came from local farms. Fresh Dover sole was flown in from Calais, vegetables were sourced from local producers and truffles came from a farm in Miami, Oklahoma. Jim even flew Rick down to the Stilwell Strawberry Festival to get fresh fruit and bring it back for a night's dinner service.

In addition to fine food like roast duckling or veal scallops, people came in just to be waited on by people like Gerard Campbell. Gerard was a charming, worldly Londoner that had come to Tulsa in 1974 and ended up staying. In those days, the oil industry was booming. "These men, Texans or something, would come in and give $100 to everybody in the restaurant, including the dish washer," Gerard told the *Tulsa World* in 2010. Rick remembered Gerard fondly: "He was an 'English' 'gentleman', *both* words in quotations. He could've been a politician. He could talk to anybody. He was just perfect." Rick spoke of several longtime staff members who all brought their own flair to the restaurant. "I can't tell you how many fun times we had."

Jim was keen on ensuring the restaurant was not a pretentious place. "We had no background music, singing and dancing. It was a place to come and bring people you want to be with, have a fine meal served in a very fine manner, and just have conversation," he said. He also insisted that the chefs did not run the restaurant. Every Thursday, they'd all sit down together, taste new recipes and make suggestions. "The waiters know how the food is received," Jim explained. "We're in the business to serve the customer, not the chef's ego." He remembered firing a chef in the middle of his shift, turning to an assistant and simply saying, "You're it."

At the Razor Clam, food was meant to be enjoyed. "I don't want it to look like a floral arrangement; I want to eat it!" Jim said with a laugh. As casual

an attitude as Jim had toward the food, it was just the opposite with the wait staff. Waiters wore a baker's apron and they were to be spotless at all times. Two waiters were assigned to each table; each one of them had an under-waiter, which allowed each plate at a four-top table to be served all at the same time. And nothing was *ever* brought to the table on a tray.

The Razor Clam also offered an unparalleled wine selection. George Suppes was a wine connoisseur, a tradition that continued under Leake. Jim had done a good deal of business in the United Kingdom; he had contacts that kept his wine cellar stocked with remarkable vintages. "The oldest wine I ever served was a 1795 Madeira. I bought a case of 1902 Lafite Rothschild, which was a wine offered on the *Titanic*," Jim said. He was most proud of a write-up that the Razor Clam received in the *London Times*, thanks to visiting author Germaine Greer. She said it was the best wine cellar she'd seen in her entire life. "Right here in the middle of nowhere," he said with pride.

The Leake family also owned the local ABC affiliate and would often entertain VIPs and visiting executives looking for a meal comparable to trendy New York or Los Angeles restaurants. Preachers came in to entertain visiting guests and donors. Jim kept sets of opaque glasses in the back and poured out of sight so that they could drink wine and not be criticized.

Since liquor-by-the-drink was not yet legal in Oklahoma, it was a tricky proposition, but the Clam rarely got into trouble. "Local law enforcement dared not interfere with operations," said James Leake III, Jim's son. "The political fallout would be too great." It contributed to a somewhat speakeasy feel of the place. The Clam also appealed to people from out of town, as Rick Kamp explained: "One night, Gerard came back and said, 'Ricky, can we do a party of twelve to fourteen, late, for a friend of mine?' I said sure, and after everyone else had gone in walked Willie Nelson and Leon Russell." Rick cooked up what he calls the Guthrie Pan Fry, a gourmet version of a chicken-fried steak. He served it with corn on the cob (complete with nails stuck in the ends) and a loaf of bread. "It was Leon Russell that stood up and said, 'Let me tell ya, that was worth waiting for.' Willie looked up and said 'Leon, you're always waiting to eat!'"

Jim Leake described his restaurant as an "expense account restaurant." The Clam did well when the oil business was booming—but when it went bust in the 1986, business didn't recover. The Razor Clam closed that same year. Jim said, "It was my dream, not anybody else's. We had a big final week, said goodbye, and shut 'er down." But he wasn't bitter about it; after all, he originally approached it as a side project, and "We had a lot of fun and we educated a lot of people with our food."

George summed up the Clam as a place "that would take care of you. There was a purpose behind what we wanted to do, and we accomplished that." Jim Leake Jr. was proud of the restaurant's place in Tulsa's history, and his food philosophy remained simple: "Christmas ain't promised; eat dessert first."

AL GEBBS' RESTAURANT

Alfred H. "Al" Gebbs Jr. was born and raised in New Orleans, Louisiana. Al learned the art of Creole cooking from his father, who was a chef on a ship that traversed from the port city to Cuba before the embargo. After serving in the U.S. Marine Corps, he moved around a bit with the Price-Candy Company. He came to Tulsa in 1961 at thirty-six years of age. For many years, Al managed several restaurant properties in town, such as the Charl-Mont downtown and the Golden Horse at the Southroads Mall.

When the company asked Al to move to Washington, D.C., to manage a few restaurants, he decided that Tulsa was where he wanted to stay. He and his wife, Hazel, opened Al Gebbs' Restaurant at 3126 South Mingo Road in 1974. In the eleven years that Al Gebbs' restaurant operated, it was either Al or Hazel who seated customers and provided them with a complimentary glass of rosé wine. Since he wasn't *selling* it, he couldn't get in trouble with the ABC Board.

The interior of the restaurant transported you to the French Quarter with its iron grillwork and low jazz music. Advertisements placed Al Gebbs' restaurant on the "beautiful Bayou Mingo." The décor was red and black. "We always had tablecloths and cloth napkins," said Sandra Combs, one of Al's daughters. "That was very important to him." One long wall was entirely *covered* in business cards.

The menus boasted, "Delicious food, prepared from old recipes and served with honorable intentions." Al took his knowledge of Cajun cooking and shared it with a city that hadn't really experienced Creole cuisine before. The *Tulsa Tribune* remarked, "Incredible. The flavors of the beans, rice, and sausage do not just go together. They go together and make music." There was a standard menu featuring dishes like jambalaya and fried frog legs in addition to a chalkboard with daily specials.

Sandra smiled as she mentioned gumbo was one of her father's favorite foods to prepare. Al's gumbo was highly respected; chock-full of okra, rice

and shrimp with a taste that could not be replicated. Jambalaya and veal cordon bleu were always on the menu. More than thirty loaves of French bread were baked daily. There was only one noticeably non-Cajun meal option on the menu: chicken-fried steak. It was "one of Gebbs' concessions to survival in his adopted city."

Al was known to walk the floor in his white chef's jacket and hat, which matched his white goatee handsomely. "Al was such a monstrous personality," remembered Glendon Combs, Sandra's husband. He would command any room he was in. "He was a barrel of a man," Glendon continued, mentioning that Al had been a championship boxer in his Marine days. But he was mostly known

Al Gebbs working in his kitchen. *Courtesy of the* Tulsa World.

for his sense of humor and his southern Louisiana accent. That and the expensive cigars he always smoked. "When you walked in, Dad would give a huge greeting; everyone was special."

Al Gebbs' Restaurant held an elaborate annual Mardi Gras celebration. The staff wore costumes and music was provided by a live Dixieland band. One of the jazz bands that played there included a man named Larry Reasor, who would later be better known for his chain of grocery stores. In October 1984, Gebbs held a celebration to coincide with "Oklahoma Day" at the world's fair in New Orleans. Al himself appeared on local television dozens of times, providing tips on how to prepare meals the Louisiana way.

The 31st and Mingo area flooded badly a few times in the early 1980s, including the memorable Memorial Day flood of 1984. Glendon remembered there being three feet of water inside the restaurant. Although they cleaned up and reopened, the costs (compounded by significant street construction) were enough to close Al Gebbs' restaurant in late 1985.

Al himself stayed busy, though. He wrote an occasional column for the newspaper and taught cooking classes. Much of his time was spent at Ted's

The menu at Al Gebbs' Restaurant. *Courtesy of Sandra Combs.*

Pipe Shoppe, where he worked well into his eighties. Al passed away in 2013. "I still try to replicate some of his recipes, but there's always something missing," Sandra said. Her son's recommendation? Smoke a cigar while cooking; it would truly replicate the Al Gebbs process.

ARGENTINA STEAKHOUSE

Roy Human was born in Deer Lodge, Tennessee, in 1933. After serving in the U.S. Army, he moved to Venezuela and Trinidad, where he sold oil field equipment. There, he met his wife, Jaine, and started a family. In 1969, they moved to Oklahoma after eleven years in South America.

In 1970, Roy opened the Argentina Steakhouse in Okmulgee with his partner, Charles Epperson. "It was in an old car showroom," remembered Jaine, "which made a fairly nice restaurant with lots of windows and great, big heavy brocade drapes. Everything was very ornate in those days." It was a successful venture, but they wondered how much more successful it would be in a bigger town. Roy and Charlie stood in the parking lot from time to time and took note of the license plates with Tulsa County prefixes. After a few years, they closed that restaurant and moved to Tulsa; the Argentina opened at 5960 South Lewis Avenue in late 1973.

The interior of the Argentina was very welcoming and reflected the influence of Roy's time abroad: cedar wood paneling, brick walls and wagon-wheel chandeliers. Each table was surrounded by high-backed Spanish-style chairs; a fireplace added a nice touch in the center of the room. The atmosphere beckoned for diners to linger a while after their meal was finished. The tables themselves had a signature feature: a grill in the middle of the table. This unique addition really set the Argentina apart.

After a time, local restaurateur Basil Blackburn joined the operation as a partner. "Tables were about five feet long on each side," remembered Randal Blackburn, one of his sons. "In the center of each table was a two-by-two-foot square grill with a diamond-shaped pattern and a large electric coil." The heating coils had been designed by Roy Human back in his oil field days. The steaks were served to the grill directly, keeping them hot throughout the meal. "You were to cut off parts of your steak and move it to your plate, which was a wooden board with a glass insert," Randal continued. The idea was that your last bite of steak would be as hot and delicious as your first.

"You cannot believe how big everything was in proportion to how everything is today," recalled Jaine Human. The filet cut of steak was twelve ounces while a "sirloin for two" clocked in at thirty-two ounces. In addition to top-grade steaks, the Argentina had several other specialties like the Parilla Argentina (sirloin steak, sausage and a smoked pork chop). There was a large salad bar with a wide variety of options, all made fresh in the kitchen. Every meal was served with Golden Crescents—that is, golden fried

empanadas made of imported Venezuelan cornmeal. The ground meat inside was seasoned with Tabasco and other spices, giving it a "zippy" flavor. The empanadas were so popular that the restaurant imported cornmeal by the ton.

The Argentina served battered steak fingers, too. They quickly became a beloved item, as evidenced by a 1978 *Tulsa World* review: "We fell in love one afternoon with a plateful of ribbon steak fingers ($3.25), tender strips of round steak fried to perfection. Just enough pepper and a touch of garlic to make them superb. Those, and the creamy frying pan gravy and biscuits, brought back memories of grandmother and her pot-bellied, wood-fired stove in a yesteryear farm kitchen."

"We had two big rooms; they'd be packed every Friday and Saturday night," remembered Basil Blackburn. "We never did a waiting list over the phone; you never knew what time they'd actually get there. People would be standing in the hall and waiting." He took pride in the fact that the same parties returned to the Argentina time and time again.

"One rule I insisted on: you *will* be to work on New Year's Eve or you don't have a job." Basil recalled one New Year's Eve when a cook didn't show. The cook was fired and Basil went to work. "I had to cook steaks in the kitchen all evening, good clothes and everything. I was still cooking steaks at two in the morning! I didn't mind, though," he said with a smile in his voice.

Basil was very involved in several youth organizations like DeMolay International. In 1977, he noticed the Highland Park chapter was struggling with funding and had an idea. He worked out a deal with Roy and Charlie and built an Argentina booth for the Tulsa State Fair. "They built a sixty-by-thirty-foot booth in a prominent location inside the IPE Building. It was huge and it matched all the dark brown, black and red leather of the dining rooms at the Argentina," Randal explained. It was hugely popular, increasing the DeMolay group's fundraising more than tenfold. Basil ran the booth at the fairgrounds for nearly twenty years.

Eventually, Charlie split off to run an Argentina branch in Fort Smith, Arkansas. Basil opened the Steak Finger House at 33 South Sheridan Avenue in 1981. It was focused on quick service, with the popular steak finger recipe he'd developed at the Argentina as the prime seller. That location eventually moved downtown; it was still running strong when Basil retired in 2015 at eighty-nine years of age.

In 1985, the combination of increased competition and a lagging economy brought the Argentina Steakhouse to a close. "After fifteen years and no vacations, it was time," said Jaine. "Our son said we had to get out of the

restaurant business so he could see the ocean!" Roy and his family moved to Kentucky, where he lived for nearly thirty years, though he never reentered the restaurant business. Roy Human passed away in 2014.

Both the Blackburn and Human families are proud that their legacy continues today with fond memories of the Argentina and a dining experience that has never been replicated. "Roy was a wonderful man, easy to have with you," said Basil Blackburn. "He would always back you on anything you wanted to do or a choice you wanted to make. He was a great man." Jaine said Roy talked about the restaurant until the day he died. "He loved the restaurant business. It was his baby, and he always talked about it, no matter what else he did."

MY PI PIZZA

My Pi Pizza didn't start in Tulsa, but it quickly became a local icon. In 1971, Larry Aronson opened the first My Pi in Chicago across the street from Loyola University. He figured the students would appreciate the double meaning of the mathematical symbol. It was so successful he started working to open franchise locations with local people in faraway cities.

The second location, a franchise in Miami Beach, Florida, was one of the first deep-dish pizza restaurants ever opened outside of the Chicagoland area. The third My Pi, opened in November 1974, was in Tulsa at 5936 South Lewis.

The restaurant was run by Harvey Chozen, a local broker who worked with Larry. Larry visited often from Chicago to check in. There was a high bar of expectations for employees, one which set many of the My Pi managers on a path of future success. One in particular, Billy Bayouth, went on to own several restaurants of his own, including Billy's on the Square, which still operates in 2018 at Fifth and Main downtown.

The sign next to the front door at My Pi was a large wooden paddle, just like the kind used in a pizza oven. The doors themselves were made from heavy maple wood; a thick golden pi symbol served as the handle. Inside, the walls featured natural cedar paneling and stained glass. The fireplace, which stood in the middle of the room, was built out of "common" Chicago-style brick that had been reclaimed from demolished buildings in the Windy City and shipped to Tulsa. Larry designed and built the fireplace himself.

Larry Aronson at the opening of My Pi Pizza. *Courtesy of Larry Aronson.*

The lights that hung around the dining room were Tiffany replicas made of beautiful glass. An artist from Denver named Frank Swanson carved two-dimensional redwood versions of marble sculptures, which were placed around the dining room.

The Hi-Fi sound system was such a big deal that the menu had a section that talked about it. The Pioneer amplifier and Bose speakers were installed by Imperial Sound of Tulsa. The speakers were hung from the ceiling and aimed in such a way that the sound resonated off the walls, creating a more ambient tone. The music played from a reel-to-reel tape deck with a selection that varied from contemporary rock to jazz to classical; Larry had curated the twenty-hour selection personally.

The pizza itself was unlike anything anyone had ever seen served in the city. For many Tulsans, it was the first time they'd experienced deep-dish pizza. The menu set the proper expectations: "Our pizza is unique. It is more similar to a quiche than a pizza. It is made to order and takes approximately ½ hour to bake.[...]So relax and enjoy yourself—we think the wait will be worthwhile."

In addition to the style, the ingredients set the food apart from everything else in town. The restaurant baked its own bread and made sausage in-

The brick fireplace and interior of My Pi Pizza. *Courtesy of Larry Aronson.*

house. The flour was obtained in Kansas, the tomatoes were grown in California, and the cheese in every My Pi location came from the same Wisconsin dairy.

All of the food was served on china rather than the paper plates common in other pizzerias of the time. Drinks came in frosted glasses "to chill the beverages properly." It was such a big deal that, according to Larry, Wichita-based Pizza Hut flew people to Tulsa to see what deep dish was all about.

Business was good, but a few challenges cut the time of My Pi in Tulsa short. The terrible Memorial Day flood of 1984 caused the nearby Joe Creek to leave its banks. The water caused significant damage, especially to the magnificent maple doors. Harvey Chozen sold the restaurant to a new owner, and according to Larry, things just weren't the same.

Though the My Pi franchise expanded to two dozen locations across the country at its peak, Larry began to draw back in the mid-1980s. The Tulsa store closed in 1986; all other remaining franchised locations folded by the early '90s. Larry instead focused on his hometown; his son, Rich, runs the last operating My Pi Pizza in Chicago.

The menu had a simple philosophy printed on it that summed up the experience: "Pi is the mathematical symbol for 3.1416—it is used to compute the circumference of a circle. A circle is considered the perfect shape. We hope that what we are presenting you is as close to perfection as we can possibly attain."

THE FOUNTAINS

In October 1974, a new chapter in fine dining started in Tulsa. The Fountains opened at 6540 South Lewis Avenue, managed by Bill Hensley. The design of the building was meticulously planned, featuring a pond in the front with three picturesque fountains, from which the restaurant got its name. A terrace was built over the water and offered a unique dining atmosphere.

In addition to the terrace, which contained the most coveted seats in the house, the extensive dining hall was stunning. The dark wood walls and stone trim were in a class of their own. Waiters matched the décor and wore full suits, while managers wore tuxedos. Live piano music was offered in the evenings, and occasionally, a singing trio appropriately called the Three Coins performed.

The menu offered delicacies like Roast Duck à l'Orange, Veal Oscar and Broiled Swordfish. William had also purchased the famous Brown Derby recipe from Bishop's Restaurant and claimed to keep it in a safe. "We had a man who cooked for Bishop's in the 1940s train our cooks," he told the *Tulsa World* in August 1975. The Mushroom Whatnots (mushroom caps filled with "a variety of cheeses, spices and whatnot") were especially popular.

After a strong start, the Fountains began struggling. In 1976, the owners were looking to turn things around. David Ingram, a restaurateur and Tulsa native, had just moved back to the city. Dave had graduated from the Oklahoma State University Hotel and Restaurant School in 1964 before gaining experience in restaurant operations in Kansas City and St. Louis.

"It suddenly dawned on me that I had been away from Tulsa and my family for sixteen years. I had a longing to return and stop traveling. I was tired of flying in airplanes nearly every week and staying in hotels," he told the *Tulsa Tribune*. When he discovered the Fountains restaurant on Lewis Avenue was for sale, he jumped in with both feet. "I went down to the Guaranty National Bank and talked to the president," remembered David. He purchased the Fountains in March 1977.

Table setting with a view at The Fountains. *Courtesy of the* Tulsa World.

Although it eventually became known as his flagship restaurant among several, it took a lot of work to turn the operations around. "Food was uninteresting, the décor looked like a funeral parlor, and waiters vied to wait on rich customers, leaving other people waiting." He changed the staff's dress code to be a little less formal without losing the elegant edge that the Fountains was known for. He also started coming in at 6:30 a.m. to make sure everything was in order.

The menu was enhanced by adding dishes such as roast duckling, rack of lamb, escargot and spinach salad. For the first two years, David personally inspected every dish that left the kitchen. He had strict rules about cooks following the exact recipes and held them accountable when they strayed off-course. "We had one cook who seasoned to his own taste. He is no longer with us," Ingram told the *Tulsa Tribune*. Fresh seafood was flown in twice a week from Boston and New Orleans.

David added hanging baskets of greenery, introducing more color to the dining room, and evaluated the wait staff. "In the first six months, I replaced 90 percent of the old employees," David admitted. Within eighteen months, the restaurant had not only returned to profitability but also became known for providing world-class service.

Jim Sellers joined Dave in 1978; they'd worked together in Missouri and operated restaurants in a very similar fashion. "It was a great showplace," recalled Jim. "I remember one Mother's Day I was standing near the end of the buffet line. I turned around and found myself face to face with Donna Reed!" He noted that celebrity visitors of all kinds often found their way to the restaurant due to its reputation.

Though the terrace remained popular, Ingram enclosed it with glass in 1979. He cited Oklahoma's fickle weather as the reason and noted the coveted seats would be comfortable throughout the year with this upgrade.

In 1983, the recession hit and Ingram began transitioning ownership of his restaurants. The Fountains ownership transferred to manager Ugur Sahinalp (known by most as Orr Nalp) who had been working at the Fountains since it opened. "I met Orr the day I met with the [original] owners," David said. "Very polite, very distinguished...just really a good man. A great man, actually. I love him like a brother." Orr had been offered a position at a new restaurant in town, and David, eager to keep his expertise, sold the Fountains to him to keep him.

Orr Nalp ran the restaurant successfully until 1997, when he sold it to focus on his catering business. Although the Fountains continued for almost another decade, for many Tulsans, it just wasn't the same. It closed in early

2006. The popular Mushroom Whatnots can still be found at the Artichoke Restaurant at Grand Lake, owned by Jim Sellers.

"There were nights when, after everyone else had gone, I'd stand in the dining room and tears would just come to my eyes," David Ingram remembered fondly. "I was so thankful for what we did. It's the old American story of rolling up your sleeves and getting to work. I felt we did an extremely good job. It was a dream come true."

THE MIDDLE PATH

After the famous Golden Drumstick restaurant closed at 4903 East 11th Street in 1975, the future of the site was uncertain. Salvation came from a young couple who saw a great opportunity in the faded landmark. Although neither Steve nor Mary Housel had any restaurant experience aside from waiting tables, they took the closed eatery and turned it into the Middle Path Café. The name came from Steve's time studying philosophy and religion at the University of Tulsa. "Middle Eastern religions mention the middle path between rivers," he told the *Tulsa World* in 1976. "We wanted to give people an alternative in restaurant food without being rigid."

Renovation wasn't easy; it took ten months of difficult work. The ceiling was sagging and the equipment needed some heavy cleaning; years of chicken grease had built up on the ventilation hood over the grill. "Two men with a steamer worked that vent hood for eight hours and the grease just poured off," Steve recalled to the *Tulsa Tribune*. Most of the restoration was done by the Housels or their friends personally. The dining area was trimmed with various woods and filled with custom-built furniture. Steve's father made several impressive stained-glass grow lamps for their greenery and hung them from the ceiling. Friends crafted hand-drawn posters, curtains, macramé plant holders and quilted pillows. The Housels' goal was to provide a second home for like-minded people. Steve elaborated:

> *I don't think it had to be a restaurant…it was in its way, I don't know if counter-cultural is the right word to use. The people that worked there, in the kitchen and in the dining room…were all scratching around trying to figure out what to do with their lives. Whatever the status-quo roads were, they weren't wanting to be on those. They didn't know what to do except love each other and help each other.*

The Middle Path at 11th and Yale. *Courtesy of the John Margolies Collection at the Library of Congress.*

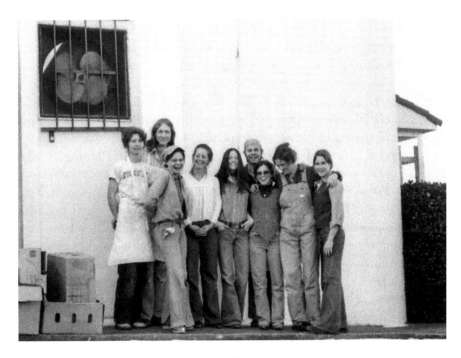

The crew at the Middle Path. *Courtesy of Steve Housel.*

By the time the restaurant was ready to open, the neighborhood was bursting with curiosity. "When there are young people with long hair and non-conventional dress going in and out of the place," the rumor mill spins into overdrive, explained Steve. "There were hundreds of people wanting to get in there and see what was going on." The Middle Path opened for business in July 1976.

The menu offered homemade soups, salads and sandwiches. Although it wasn't entirely vegetarian, it highlighted fresh vegetables, fruits and whole grains over red meat and processed sugar. "Our standards were three: nutritious, tasty and fresh," Steve said. "It doesn't mean you're forced into the status quo…it means that you've gotta have the chops to find that great little recipe." They used all-natural ingredients and made everything from scratch, including their yogurt. They even grew their own alfalfa sprouts; Tom Butcher from the nearby Impressions restaurant would purchase his from their stash. The food was designed to be beautiful as well as delicious; Steve's goal was to "make a picture" out of each dish that left the kitchen.

Steve and Mary wanted the working environment to be as pleasant as the dining experience. They offered every employee "commissary privileges," which allowed them to buy anything the restaurant stocked or ordered at cost plus 10 percent. They offered health insurance to full-time employees with management paying 50 percent of the monthly premium, a benefit unheard of in the restaurant business at the time. The restaurant even featured one of the first non-smoking sections in town.

Business was booming in the early 1980s. The oil industry was doing well, which translated into more people eating out. Steve estimated the restaurant served more than four hundred people day, and it wore everyone out. As the owners, they worked seventy hours a week to keep up. Though it was exhausting, the work was also fulfilling. The restaurant hosted benefit dinners for people like journalist Frosty Troy to talk about nuclear disarmament. The Middle Path had become the haven that Steve and Mary set out to provide.

The recession had an impact on business. Competition was on the rise, too, and many people considered 11th and Yale to be a dying part of town. "Another thing that hurt us is the image of being a health food restaurant," Steve Housel told the *Tulsa Tribune*. "We never called The Middle Path a health food restaurant. What we offered was fresh food made from scratch. We were interested in nutritional integrity, not in trying to change people's diets." The Housels worked for free to keep the restaurant open.

In February 1984, the recession became too much to bear; the Middle Path closed for business. On their last day, waitresses were taking pictures

with their customers. A spiral notebook at the cash register held names and addresses of well-wishers hoping for a reopening in the future. Tables were full of favorite dishes: corn potato chowder, black-eyed pea stew, tabouli and more. A single patron bought the last seven loaves of Hot Toddy bread to take home.

A cold rain fell from the sky as the last customer left the Middle Path. Steve and Mary sat alone in the restaurant overnight, reading the memories left in the spiral notebook. It had been a taxing but wholly worthwhile eight years. The closure was originally referred to as a "time-out" to monitor the recession. Seven months later, the Housels decided not to renew the lease. The fate of the stucco and glass Route 66 restaurant was decided shortly afterward.

The owner of the building, Harry Kravetz, told the *Tulsa Tribune* at the time that selling the site was a difficult decision: "It is sort of a landmark to me. I hesitated a little while, but business before pleasure. I had a few prospects interested in a restaurant, but I wasn't too enthused. I was pretty well satisfied when Circle K gave me their proposition. It's a good company, it's a good corner, and I wish them lots of luck."

"We're sad to see the building go," remembered Mary Housel. "And not just because of the years we invested there. It was a Tulsa landmark." Steve recalled the Golden Drumstick as the demolition equipment moved in. "It

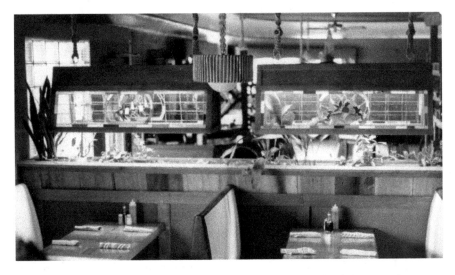

Inside the Middle Path; Steve Housel's father made the custom stained-glass grow lamps behind the booths. *Courtesy of Steve Housel.*

was *the* restaurant in town. People used to line up around the corner for chicken after church on Sunday."

Even the contractor supervising the destruction of the building was reluctant. "I had a birthday about every four months, just so I could go to the Golden Drumstick and eat," Jerry Clem told the *Tulsa Tribune*. Alas, on January 25, 1985, the home of two beloved Tulsa restaurants was razed. A convenience store stands on the corner today.

THE BAKERY ON CHERRY STREET

The Bakery on Cherry Street was the product of two dedicated women: Caroline Brune and Cheryl Dobbins. They met in graduate school at the University of Tulsa and found common interests in poetry, women's studies and the art of baking.

Caroline grew up on a farm outside of Enid. Her mother, Gertrude, had a home wedding cake business; Caroline began piping roses and finishing decorations at an early age. She didn't think about baking as a profession until she was studying English at the University of Tulsa. "I just started fooling around in graduate school, mostly cooking, not just baking, just kind of to keep my sanity, to do something that was earthbound. That was my release," she told the *Tulsa World*.

Cheryl Dobbins moved to Sayre in western Oklahoma at a young age. Books were her connection to the larger world; she also loved how the art of storytelling connected the community. When she moved to Tulsa, she found that baking was a great way to "balance the interests of research and writing with the physical world of food."

"When Caroline and I began talking about starting a bakery," Cheryl remembered, "we were told by a couple of old bakers that, 'Two girls can't do that. It's hard work.' That just sealed our determination." In November 1977, The Bakery opened at Seventh and Main downtown.

The place started by primarily offering donuts. There were four small handmade tables, which were often full. When they were able to buy a better oven, their selection grew to include breads, turnovers, sausage rolls and more. Classical music drifted through the air, intermingled with the scent of fresh bread. When they added croissants to the menu, it took things to a whole new level.

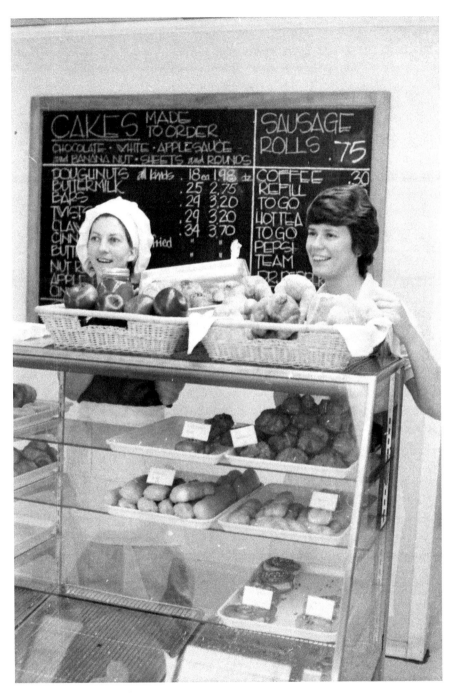

Caroline Brune (*left*) and Cheryl Dobbins at The Bakery downtown. *Courtesy of the* Tulsa World.

In the early 1980s, croissants weren't common menu items in northeastern Oklahoma. In fact, The Bakery only made them on Thursdays. Croissant dough takes a lot of time to make when done properly, especially when it's rolled by hand. As such, Thursday mornings started at 1:00 a.m. to ensure The Bakery had enough on hand to feed its customers. At first, people weren't sure what to make of the airy baked good. Once word got out, though, things got busy in a hurry, and it seemed like there were never enough.

"Some of our customers have a hard time trying to say 'croissant,'" Cheryl told the *Tulsa World* in 1981. "So they just mumble and point at what they want." Regardless of pronunciation, they were a hit. People walked from their homes half a mile away to stand in line to get a few. At one time, The Bakery's owners approximated, they made thirty dozen each Thursday. Friend Jan Stevens took bundles of them to the Williams Center to sell.

The Bakery was running strong when the building came up for demolition, so they started looking for a new space. After a long search, they settled on 1344 East 15th Street. "When we found that place, it hadn't been anything for a couple of years. A dry cleaners, I think. It was a little shabby, run-down building," Cheryl remembered. They even discovered that someone had taken up residence on the roof.

At that time, the area was just known as 15th Street. The "Cherry Street" name had been lost ever since the street was numbered in the early twentieth century. When Cheryl and Caroline found the original Cherry Street name listed on old city plats, they added it to their bakery and unknowingly helped start a revitalization of the district.

On October 19, 1982, they reopened and were immediately greeted by throngs of customers. "We had no idea how swamped we were going to be," Cheryl said, noting they had been closed for nearly a year since vacating their downtown space. She continued, "After several years of hard work, we were an overnight success!" The sense of community that came with being a part of a neighborhood was an important new ingredient in that success.

"I remember one day I turned around to see my dentist washing dishes in the kitchen," Cheryl continued. "Another friend was standing at the front counter bagging things up for people. Other friends worked for us when we needed it. It was just amazing; it was like the dream of a community spirit that I had wanted to happen. I have tremendous gratitude for people that cheered us on."

The Bakery became a sanctuary from busy city life. People were encouraged to stay as long as they liked, so many enjoyed their coffee while

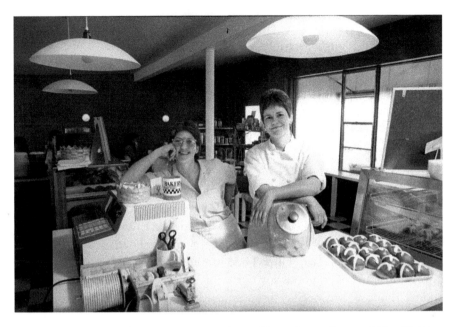

Caroline and Cheryl at The Bakery after moving to Cherry Street. *Courtesy of Cheryl Dobbins.*

reading the newspaper. "We had a lot of regular customers that became friends," Cheryl noted wistfully.

"Caroline was good at the process. She loved getting back in the kitchen and figuring out how to orchestrate things, so they got done at the right time," remembered her brother Carl. "She really had a knack for it." Cheryl explained, "When we developed recipes, we would get multiple sources. The books we found were written for home cooks, not anything professional. We'd look for commonalities, how to do it in a consistent manner, and how to teach it to somebody else."

"What we both really loved was that it really felt like a dance. As you're moving things out of ovens, and fixing something else, and preparing. We both really enjoyed the physicality, and teaching other people to be able to do that was fun," Cheryl said.

Hobo bread, coffee cake, ham-and-cheese sandwiches and cinnamon rolls were on offer for breakfast. Their morning buns were described as "what cinnamon toast would be if it had wings and could fly." The lunch menu expanded to offerings like French bread, pizza, soups and sandwiches. The working crowd came in and bought full loaves of bread to take back to the office. On Sundays, church-goers streamed in from the nearby Parish of

Christ the King. People camped out for hours with a good book, noshing on handmade croissants and drinking cappuccino.

By 1994, the increased popularity of the district threatened many restaurants with higher rent prices. The Bakery on Cherry Street was no different. "There have been a lot of changes in the last couple of years," said Caroline Brune at the time. She observed that many businesses along 15th Street were in the same position. The closing was positioned as temporary: T-shirts worn by staff exclaimed, "Yes, we're closing. Yes, we will reopen. Yes, we don't know when or where."

Caroline told customers that they would reopen at a new location when they found the perfect spot. They encouraged ideas from their patrons; an article in the *Tulsa Daily Business Journal* included a P.O. Box where readers could send suggestions. The Bakery on Cherry Street closed on June 19, 1994.

Alas, it never reopened. Cheryl had moved to the West Coast a few years prior. Caroline baked goods for the Wild Fork in Utica Square for a time and went into woodworking. She was also involved with the Tristesse Grief Center. Caroline Brune passed away in 2006.

A mention of the Bakery on Cherry Street today inspires a yearning—not just for the food, but for the people. "There were times after we opened on Cherry Street that I would go out after we'd gotten the basic morning baking done and say good morning to the people in the front," Cheryl recalled. "I'd be on the verge of tears; I felt so grateful for all the people that were there and supporting us."

"Caroline was really brilliant at isolating the right recipe and making it very well. Everything was just *good*," remembered Carl Brune. "She was just a warm person with an easy laugh. She was a brave person; she didn't let anything get in her way." Some years later, Carl gave a few of the recipes to Antoinette Baking Company in Tulsa, where they live on in the Tulsa Arts District.

IMPRESSIONS

Tom Butcher, a native of Seattle, Washington, had been crisscrossing the country as an efficiency expert and food coordinator for Sambo's Restaurants. When he came to Tulsa to open one near 31st and Yale, he stopped to get directions at a service station on the corner of 15th and Lewis. Little did he know that intersection would later be a cradle for his dream of owning his own restaurant.

Tom moved to Tulsa in 1972 after falling in love and marrying his first wife, Shirley. After working for a few eateries in town, he realized that Tulsa was missing a West Coast–style delicatessen. Tom decided to make his dream a reality at 1441 South Lewis Avenue. With the help of his father, Verlyn, and his brother Galen, Impressions opened on February 8, 1978.

It was in an impressive building of unfinished "lap and gap"–style cedar, designed by Steven Cole and Tom himself, full of diagonal lines, unique patterns and iconic round windows. The back of the house was laid out with efficiency in mind. The building's roof had a striking modern feature: fifty-two solar panels. The cutting-edge technological feature drew visitors from all across the country.

Once inside, diners were treated to a variety of sculptures and handcrafted furniture, such as tables designed by local artisan Joel Zane. The large dining area included many windows, several paintings and a loft. The building was so close to the intersection of 15th and Lewis that the tables next to the windows at that corner of the restaurant felt adventurous.

The ordering line was set up cafeteria-style. The varied menu was on a large chalkboard; diners waited in line and watched as their meals were assembled by Tom himself. Night business was slow at first, so Impressions started offering full table service for dinner and added a bar. "People went crazy," remembered Tom. "You wouldn't believe our menu, it was elaborate."

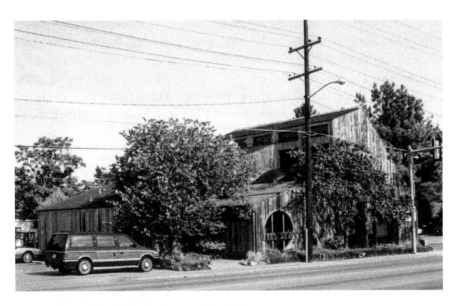

Impressions at 15th and Lewis. *Courtesy of Roy Wilkerson.*

Offerings included homemade soups, super spud potatoes, sandwiches and pastries. The namesake sandwich was a huge creation composed of salami, ham, turkey, swiss and cheddar cheese. The prime rib became known throughout the city. "We had a Mexican plate, pita bread and hummus, cabbage rolls…it worked out really well," Tom continued. Business was so strong that they had to expand the kitchen to add a grill; it was then that "I became my own best cook. I'm not a chef; I will *always* be a cook."

Impressions also became well known for its desserts: carrot cake and peanut butter pie especially. Tom's wife was the dessert chef in addition to helping out with other duties. Tragically, Shirley died in a car accident on Christmas Day 1981. Tom continued forward, raising his two children and running an increasingly popular restaurant.

Impressions continued to evolve through the 1980s and '90s. The solar panel system, once considered a revolutionary game-changer, was removed due to upkeep costs. Before the alcohol laws were passed in 1984, Tom had several run-ins with the ABC Board. "I got busted five times and went to jail four times. The fifth time I hid in the attic and my wife told them I wasn't there," he told the *Tulsa World*.

By the late '90s, the stress of the long work weeks and increasing competition convinced Tom it was time to take a break. "I thought it would be best to go out while I'm still on top—when business is good," he told the *Tulsa World*. "After 20 years, I'm amazed I lasted this long. Not very many restaurants get to decide when they will go out of business."

Impressions closed on August 21, 1998. The striking building was demolished to make way for a new grocery store. Retirement didn't stick. "After about a year, my kids got tired of it and told me to find a job," Tom said with a smile. He operated Pizza Dot Tom in the Tulsa Arts District and later reopened Impressions as a lunch-only restaurant at 507 South Main Street. It closed in 2011 when the owner of the Oil Capital Building vacated all tenants. Shortly after that, Tom was diagnosed with a rare cancer that required significant surgery. Tom recovered fully and, a few years later, returned to work.

Tom's work continued at Take 2, a downtown lunch café that operates under the Resonance Center for Women to help recently incarcerated women reintegrate into society. Several of Impressions' most popular dishes were on the menu, including the prime rib. Many of their customers had followed Tom around since 1978. In mid-2018, Tom left Take 2 to take a well-deserved break.

Tom feels good about his legacy in Tulsa. "We didn't have a name [for the original restaurant] even after we started construction. I saw the light

Inside Impressions on its last day of business. *Courtesy of Tom Butcher.*

rise and fall across the windows and as the walls went up. It left a lasting impression…which is where the name came from. I still have people coming here and telling me they proposed at Impressions; an amazing amount of people had a relationship with that restaurant. I just wanted to do something totally different for the city."

MOLLY MURPHY'S HOUSE OF FINE REPUTE

Molly Murphy's was a destination unlike any other. It was an unpredictable and unique experience every time you walked through the door.

Robert "Bob" Tayar operated a series of restaurants in Oklahoma City that had moderate success. Inspired by a few dining hall experiences in Texas, he wanted to create a new dining experience that was truly spectacular. In 1976, Bob unveiled Molly Murphy's House of Fine Repute.

The building at 1100 South Meridian in Oklahoma City was custom-built using a variety of architectural styles. *Playboy Magazine* described the structure as "a Russian Orthodox Church that mated with a ranch house."

One corner of the building featured a large iconic Russian-style turret. "It had great eye appeal from the road, really intriguing," said Hank Kraft, the first general manager. "It just said fun and interesting."

The interiors were equally jaw dropping. The entry was filled with loveseats and comfortable chairs. The dining area was split into two rooms with a disco in the middle. The décor was haphazard. "It was a hodgepodge of everything. From fire hydrants to buttons on walls to pinups in the bathrooms to the salad car." Yes, the soup and salad bar was housed in the shell of a custom-built automobile. One booth was shaped like a wishing well, and another had walls made from hundreds of buttons. There were stained-glass panes in the middle of circular wall panels and Tiffany lamps hanging from the ceiling.

"We had people lined around the building; it was so much fun. We were serving margaritas to people waiting in the parking lot," Hank remembered. It was so successful that Bob looked to expand with a second restaurant. For that, he looked to Tulsa.

The location at 3900 South Sheridan was identical to its counterpart in the state capital. Weeks before opening, a mysterious fire gutted the building, causing hundreds of thousands of dollars in damage. After rebuilding, Molly Murphy's House of Fine Repute finally opened in Tulsa on November 2, 1978.

Opening night was also marred, but not by flames. The state Alcoholic Beverage Control Board raided Molly Murphy's. This was before liquor-by-the-drink was legal. They arrested three employees for charges of operating an open saloon and confiscated 603 bottles from the restaurant's storeroom. Considering the restaurant had only been open a few hours, law enforcement didn't feel that the labels bearing owner's individual names were valid. Lawyer (and future governor) Frank Keating helped get most of the booze returned in short order.

In addition to the zany décor, another unique touch set Molly Murphy's apart: every member of the staff was in costume and in character. You might be seated by Raggedy Ann and served by Blackbeard the Pirate. They played their parts to the hilt. If you spilled any soup on the salad car, you were loudly chastised by a nearby waiter. When the song "Car Wash" played over the sound system, everyone stopped what they were doing to perform an elaborate dance routine polishing the salad car.

"We hired kids and they had to *audition* for their spot," explained Hank. "Here came Wonder Woman, here came Superman...here came Zorro." They had to present the food menu in the manner of their character; some brought their own ideas, but Molly Murphy's had a rotating cast of regulars.

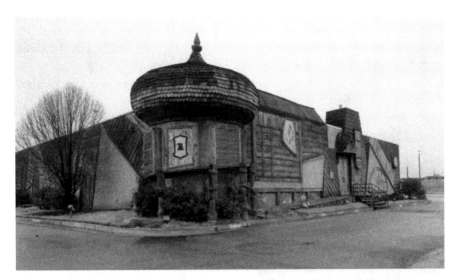

Above: Molly Murphy's House of Fine Repute. *Courtesy of the* Tulsa World.

Right: The salad car at Molly Murphy's in Tulsa, with Byrom Andreatte as Raggedy Andy and Eddie Lollie as Captain Hook. *Courtesy of the* Tulsa World.

"We had more Groucho Marx than anybody; it gave you a chance to say what you want to say and get away with it." Once you walked in the door, there was no telling what your experience would be.

Woe to anyone that asked where the restroom was, as you experienced the Potty Train. Rex Reynolds explained:

> I took my daughter to Molly Murphy's for her 16th birthday and told her how nice and opulent their restrooms were. Of course, she needed to go check them out. What she didn't know was that the huge staff of servers were always dressed as famous characters, and as she rose to go to the restroom, several of them surrounded her and formed a conga line, waltzing her around the entire restaurant multiple times, the whole while shouting out at the top of their lungs: "HEY EVERYBODY THIS IS LAURA AND SHE HAS TO GO TO THE BATHROOM TO POTTY!"
>
> Other diners joined in the conga line, and about seven or eight minutes later, she ducked into the restroom with a bright-red face. When she returned to the table, she was totally embarrassed and obviously not too happy with her dad. The rest of the evening, the various servers would stop by the table asking if she needed to go potty again. A very memorable moment at a very memorable restaurant.

It wasn't *just* the character experience at Molly Murphy's that brought people through the door; the food was good, too. "I thought our food was really good," said Hank. "The prime rib, the minestrone soup we made every day. Bob was a food fanatic; I learned a lot from Bob about the quality of food." It was all presented in colorful, cartoon fashion on a humorous menu.

The Bacchus Feast (for four or more) consisted of a thirty-eight-ounce steak, sautéed mushrooms, a whole chicken and a pile of fruit and vegetables. It also came with a show-stopping presentation consisting of half dozen staff parading through the rooms, chanting a song as they delivered the meal on a big platter.

Molly Murphy's was very popular. Repeat business was strong, as each dining experience was nearly impossible to replicate. It survived the recession and the oil bust in the early 1980s. In late 1986, unexpectedly, the doors at Molly's closed. Although it was turning a profit, Bob Tayar told the *Tulsa World* at the time that its revenue could not cover expenses associated to an unrelated investment. According to his wife, Jeffiee Tayar, in her book *Whatever Happened to Molly Murphy's House of Fine Repute?* those expenses came mostly from an Oklahoma City restaurant they launched called TaMolly's.

Bob Tayar continued running several other restaurant operations in the Oklahoma City metro. The original Oklahoma City Molly Murphy's lasted for another decade. In 1996, it closed after a public feud with a local TV station. Former employees keep the restaurant alive on social media, and all it takes is a mention of the restaurant to get people talking about the fun times they had at Molly Murphy's.

CHARLIE MITCHELL'S

Charlie Mitchell was an all-star soccer player from Scotland. He played for various teams in the 1970s throughout Europe, the United States and Canada. In 1978, he was a player-coach in Hawaii when that team moved to Tulsa. Two years later, he became the full-time coach for the Tulsa Roughnecks.

Across the pond, many successful players opened pubs in their names. Since the Oklahoma liquor laws were so strict, Charlie decided to go into the restaurant business instead. The plan was to have his parents, Charles Sr. and Anna Mitchell, help work the restaurant as hosts along with general manager Greg McGill while he continued coaching the Tulsa Roughnecks. Sadly, his father passed away while the restaurant was still under construction. Additionally, Charlie was fired from his coaching position weeks before the restaurant opened. He decided to go all-in with his new venture.

The first Charlie Mitchell's opened in 1981 to great fanfare at 8204 South Harvard Avenue. The space was designed to look like an English pub with American flair: framed soccer uniforms adorned the walls alongside stained glass and dark wood accents; a set of bagpipes hung over the bar. Charlie's personal signature was etched on a few of the tables and served as the sign on the front of the building.

Food was a spread of traditional, straightforward fare: steak, chicken, burgers and prime rib. Fish and chips were a big seller, as one might expect. Charlie's favorite offering was the ribeye steak sandwich. Some of the dishes had decidedly British names: Prince Charles steak, Buckingham chicken, Fleet Street burger. Wedding cake was served for free the night of Prince Charles's royal wedding to Lady Diana.

Charlie placed a value on customer service, noting it would make or break a restaurant regardless of the food quality. "A good meal and bad service? You're going to lose the customer. A bad meal but good service…you can

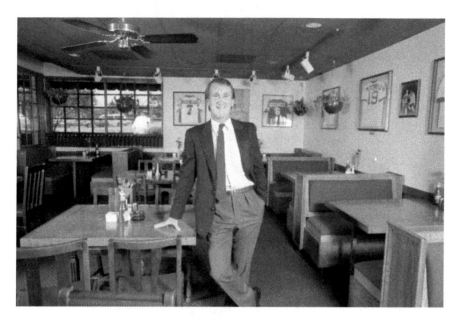

Charlie Mitchell at his first restaurant. *Courtesy of Tulsa Historical Society and Museum.*

get them back," he explained. He also said having the right people was vital. "It's like managing a soccer team; if you don't have the right players, you're not going to win."

He was right; Charlie Mitchell's was an astounding success. The tables and booths were filled with Tulsans of all kinds: businesspeople, families, couples. A year after its opening, the *Tulsa Tribune* reported that people were *still* waiting in line for dinner on weeknights. "I've never seen anything like it," remembered local restaurateur Howard Smith. "It was a real phenomenon."

Charlie walked the floor and talked to his customers, charming them with his Scottish accent. His mother, Anna, did the same. "When my dad passed away, my mom hadn't written a check in her life," Charlie said. "She came into the restaurant strictly as a housewife...a little shy." But she quickly became a fixture at the restaurant. "If I did have a customer that...was hard to deal with or had an attitude, I used to go get my mom!" Charlie remembered with a laugh. "She would go up with her accent...and ask how she could help. Who's going to get mad at *her?*"

Because of the runaway success, Mitchell's expanded to a second location at 2705 East 21st Street in August 1982. It was another hit, drawing business people from downtown Tulsa and the surrounding area. Charlie attributed part of this success to his business philosophy of making a restaurant

comfortable and family-friendly: "I built the whole concept of Charlie Mitchell's on the concept that I had two kids and going to restaurants can be a lot of hassle. At fast food places, you couldn't sit down with your family. At some other places you're not welcome." Charlie remembered how his mother would befriend frazzled mothers and carry their babies around the restaurant, allowing them to enjoy their meal.

In November 1985 Mitchell opened his third location, this time in the suburb Broken Arrow. It was also decked out in soccer gear, most of it from the local Broken Arrow Soccer Association. He attributed his increasing success to a few things: prompt service, a welcoming atmosphere, fair prices and good food. "In this economy you cannot afford to not give the customer the best service. People are budgeting and are watching where they go," he told the *Tulsa World* that November.

The 81st and Harvard location was still the flagship restaurant. Business remained steady throughout the chain despite the slow economy. Mitchell traveled between his locations during the lunch rush, making sure he was visible and to ensure his restaurants were operating as they should. "I get a kick out of being able to run my own day," Charlie said at the time.

In 1987, a fourth location opened downtown at 201 West Fifth Street partially thanks to a new city program to revive downtown retail. "I'm excited about it," Mitchell told the *Tulsa World* that September. "I've been thinking about downtown for a long time. The deal was hard to turn down." The downtown location also provided catering to the Tulsa Press Club, which was in the same building at the time.

In 1991, Mitchell relocated his original flagship location to 8178 South Lewis. He also operated Winning Colors restaurant at the Fair Meadows Racetrack and the Outback Sports Café at 5154 East Skelly Drive.

Outside of the restaurant business, Charlie was heavily involved in youth soccer programs. He focused on helping children use soccer to receive scholarships to further their education. He was also involved with the Little Lighthouse and the Gatesway Foundation.

Business took a downturn in the early '90s; the influx of national chain competition caused Charlie to start selling off his restaurants in 1993. The last Charlie Mitchell's, the midtown location on 21st Street, closed in August 1995. Charlie returned to the game that brought him to America and began coaching soccer at Northeastern State University.

In 2011, Charlie Mitchell's restaurant was revived near 51st and Yale along with co-owner Greg McGill, general manager of the first restaurant on Harvard Avenue. In the interim, Greg had achieved success with his

own McGill's steakhouses and the Full Moon Café. While the new Charlie Mitchell's enjoyed moderate success, the restaurant landscape was fiercely competitive. It closed in 2015.

Charlie had nothing but gratitude for his restaurant career. "For me it was a great challenge. I learned so much….It was a great experience," he said.

CHARADES

When Charades opened in 1983, Suzanne Holloway of the *Tulsa World* referred to it as the "Robert Redford of the restaurant beat." An old brick warehouse at 318 South Cheyenne Avenue, dating to 1929, had been transformed into a swanky dining space with street lamps and a mural on the outside. Curious downtown workers watched as the space took shape; to many, it seemed like the restaurant would never open. Owner Ray Weiland was making something special.

Ray came to Tulsa by way of Chicago and worked at the Interurban before embarking on his own. He named his new restaurant after the game he loved to play as a child. He told the *Tulsa World* that he didn't advertise in the weeks leading up to the opening day; he added he "didn't want sightseers or people who might carry things away." When people finally got to see the inside of the restaurant, they understood why.

The front doors were made of oak and brass and weighed three hundred pounds apiece. Once you got inside, it was an awesome sight. The interior was divided into four rooms: one had reconstructed oak paneling taken from the offices of Lloyds of London while another had been reconstructed from the walls and bar from the Standard Chartered Bank of London. There was also a garden room with plentiful plant life and a club room of brick and mahogany.

There were small, expensive touches everywhere. The men's room included marble flooring from the Skirvin Hotel in Oklahoma City. One of the doorways was trimmed with the remains of a mansion built in Guthrie, Oklahoma, circa 1890. Weiland estimated that he had spent more money than had ever been spent in building a restaurant in downtown Tulsa. The *Tulsa World* called it "an oasis of open-faced opulence in a downtown desert of cabaret depravity."

The food on Charades' menu catered to a wide variety of tastes and budgets. It ranged from sandwiches and salads to escargot and chicken Kiev.

Charades restaurant during its short-lived downtown existence. *Courtesy of the* Tulsa World.

Early reviews were positive and Charades was known to fill to capacity for the downtown lunch crowd. It even drew a crowd at night in a time when downtown Tulsa emptied promptly at 5:00 p.m.

Eight months later, though, patrons were greeted with a small paper sign: "Closed for Repairs." The restaurant never reopened. Investors at the time claimed they spent an eye-watering $500,000 on renovating the space when it opened; the debt was generally considered the reason for Charades's short life.

METRO DINER

Back when Route 66 was a bustling transcontinental highway, a gas station stood at 3001 East 11th Street. It was converted into an Arby's in the late 1970s. In the 1980s, it transformed again: this time into the retro-inspired icon that Tulsans remember best.

The Metro Diner was conceived by Robert L. "Bob" Davis. The Davis family had been in the restaurant business for decades, starting with Dumar's Drive-in at 31st and Yale in the late 1950s. The family also ran a restaurant in the Sheridan Lanes bowling alley for several years. "It was a blue-collar kind of joint," remembered son Mark Davis. "Every day the counter was lined up with mail carriers and construction workers." During the time when the

Broken Arrow Expressway was under construction, the Davises ran a few food trucks around town to help serve workers that were stuck in hard-to-navigate areas.

In 1969, Bob Davis opened his first Arby's franchise. By the time the Metro Diner opened, his U.S. Beef Corporation owned seventy Arby's restaurants in multiple states. When Bob had the opportunity to move the Arby's on 11th Street to the corner of Harvard, he decided to renovate the old building into a diner. Mark and his brother Jeff went to New York, where they spent a weekend going to many classic establishments to get a feel for what they wanted.

The Metro itself was designed by Dale Brackett and looked as if it had stopped time in the mid-1950s, even though Bob and his sons didn't open for business until 1984. The aluminum siding with glass bricks around the outside was an excellent likeness from the doo-wop days and a bright neon sign towered proudly next to historic Route 66. Below the buzzing tubes, it read, "Elvis Eats Here."

Although many restaurants have tried to capture the 1950s feeling over the years, the Metro was one of the few that all agreed got it right. The light fixtures were delightfully deco. The walls were adorned with murals and glass blocks. The hostess station was made from the back end of a 1957 Chevy. Behind it, a long mirror advertised the day's specials.

Beyond that sat a soda fountain complete with spinning chrome bar stools. One wall displayed a giant Route 66 mural. A metal pink flamingo sat by the door. Most of the nostalgic memorabilia had been gathered by the Davis family at flea markets throughout Oklahoma and Texas.

The Metro offered a daily special in addition to the traditional eats one expected to find. The hand-breaded chicken-fried steak and the Monte Cristo sandwich were particularly popular. Shakes and malts were served in old-fashioned soda glasses along with the metal tumbler containing the excess. Connie Cronley of the *Tulsa Tribune* called the chocolate shake "unbelievable." It even had a Blue Plate Special.

The menu of homemade goods was particularly attractive to students and faculty at the neighboring University of Tulsa. On game days, the diner closed its parking lot and set up tables to handle the crowd. Of course, a good number of Route 66 tourists and other folks from the neighborhood were a big part of the business too.

People didn't just come to the Metro for the food; they also came for the service. Like the diners of old, the waitresses were a big part of the experience. One such waitress came in after having worked for Pennington's

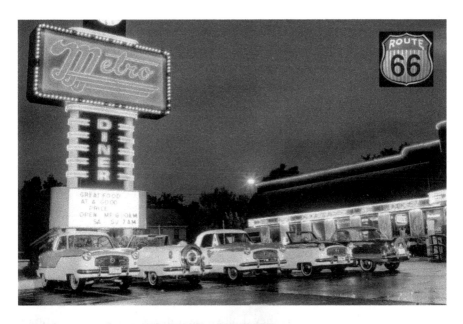

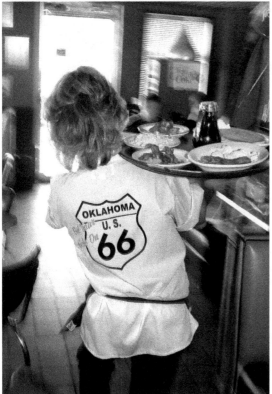

Above: Postcard for the Metro Diner on 11th Street. *Courtesy of the Tulsa Historical Society and Museum.*

Left: Serving customers at the Metro Diner. *Courtesy of the Tulsa World.*

Drive-Inn for over twenty years. "We were interviewing for waitresses and waiters before we ever opened," said Mark. "Dot walked in with her red hair; she looked like she was right out of a movie! It's kinda like we looked at her, she looked at us…and we knew she was in the right place. She came to work for us, and she was a classic. People came just to see her!"

Business was going so well on 11th Street that a second location opened at 8108 East 61st Street in 1989. The new site's two-level dining room was chock-full of bright pink and turquoise décor as well as neon and a robust sign collection. A glass pie cabinet and a soda fountain completed the vintage look. Although the Metro was successful, the influx of chain restaurants in the early '90s was overwhelming. "Twenty restaurants opened within a mile of us over there in two years," recalled Mark Davis. When business wasn't profitable anymore, the Davises closed it and re-focused on the original location.

"It was a real special place for our family," Mark said fondly. "It reminded us all of where my dad had come from." The restaurant held a lot of memories for all of them, as they'd all worked in the diner at one time or another, even their mother. "There were some good times back there."

By the mid-nineties, the Metro was being run by Chuck Essman and his wife, Annie Davis. Eventually, it was purchased by veteran restaurateur Jim Rowenhorst, who was eager to continue the popularity of the Metro. Much of the staff stayed on.

"There were a lot of interesting people at the Metro," recalled Rowenhorst. "We had a guy called Sundown, he came in every day. Older guy…rode his Harley every day, winter or summer. Noel, a building inspector, was in twice a day. Mostly to drink coffee and to visit with our staff." There were whole groups of people that made Metro a regular part of their lives. "It was a fun place."

In July 2006, the Metro Diner property was bought by the Tulsa Development Authority in order to build a new entrance at the University of Tulsa. Jim considered relocating the restaurant, but the cost involved and difficulty in replicating the unique mix of customers was so great that he announced that the Metro would be closing for good.

Shortly after word got out, the restaurant had to stop dinner service; it simply didn't have enough staff to support it. Several of the longtime employees held the torch, though. Alberta Caldwell had worked at the diner for over sixteen years and didn't plan on stopping until they locked the doors. One of her sons was a cook, another was a dishwasher. Her sister and niece earned a paycheck at the Metro, too.

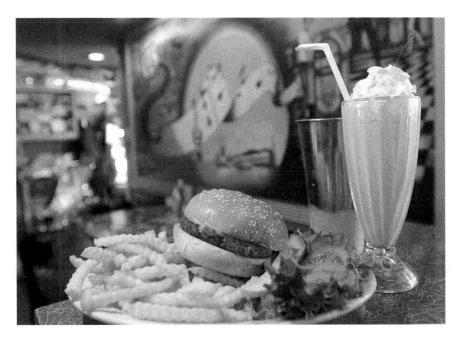

Classic diner fare at the Metro. *Courtesy of the* Tulsa World.

On November 26, 2006, the Metro Diner closed after twenty-two years of business. It looked like something out of a movie; barricades were set up around the building, and all the land around the Metro had been cleared. It stood alone. According to Ron Warnick at route66news.com, who visited on that last day, lots of folks turned up for one last bite. "I squeezed in a visit to the Metro right before it finished its final 7:00 a.m. to 3:00 p.m. shift. The place was packed with customers, although many were turned away because it began running out of food about 2:00 p.m.," he wrote.

Though an auction was scheduled the following month to sell off parts of the restaurant, some people couldn't wait. A few of the black and pink tiles on the exterior of the building had been pried off by the time they closed the doors on that last day.

Epilogue
Blue Dome Diner

Out of all the restaurants I researched and wrote about in this book, there's only one that I ever ate at myself. I had a burger at the Metro Diner once; although I enjoyed it, I didn't find myself on that side of town very often. Before I knew it, it was closed. I grew up in Broken Arrow and by the time I really started exploring Tulsa, most of these locally famous restaurants were already history. There *is* one restaurant that the city has lost that does have a personal connection to me: The Blue Dome Diner.

The diner near Second and Detroit was the last place I shared a meal with my father, Tony Martin. His unexpected passing in early 2011 hit me like a freight train. As I worked through the "new normal" of my life, I returned to the restaurant often to sit in the same booth where we ate breakfast together. The comfort of being in a place so strongly tied to a cherished memory is irreplaceable. When the diner announced it was closing, I was beyond crestfallen. I ate there on the last day of business; funnily enough, so did my future wife though our paths hadn't yet crossed. Although the diner has been gone for years, I can still close my eyes and picture it perfectly.

The story of the Blue Dome Diner starts and ends with Brian Prewitt, a longtime Tulsa caterer who also worked for Bodean's Seafood for nearly a decade. When he felt it was time for something new, he looked to a part of town that had been written off for new, trendy development: downtown.

The space at 313 East Second Street had been a nightclub called Goodfellas for years. When that went out in 2004, the space was renovated

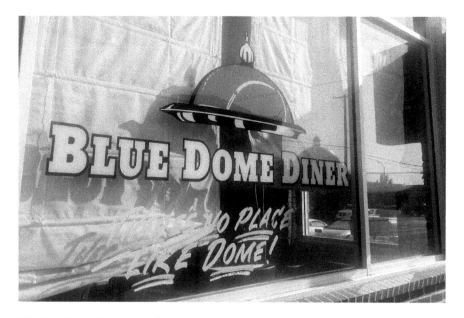

The Blue Dome Diner on its final day. *Courtesy of Cloudless Lens Photography.*

by Debbie Higgs and made into the new home of her long-running Route 66 Diner. Business was good, but the massive seven-thousand-square foot space was a lot to manage. Brian worked there on the weekends to help out and saw his opportunity when Debbie wanted to take a step back. In February 2006, Brian took over the space with several partners from his time at Bodean's; the Blue Dome Diner (named after the iconic former service station across the street) was born.

"One thing that happened when I took over the diner from Debbie was that the Metro Diner was closing," said Brian. "I couldn't have done it without all the employees that came to me from the Metro." Several waitresses and a cook transitioned from the modern alignment of Route 66 to the original one downtown—and brought their clientele with them.

After about a year, Brian was running the place on his own and working hard to set his restaurant apart from the typical diner. In addition to the traditional fare you'd expect, it offered more upscale options like quiche, lamb, stuffed pork chops and citrus-infused chicken breast. It didn't have a deep fryer in the kitchen. Everything was made fresh. The place was packed, especially on the weekends; breakfast was the most popular time of day. "It was great to survive our time there off word-of-mouth; we had very little advertising."

"A lot of people didn't know what it took to keep the place alive," said Brian. "It was fun, but it wasn't ever easy." The enormous footprint of the restaurant was divided in two. Up front it looked more like a standard diner with partially exposed brick and large historic photos. In the back, a big open room was used for overflow seating and often rented out for live music and large gatherings.

In addition to the dual nature of the space, Brian ran his catering business out of the kitchen. He served performers at the Brady Theatre and BOK Center in addition to parties, weddings and whatever else came his way. It was all required to keep the machine rolling in an area not yet known as a prime dining destination.

The Blue Dome Diner was a witness to the overall awakening of the district. Soon, the area was home to all sorts of downtown events: the Blue Dome Arts Festival, Free Tulsa Music Festival and more. Businesses continued to open downtown and the district experienced a renewed energy, of which the diner was a part.

With the rise in popularity came a rise in property value, which translated to a rise in rent. It more than doubled over the relatively short life of the

Breakfast at the Blue Dome Diner. *Courtesy of Cloudless Lens Photography.*

diner. "We always tried to do the best we could; people were enjoying the food, which to me is the most important part," said Brian. The landlord did not renew their lease and the Blue Dome Diner served its last meals on July 29, 2012.

Although it was disappointing to have to leave the district he helped bring back to life, Brian had a plan. He worked out a deal to provide lunches for the Tulsa School of Arts and Sciences near 15th and Lewis, which allowed him to continue his catering business. Five days after the move, disaster struck: the school burned to the ground.

For a brief time, Brian worked to jump-start another local establishment. The Family Diner at 3535 East Admiral had been a fixture for years when Brian attempted to bring it back to life. Sadly, he never could get Blue Dome's clientele to follow him over. "We did okay, but, it was better to use that space as a catering kitchen to help support Sequoyah Elementary," he remembered. (Sequoyah had been selected as the new home of the Tulsa School of Arts and Sciences after the other one burned down.)

Brian remembered his time running the Blue Dome Diner fondly: "From the homeless people to the richest lawyers in Tulsa, everybody was welcome there. If you're hungry, we're going to take care of you," he said proudly. "It was a fun ride. There's a lot of gratification to doing what you love."

I agree with Brian and the rest of the people who made the diner special: "There's no place like Dome."

Acknowledgements

Writing this chronicle has been a joy. You can learn a lot about the evolution of a city by understanding the greasy spoons and dinner destinations that tie everyone together. It was a treat to spend time in the archives at the Tulsa Historical Society, the Tulsa City–County Central Library and the University of Tulsa. My favorite part of this journey, though, was experiencing the city's lost eateries through the words of those who owned and ate at our Tulsa's beloved establishments.

I want to thank my wife, Samantha Extance, for her endless support and encouragement. This book would not exist without everything she has done to guide me through this process. Also, I must give special thanks to my mother, Lory Martin. She has been encouraging me to write and follow my dreams for my entire life.

I am grateful to so many others for their time, their support and their generosity:

Michael and Suzanne Wallis, Ken Busby, Scott Cherry, Tom Gilbert, Hilary Pittman, Ian Swart, Marc Carlson, Jennifer Murphy, Tom Baddley, Mark Messler, Toni Hile, Dick Greenwood, Michael Greenwood, Sue Greenwood, Greg Cunningham, Lynn Lipinski, Dennis Whitaker, Joe and Margaret Miller, Beverly Salley, Gary Reynolds, Betty Funston-Collins, J. Patrick Cremin, Walter Powers, Steve Clem, Joe Kifer, Darrell Brown, Joanie and David Stephenson, Forrest Cameron, James Leake Jr. and James Leake III, Randolph Stainer, Wilhelm Murg, Angela Kantola, Erica

ACKNOWLEDGEMENTS

Cook, Jim Rowenhorst, Mitch Latting, Kelli Bruer, Kay Watkins, Marilyn Trout, John Erling and Voices of Oklahoma, Bob Reavis, Brian Prewitt, Susi Wallace McCauley, Tom Winslow, Terry King, Cheryl Dobbins, John Siu, Charles and Norma Miller, Howard Smith, Jean Eng and family, Faye Parkey, Theresa Bishop, Rick Kamp, Cat Burton, Jim McCollum, Clark and Keith Ferguson, Lori Williams, Jim Sellers, Basil and Randal Blackburn, Roy D. Wilkerson, Hank Kraft, Harvey Shell, Rick Morton, Dewey Bartlett, Jeff and Dan Downey, Charles Claybrook, David Ingram, Sandra and Glendon Combs, Danna Sue Walker, Josh and Jaine Human, George Suppes, Tom Butcher, Greg McGill, Tammy Posey, Ron Baber, Steve Housel, Charlie Mitchell, Lorrie Gran, Rick Morton, Joe Saab and Peggy Helmerich.

Bibliography

Collections

The Beryl Ford Collection/Rotary Club of Tulsa, undated. Tulsa City–County Library and Tulsa Historical Society, Tulsa, Oklahoma.

Bishop's Restaurant, 1939–1955. Robert M. McCormack photographic studio archive, 1935–2000, 2008-049-3-14. The University of Tulsa, McFarlin Library, Department of Special Collections and University Archives.

Connor's Corners Restaurant, undated. Robert M. McCormack photographic studio archive, 1935–2000, 2008-049-3-39. The University of Tulsa, McFarlin Library, Department of Special Collections and University Archives.

Howard Hopkins Photo Collection, Courtesy of Dewey Bartlett Jr., Tulsa, Oklahoma.

Louisiane Restaurant, undated. Robert M. McCormack photographic studio archive, 1935–2000, 2008.049.3.115. The University of Tulsa, McFarlin Library, Department of Special Collections and University Archives.

Pennington's Drive In, 1959-04-30. Robert M. McCormack photographic studio archive, 1935–2000, 2008.049.6. Buildings 426. The University of Tulsa, McFarlin Library, Department of Special Collections and University Archives.

Powers Restaurant, Undated. Robert M. McCormack photographic studio archive, 1935–2000, 2008.049.3.165. The University of Tulsa, McFarlin Library, Department of Special Collections & University Archives.

Silver Castle Restaurants. Tulsa Art Deco archive, 1977–1981, 1982.006.2.002. The University of Tulsa, McFarlin Library, Department of Special Collections and University Archives.

Tulsa Vertical Files, Restaurant Folder, Undated. Tulsa City–County Library, Research Center-Oklahoma Collection, Tulsa, Oklahoma.

Villa Venice Restaurant, Undated. Robert M. McCormack photographic studio archive, 1935–2000, 2008.049.3.239. The University of Tulsa, McFarlin Library, Department of Special Collections and University Archives.

Books

Tayar, Jeffiee. *Whatever Happened to Molly Murphy's House of Fine Repute?* Indianapolis, IN: Dog Ear Publishing, 2007.

Magazines

Tulsa People (July 1997, May 2015)
Tulsa Voice (February 2014)

Newspapers

Local newspaper articles were the genesis of the research process. I spent hours at the Tulsa City–County Library and the Tulsa Historical Society and Museum scouring their vertical files to find restaurant reviews and profiles. I read obituaries to learn more about the people involved and used that information to find family with whom I could sit and talk. Support your local paper, because without them I would've had no place to start.

Tulsa Tribune (1954–1988)
Tulsa World (1951–2015)
Union Boundary (February 1993, Vol. 1 No. 1)

Interviews

Aaronson, Larry. Interview by the author, Tulsa, Oklahoma, February 6, 2018.

Alexander, Jeff. Interview by the author, Tulsa, Oklahoma, December 11, 2017.

Baber, Ron. Interview by the author, Tulsa, Oklahoma, March 17, 2017.

Bennett, Lynne. Interview by the author, Tulsa, Oklahoma, February 28, 2018.

Bishop, Theresa. Interview by the author, Tulsa, Oklahoma, February 23, 2018.

Blackburn, Basil. Interview by the author, Tulsa, Oklahoma, March 1, 2018.

Brown, Darrell. Interview by the author, Tulsa, Oklahoma, February 26, 2018.

Brune, Carl. Interview by the author, Tulsa, Oklahoma, February 14, 2018.

Butcher, Tom. Interview by the author, Tulsa, Oklahoma, March 14, 2018.

Claybrook, Charles. Interview by the author, Tulsa, Oklahoma, March 8, 2018.

Combs, Sandra, and Glendon Combs. Interview by the author, Tulsa, Oklahoma, March 10, 2018.

Cunningham, Greg. Interview by the author, Tulsa, Oklahoma, October 20, 2017.

Davis, Mark. Interview by the author, Tulsa, Oklahoma, February 22, 2018.

Dobbins, Cheryl. Interview by the author, Tulsa, Oklahoma, February 11, 2018.

Eng, Don, and Peggy Char. Interview by Rodger Harris and Michael Bell, Oklahoma Historical Society, Oklahoma City, Oklahoma, April 25, 2007.

Eng, Jean. Interview by the author, Tulsa, Oklahoma, February 18, 2018.

Funston-Collins, Betty. Interview by the author, Tulsa, Oklahoma, January 19, 2018.

Greenwood, Dick. Interview by the author, Tulsa, Oklahoma, December 8, 2017.

Helmerich, Peggy. Interview by the author, Tulsa, Oklahoma, March 29, 2018.

Hile, Toni. Interview by the author, Tulsa, Oklahoma, October 22, 2017.

Housel, Steve. Interview by the author, Claremore, Oklahoma, March 7, 2018.

Human, Jaine. Interview by the author, Tulsa, Oklahoma, March 13, 2018.

Ingram, David. Interview by the author, Tulsa, Oklahoma, March 8, 2018.

Kallmeyer, Michael. Interview by the author, Tulsa, Oklahoma, March 7, 2018.

Kamp, Rick. Interview by the author, Tulsa, Oklahoma, February 22, 2018.

Kifer, Joe. Interview by the author, Tulsa, Oklahoma, January 16, 2018.

King, Terry. Interview by the author, Tulsa, Oklahoma, February 9, 2018.

Kraft, Hank. Interview by the author, Tulsa, Oklahoma, March 2, 2018.

Latting, Mitch. Interview by the author, Tulsa, Oklahoma, January 18, 2018.

Leake, James Jr. Interview by the author, Tulsa, Oklahoma, January 17, 2018.

McCollum, Jim. Interview by the author, Tulsa, Oklahoma, February 25, 2018.

McGill, Greg. Interview by the author, Tulsa, Oklahoma, March 14, 2018.

Messler, Mark. Interview by the author, Fort Gibson, Oklahoma, October 17, 2017.

Miller, Charles, and Norma Miller. Interview by the author, Tulsa, Oklahoma, February 11, 2018.

Miller, Pat, with Judy and Patrick Carroll. Interview by the author, Tulsa, Oklahoma, August 27, 2018.

Mitchell, Charlie. Interview by the author, Tulsa, Oklahoma, March 23, 2018.

Morton, Rick. Interview by the author, Tulsa, Oklahoma, March 4, 2018.

Parkey, Faye. Interview by the author, Tulsa, Oklahoma, February 20, 2018.

Powers, Ruth. Interview by Joe Todd, Oklahoma Historical Society, Oklahoma City, Oklahoma, May 5, 1983.

Prewitt, Brian. Interview by the author, Tulsa, Oklahoma, February 6, 2018.

Reavis, Bob. Interview by the author, Tulsa, Oklahoma, February 9, 2018.

Redeker, Linda. Interview by the author, Tulsa, Oklahoma, March 25, 2018.

Rowenhorst, Jim. Interview by the author, Tulsa, Oklahoma, January 19, 2018.

Sellers, Jim. Interview by the author, Tulsa, Oklahoma, February 27, 2018.

Smith, Howard. Interview by the author, Tulsa, Oklahoma, February 12, 2018.

Stephenson, Joan. Interview by the author, Tulsa, Oklahoma, January 23, 2018.

Suppes, George. Interview by the author, Tulsa, Oklahoma, March 15, 2018.

Trout, Marilyn. Interview by the author, Tulsa, Oklahoma, February 15, 2018.

Watkins, Kay. Interview by the author, Tulsa, Oklahoma, January 19, 2018.

Williams, Lori. Interview by the author, Tulsa, Oklahoma, March 7, 2018.

Winslow, Tom. Interview by the author, Tulsa, Oklahoma, February 10, 2018.

Other Communications

In addition to formal interviews, I had conversations over e-mail and various social media platforms with the following people throughout 2017 and 2018. Their additions, no matter how minor, helped shape the stories in this book.

Amy Adair, Lynne Bennett, Theresa Bishop, Randall Blackburn, Kelli Bruer, Glenn Char, Jeff and Dan Downey, Eddy Elias III, Clark Ferguson, Keith Ferguson, Joy Frangiosa, Lorrie Gran, Michael Harbour, Bennie Johnson-McCormick, Ken Jow, Angela Kantola, Anissa King, Linda Kelley, Lynn Lipinski, Joe Miller, Rick Morton, Walter Powers, Joe Saab, Beverly Salley, John Siu, Susi Wallace-McCauley, Michael Wallis and Ron Warnick.

Websites

"Historic Preservation at the Park Plaza Court," Cornerstone Environmental, June 12, 2015, https://www.cornerstone-environmental.com/single-post/2015/06/12/Historic-Preservation-at-the-Park-Plaza-Court-Flagstaff.

"The Beloved Family Diner Has Risen from the Ashes," Brian Schwartz, Tulsa Food, April 5, 2013, http://tulsafood.com/tulsa-american-food/family-diner-is-now-open/.

"Blue Dome Diner," Emily Priddy, Indie Tulsa, July 10, 2007, https://indietulsa.wordpress.com/2007/07/10/blue-dome-diner/.

Voices of Oklahoma, John Erling, Oklahoma Center for the Humanities at the University of Tulsa, December 2, 2011, http://www.voicesofoklahoma.com/interview/stephenson-steve/.

Index

M

Magician's Theatre 133
Mancini, Henry 66
Mandarin Café 20, 21, 109, 111, 113
Mayo, John 25
McCollum, Dale 72, 74, 76
McCollum, James W. 36, 39, 72
McCollum, Jim 73, 74
McCollum's 73, 74
McGill, Greg 165, 167
McGill's 168
Memorial Day flood 140, 146
Menca, Adolph 44
Messler, Mark 93, 96
Messler, Mike 95
Metro Diner 169, 170, 172, 173, 175, 176
Miller, Charles 24, 27
Miller, Genevieve 101
Miller, George 24, 25
Miller, Joe 101, 102
Miller, Margaret 24, 25
Miller, Norma 25, 26
Miller, Paul 101, 102
Miller, Ray 24, 25
Miller's Drive-In 80, 81, 93
Miller's Korner Shoppe 101
Miller, Waller 80, 90
Ming Palace 113
Miss Tulsa Lunch 73
Mitchell, Anna 165, 166
Mitchell, Charlie 165, 166, 167, 168
Molly Murphy's House of Fine Repute 161, 162, 164, 165
Moody, Ernest 51
Morrow, Marvin 82
Morton, Louise 29
Morton, Rick 28, 30, 32
My Pi Pizza 144, 146

N

Nalp, Orr. *See* Sahinalp, Ugur

Nelson, Willie 138
Nine of Cups 131, 132, 133, 134
Norman Angel's Auto Café 81

O

O'Keefe, Callie 131
O'Keefe, Sarah 132
Oklahoma Martini 99
Outback Sports Café 167

P

Page, Patti 58
Pang, Loy 20, 22, 23
Pang, Yuen 23
Parkey, Faye 38
Parkey, Ike 36, 38, 39, 41
Pennington, Archie 80, 90, 92, 93, 94
Pennington, Judy 94, 95
Pennington, Lola 80, 90, 95
Pennington's Drive-Inn 76, 80, 90, 172
Perrin, Gladys 25, 26
Pizza Dot Tom 160
Powers 1800 69
Powers, Bill 69
Powers, Don 14, 66, 68, 69
Powers, Harry 19, 66
Powers, Joseph H.. *See* Powers, Harry
Powers, Joseph H. Jr. 66
Powers Restaurant 66, 69, 71
Powers, Ruth 67
Powers, Walter 69
Powers, William 117. *See* Powers, Bill
Prewitt, Brian 175, 176, 177, 178

R

Ray's Coffee Shop 24, 26
Reasor, Larry 140
Reavis, Jack 45
Reed, Donna 149
Restless Ribbon 79, 93, 109, 110

About the Author

Rhys Martin has been writing about his travels throughout the Midwest and beyond since 2009. He discovered a passion for photography and history while backpacking Southeast Asia and Europe; when he returned to Oklahoma, he saw his home state with fresh eyes. It was through this lens that he began to explore Route 66 and the story of Tulsa. His writing and photography has been featured in various publications such as *This Land*, *Route 66 Magazine*, the *Tulsa World* and *Tulsa People*. You can learn more at www.cloudlesslens.com.